BEHOLDING THE GLORY

Bible
19.80

BEHOLDING THE GLORY

Incarnation through the Arts

Edited by
JEREMY BEGBIE

 Baker Academic

A Division of Baker Book House Co
Grand Rapids, Michigan 49516

© 2001 by Jeremy Begbie

Published by Baker Academic
a division of Baker Book House Company
P.O. Box 6287, Grand Rapids, MI 49516-6287

Printed in the United States of America

Library of Congress Cataloging-in-Publication Data

Beholding the glory : incarnation through the arts / edited by Jeremy Begbie.
 p. cm.
 Includes bibliographical references.
 ISBN 0-8010-2244-4 (paper)
 1. Jesus Christ—Art. 2. Incarnation in art. 3. Arts, Modern—20th
century. I. Begbie, Jeremy.

NX660.B44 2000
261.5'7—dc21 00-05 '177

Scripture quotations are from the New Revised Standard Version of the
Bible, copyright 1989 by the Division of Christian Education of the National
Council of the Churches of Christ in the USA. Used by permission.

For information about academic books, resources for Christian leaders, and
all new releases available from Baker Book House, visit our web site:
http://www.bakerbooks.com

Contents

List of Illustrations

Contributors

Lynn Aldrich is a sculptor who lives and works in Los Angeles. She teaches art history, theory and studio classes at the Art Center College of Design in Pasadena, California. Lecturing widely on contemporary art and theology, her work has been exhibited throughout the United States and in Germany, Italy and the Netherlands. Her sculptures are in the collections of the Los Angeles County Museum of Art and the Museum of Contemporary Art, Los Angeles.

Jeremy Begbie is Vice Principal of Ridley Hall, Cambridge and Director of 'Theology Through the Arts', a research project at the Centre for Advanced Religious and Theological Studies, Faculty of Divinity, University of Cambridge. He teaches systematic theology at Ridley Hall and in the University. He studied music and philosophy at Edinburgh University, and theology at Aberdeen and Cambridge. He is a professionally trained musician, and h..s performed extensively as a pianist, oboist and conductor. He serves on the Doctrine Commission of the Church of England and is author of *Music in God's Purpose* and *Voicing Creation's Praise: Towards a Theology of the Arts*. His latest book, *Theology, Music and Time* is published by Cambridge University Press. Dr Begbie has taught and lectures widely in the UK, North America and Canada.

Graham Cray is Principal of Ridley Hall, Cambridge, teaching theology and cultural studies at undergraduate and postgraduate levels. Formerly Vicar of St Michael-le-Belfrey in York, he has chaired the Greenbelt Arts Festival, and has a special interest in the relation of the Christian faith to popular culture. He is author of numerous essays and contributions to books, including 'The Gospel and Tomorrow's Culture', 'Postmodernism: Mutual Society in Crisis', in *Building a Relational Society*, 'The Post-Evangelical Debate', 'Postmodern Culture and Youth Discipleship', 'The Eucharist and the Postmodern World'.

Jim Forest is a writer, lecturer and occasional teacher. A member of the Russian Orthodox Church, he is the author of *Praying With Icons, The Ladder of the Beatitudes*, and biographies of Thomas Merton and Dorothy

Day. He is secretary of the Orthodox Peace Fellowship and editor of its quarterly journal *In Communion*.

Malcolm Guite is Chaplain of Anglia Polytechnic University, Cambridge, where he teaches literature at undergraduate and postgraduate levels, as well as teaching doctrine and pastoral theology in the Cambridge Theological Federation. He studied English Literature at Pembroke College Cambridge, and pursued his doctoral thesis at Durham University. He has taught at seminars and conferences on seventeenth-century literature and theology in Oxford and Winchester, and for Continuing Ministerial Education in both the Anglican and the United Reformed Church. His publications include academic papers on seventeenth-century literature, and theological reflection on pastoral experience. He is currently preparing a book for publication: *Faith, Hope and Poetry: a Study of Transfiguration in English Poetry.*

Trevor Hart is Professor of Divinity at St Mary's College in the University of St Andrews. He was formerly lecturer in systematic theology at Aberdeen University and pursued doctoral studies in the theology of the Greek fathers. He has lectured widely in the UK and the United States and has recently developed a special interest in the relationship between theology and imagination. He is author of *Faith Thinking, Regarding Karl Barth*, 'Imagination for the Kingdom of God', in *God Will be All in All*, and, with Richard Bauckham, *Hope Against Hope.*

Andrew Rumsey is a poet and an ordained priest in the Church of England. An experienced performer, his songs, sketches and poetry have been performed in numerous contexts including the Edinburgh Fringe Festival and BBC Radio. His first collection of poetry, *Homing In*, was published in 1998 by Paternoster Press.

Sara B. Savage lectures in psychology and sociology at the Cambridge Theological Federation and works as a researcher with the Psychology and Christianity Project, Centre for Advanced Religious and Theological Studies, Faculty of Divinity, University of Cambridge. For many years Dr Savage danced with a Christian dance group, touring widely. She now directs and dances with the dance group *Icon*.

INTRODUCTION

JEREMY BEGBIE

When we learn another language for the first time, we discover more about the world. However hard we may find the process of remembering new words, we can never see things in quite the same way. When an Eskimo gives me a huge range of words for 'snow', each referring to a different type, my perception of snow is enriched – I see more than I saw before. To 'get inside' a fresh language means that I will discern more, understand more.

The writers of this book believe that something similar happens when we 'get inside' the arts and explore the Christian gospel from this 'inside'. Our discernment and understanding are enriched. We discover more.

The urge to make and enjoy art seems to be universal: the impulse to scratch out images on stone walls, revel in the delight of notes strung together, shape and re-shape words into patterns, and so on. And for most people these activities are more than entertaining and ornamental (though they are often that), and more than means of expressing ourselves (though they can be that too) – they can also reveal, disclose, open up the world we live in, and in unique ways. In other words, they can be vehicles of *discovery.* We need only think of Van Gogh's landscapes and interiors, Dürer's meticulously detailed drawings of the human body, Bach's exploration of the inherent properties of sound. Or

we might call to mind S.T. Coleridge's comments on Wordsworth's *Lyrical Ballads*: they served the purpose of 'awakening the mind's attention from the lethargy of custom and directing it to the loveliness and the wonders of the world before us'.[1] Or again, John Macquarrie speaks of art as 'something like revelation. What is revealed has been there all the time, but it has gone unnoticed in our humdrum everyday experience. It needs the sensitivity of the artist to bring it to light, so that we notice things for the first time.'[2]

Sadly, when it comes to discovering and 'bringing to light' the Christian faith, the Church has often left the arts to one side. Certainly, the arts have played a massive part in the story of Christianity, and, for centuries, the arts have been recognised as powerful theological interpreters. However, especially in the last two or three centuries, theology – which I am here taking to mean 'faith seeking deeper wisdom' – has been wary of allowing the arts very much room. It has typically been dazzled by a kind of intellectualism, where the mind is effectively divorced from other parts of our humanity and forced to work at a high level of abstraction with a very restricted set of tools. All too easily, it is assumed that theology can only be done in universities and colleges, and only by those highly expert in certain disciplines – such as modern European philosophy, for example. While not for a moment denying the benefits to be gained from these ways of working, this book is an attempt to show how artistic practices (and reflection on them) have their own distinctive and indispensable role to play in what we might call the 'ecology' of theology – the whole gamut of ways in which the wisdom of God comes to be learned and articulated. This is not to say that the arts should necessarily replace more standard and well-tested ways of pursuing theology, only that they have a legitimate place alongside and in conversation with those more familiar methods. In the last few years I have been privileged to bring together a number of academic theologians and practising artists for intensive conversation – invariably this has reaped enormous benefits for all involved.

Our concern, then, is with what we might call 'theology through

the arts'. This means giving the arts space to do their own work as they engage with the primary testimony of Scripture and with the wealth of Christian tradition. It means that unfamiliar theological themes are uncovered, familiar topics exposed and negotiated in fresh and telling ways, obscure matters clarified, and distortions of truth avoided and even corrected. It means hearing 'a music that you never would have known to listen for' (Seamus Heaney). It also means benefiting from the extraordinary integrative powers of the arts, their ability to reunite the intellect with the other facets of our human make-up – our bodies, wills, emotional life, and so on.

This kind of engagement between theology and the arts is certainly not new – a recent visit to South Africa reminded me that in many cultures the arts have never left the theological scene at all – but it has certainly not been prominent in the modern and postmodern West. It is, however, both important and urgent. Much cultural theory would suggest that in the decades to come, the arts will play an ever more active role in shaping the way we come to terms with the world. A disillusionment about some of the grand claims once made for the natural sciences has led many to seek fresh meaning in the world of the arts and the imagination. As the western Churches face the enormous challenge of how the faith 'once delivered' is going to be re-delivered in a society increasingly alienated from the institutional Church and increasingly ignorant about the Christian faith, to neglect the arts' potential would be curious, perhaps even irresponsible. The sculptor Henry Moore was once asked by a vicar about the process of sculpting a Madonna and Child. Moore said: 'I think it is [only] through art that we artists can come to understand your theology.'[3] What was true of Moore is probably true of a growing number today, whether they are professional artists or not.

In this book, the focus is on one theme: the astounding claim that God has come to be one of us in Jesus of Nazareth, what the tradition has called the 'incarnation'. The authors seek to 'behold' the 'glory' of the Word made flesh (John 1:14) through different art forms. Following Trevor Hart's introductory chapter,

each writer tries to let a form of art (and reflection on that art) exercise its own particular powers, so that the miracle of 'God with us' can be sensed and enjoyed in fresh and illuminating ways. As Professor Hart points out, there is no supposition here that the mystery of the incarnation can be explained away or subsumed under a higher principle (such as the 'aesthetic', or 'Art'), only that the mystery, through the arts, can disclose itself more fully in all its wonder and uniqueness.

The authors write from many different backgrounds. Some are academics, some are practising and professional artists, some are writers, some are teachers, some are ordained clergy – and some belong to more than one of these categories. We come from different denominations and traditions – including Orthodox, Presbyterian, Anglican, evangelical and charismatic. We write in very different styles, and by no means agree in every respect. I have made no attempt to homogenise this diversity; indeed, it is part of the point of the book to show that such variety has its proper place in theology today.

There is no pretence to be comprehensive. We have confined ourselves largely to the arts of the twentieth century (icons, though they belong to a very ancient tradition, are included mainly because they have enjoyed a surge of popularity in recent decades). Some types of art are hardly addressed at all – for example, there is no chapter devoted to painting outside the icon tradition, neither is there one on film. And there are significant dimensions of the incarnation left unconsidered. But our purpose is limited: concentrating principally on one historical period, we hope to demonstrate what *some* aspects of *some* of the arts can do in opening up *some* aspects of the incarnation. We hope that others will be provoked into extending the discussion much further afield.

Theological jargon is deliberately kept to a minimum. Though some of the essays will be more demanding than others, it is hoped that they will all be largely accessible to those without formal training in academic theology.

Beholding the Glory is one of the fruits of a project, 'Theology Through the Arts', in the Centre for Advanced Religious and Theo-

logical Studies in the Faculty of Divinity, University of Cambridge. The book owes an enormous amount to the enthusiasm and dedication of my colleagues in that project, Fiona Bond, Ally Barrett and Michelle Arnold. 'Theology Through the Arts' is funded in large part by the British and Foreign Bible Society, whose support we acknowledge with much gratitude. My thanks also go to Katie Worrall at DLT for her courteous and patient efficiency.

<div align="right">

Jeremy Begbie

Christmas 1999

</div>

NOTES
1. *Biographia Literaria*, II (Princeton: Princeton University Press, 1983), p. 7.
2. *In Search of Humanity* (London: SCM, 1982), p. 195.
3. As quoted in Walter Hussey, *Patron of Art* (London: Weidenfeld and Nicholson, 1985), p. 24.

1

THROUGH THE ARTS:
Hearing, Seeing and Touching the Truth[1]

TREVOR HART

If we are to speak about the power of the arts to give us some purchase on the claim that God has 'taken flesh' for our sakes, we need to be wise about the ways in which we have habitually come to view them. Trevor Hart shows that many of our assumptions about the arts and the artistic imagination have come to us caught up in currents of thinking with ancient origins, some of which have been more harmful than helpful. Carefully tracing these currents, he evaluates them in the light of the incarnation, raising themes which are taken up many times elsewhere in this book. He goes on to indicate not only what a perspective shaped by the incarnation can provide for the arts, but that the arts and the artistic imagination can play a positive role in illuminating the meaning and implications of the incarnation.

Considering the delight which various types of participation in the arts grants to human beings, one might reasonably expect artistic imagination to be counted naturally among the greatest of God's gifts to humankind. While the precise nature of art's affect upon us remains a subject of complexity and dispute, we hardly need a degree in aesthetics to identify the affect when it happens, to realise its force and depth, and that it is something good for which we are

mostly glad. The work of art is not the only thing to affect us in such ways (there are other 'natural' sources of the affect), but art probably does it more consistently and well than most other things. We may not be able to define it, but most of us have some intuitive sense of the sort of response it is that melodies, paintings, poems, films, novels and other works of artistic imagination often grant or provoke in us. And, as I have already said, it is a response for which we are grateful when it occurs. On the whole, then, artistic creativity is a source of joy and leaves us with a sense of having tasted something good and worthwhile, even when we can't say exactly why. The world would somehow be a far less attractive place without it.

Curiously, though, the artist has not always been a figure whose contribution to human life has been valued, or towards whom any great appreciation has been shown. On the contrary, imagination in general and 'creative' or artistic imagination in particular has often been treated with great suspicion, and correspondingly relegated to a lower level of importance, influence and practical support than other human activities or capacities. The products of human imagining have regularly been viewed as at best a frivolous distraction from serious engagement with the world (whether that be scientific, economic, political, religious or some other form of engagement) and at worst a dangerous hindrance to such engagement, weaving a skein of falsehoods which distance us further from rather than facilitate any meaningful contact with truth. The brutal description by philosopher David Hume (1711–76) of poets (and by extension all artists aspiring to *poesis* of some sort) as 'liars by profession' encapsulates a judgement with a respectable if not attractive pedigree within the western intellectual tradition stretching all the way back to Plato (*c.* 427–347 BC). In theological terms, far from artistic creativity being viewed as an evident gift or even an echo of God's own creative goodness towards us, it has frequently been viewed negatively, as a potential source of untruth and idolatry. Within the Protestant tradition in particular, where the products of human imagination have been tolerated and embraced at all, they have often been shackled and rigorously subordinated to the allegedly

superior judgements of reason and experience, these being held to be necessary bulwarks against a tide of human fancy which might otherwise sweep us away into all manner of intellectual, moral and spiritual confusion or worse. Where our engagement with what really matters is concerned, it seems, we do not really expect the artist to be of much positive help in getting at the truth, and may even suspect her creations of some inherent and dangerous seductive draw away from its shores.

Our task in this chapter is to bring together the themes of artistic imagination and the incarnation. I shall suggest that the outcomes of such a venture prompt some serious theological reconsideration of art and its place in the scheme of things in God's world. Reciprocally, there are aspects of artistic creativity which serve to illuminate the meaning of the central Christian claim that in Jesus Christ God has 'taken flesh' and given himself to be known in faith. This latter claim will be explored more fully in subsequent chapters from the perspectives of those who deploy creative imagination with respect to particular art forms. Let us be clear, the claim is not that we can finally 'understand' the incarnation by applying such categories to it, as if it could be subsumed and classified neatly within an aesthetic. That God should indwell our humanity as one of us ('in such a manner that he had God in common with us' as John Calvin puts it) is a mystery which we should not expect ever to fathom. Indeed, its uniqueness means that there could never be any more general truth drawn from nature in terms of which we might classify or account for its fundamental pattern. Yet even mysteries may be discerned in part, and this particular mystery is so central to the Christian story that a moral burden rests upon us to share with others whatever partial and stumbling apprehension of its contours has been granted to us in faith. The claim made here, then, is simply that in those dimensions of our existence in the world which we recognise as 'artistic', there are elements which may serve for us as parables, casting light upon the remarkable claim of faith that in Jesus God has taken flesh and entered the stream of history as one of us. Attending to these may help us (as all good parables do) to grasp the shape of the unfamiliar

through the familiar, and yet in doing so hopefully deepen, rather than exhaust, our appreciation of and appetite for the mystery which remains.

Receivers of Stolen Goods? Art as Offence and Transgression

The perception of artistic imagination as a powerful shaping force in human life, and as in some sense a participation in or at least an aspiration to the very creativity of God himself, has ancient roots. Indeed, the articulation of it predates the philosophical tradition which has so often been suspicious of art's motives and worth, and was in part responsible for generating much of that same suspicion.[2]

Prometheus unbound?

According to the Greek myth, Prometheus stole fire from the gods and thereby kindled a divine spark in humanity. This myth has been variously interpreted, but Plato's reading of it in his *Protagoras* identifies the gift bestowed upon humankind with what we might call the capacity for culture (he calls it 'skill in the arts'), the ability to take what is given in 'nature' and to do something creative with it which grants the world a distinctly human dimension.[3] At the most basic level this includes the ability to fashion tools for the acquisition and cultivation of the resources for life itself – food, water, warmth, protection and so on. But it also includes the capacity for what philosopher Suzanne Langer suggests may be the most distinctive and most basic of human activities in the world, the 'symbolisation' or 'symbolic transformation' of our experience of the world.[4] Language is the most common form of this symbolic exchange with reality, but it takes many other forms. Symbolisation has many aspects and functions, chief among which is the presentation to ourselves of things (objects, people, events, states of affairs) which are not directly given in our current experiencing of the world. When, for example, we refer by name to someone who is not present, we render them present *in absentia* in our imagination. Symbolis-

ation, we might say, characteristically goes beyond what is given to or in our experience of the world in any given moment. In this respect it is closely allied to one of the most basic features of human imagining, namely, its characteristic trespassing beyond the given – in memory, in hope, in the generation of fictions, and so on.

Creative or artistic imagination (which Langer identifies among the highest forms of symbolisation) in particular involves going beyond what is given, the voluntary generation of some symbolic supplement to or modification of the actual. The artist finds her raw materials lying to hand in words, patches of colour, pieces of wood and stone, all manner of things. In her hands they are transfigured by imagination into media of a particular sort of symbolic transaction with reality. The artist, we might say, sees more or otherwise than what is generally perceptible, and symbolises her vision that others may share it. Her art grants 'eyes to see and ears to hear' to those whose seeing and hearing is otherwise less full, or differently focused and attuned. Here again we risk lifting the lids on some cans of worms to which we cannot possibly do justice. Such statements can be, have been and are understood in all manner of different ways by those who reflect deeply on such things, and there is certainly no consensus on *how* or in what precise sense art does any of this. None the less, it may be relatively uncontentious to suggest *that* it does it; that art, in one writer's phrase, involves a 'transfiguration of the commonplace' in some sense,[5] a presentation of things which differs in some identifiable way from the presentation more widely available. If it did not do this we should arguably have little reason for differentiating it as a product of imagination at all, or identifying it as 'art', the product of a human act of *poesis*. It would simply be more of the same, another instalment in our day-to-day sensory engagement with the world.

It is precisely this 'added-value' dimension of artistic creativity, the fact that art characteristically renders back something more or other than is given to it in nature as raw material, which has attracted suspicion and approbation from those concerned above all for truth and an appropriate relation of humans to the reality of the world in which we find ourselves. We recall that, according

to Plato, human culture is contingent upon a primal act of cosmic burglary. Creativity of the sort to which art (although not only art) aspires is, on such a view, the proper prerogative not of human beings but of the gods. In our enjoyment of art, therefore, we are technically receivers of stolen goods passed on to us by the various 'fences' who paint, write, compose, sculpt or whatever. Indeed, since only the gods can *truly* create at all, acts of human *poesis* result at best in a series of clever fakes or imitations of the genuine article. What such a judgement expresses is a deep sense of a fundamental givenness in the structures of the world which God has created, a givenness which is somehow devalued and knowledge of it put seriously at risk if human beings now seize to themselves the responsibility for modifying, improving, adding to, or even deconstructing that order through their symbolic engagements with the world. Art, on such an accounting, is inherently transgressive of the limits which creation sets, and thereby constitutes an offence to the divine creativity which it emulates. The aspiration to participate in some sense in a creativity akin to God's original creative act is, in other words, inherently rebellious. Its illicit products are not what they appear to be and should be handled with caution.

Creativity and questions of copyright

This is certainly in line with the sort of judgement which Plato himself offers in Book 10 of *The Republic*.[6] In order to understand why, we need to remind ourselves of the stress which Plato consistently lays in his philosophy upon the existence of an eternal, unchanging, perfect divine realm of 'Forms', a realm in which, he insists, reality and truth are finally to be located. If we would discern the essence of something, in other words, then our attention must be directed not towards this material world in which we live (in which things are forever changing and never perfectly manifest their nature) but towards the 'spiritual' realm of divine Forms of which things in this world are themselves but a pale reflection or imitation. This realm is, as it were, the reliable bedrock which underwrites the human quest for truth. If it were not there, there could be no truth. The Forms consist effectively

in a divinely given stable order behind or blueprint for the cosmos which, as it presents itself to our experience, is in constant flux and, because it never stands still and is never the same twice, cannot properly be known or spoken of.

Given such a framework for discussion it is possible to appreciate (if not entirely to endorse) Plato's worry about art. For art in all its manifestations directs us initially towards, and immerses us in one way or another and to some extent in, the world of the senses. Whatever else it may be, art is about colour, shape, sound, texture; the manipulation of wet clay, the smearing of oil paint on a canvas surface, pushing air from our lungs through lengths of metal tubing; and so on. Of course there is more to it than this, but this physicality is an essential part of art. In this sense art, no matter how sublime, roots us again and again in that fleshliness which is an inescapable feature of human life in God's world at its best and its worst alike. It is this same fleshliness, of course, from which Plato advises us it is *necessary* to escape in order to get to grips with truth. But there is more to it even than this. In many of its main types (here Plato has chiefly in mind painting, sculpture, literature and drama) art presents us at some level with an imaginative representation or *imitation* of aspects of the physical world in which we live. The artist, that is to say, begins by looking to the world around him, and then, on the basis of his powers of observation, offers some perceptual account of it for our appreciation. But, Plato observes, what art does thereby is to take us yet one step further away from truth, since a copy of a copy is bound to be paler and less adequate than the original copy; and the world, we must remember, is itself already a pale copy of the truth of things. When, in addition to *representing* objects in the world in this way, art seeks to modify or improve upon them then, we might suppose, the final blow to truth has been struck. The givenness of God's creative order is now not just damned by faint likeness, but set aside in preference for some other order with pretensions to take its place. God's copyright on the cosmos itself is, as it were, put at stake by such human aspirations to 'creativity'. Either way, the result is not an enhanced engagement with or penetration into the truth,

but an efficient obscuring of it, and Plato has no qualms about associating imaginative creativity directly with the human propensity to produce idols. The better course for humans to take in their engagement with the world, therefore, is the way of reason which attends faithfully to the givenness of the divine Forms, and does not seek to meddle with them or to discover truth elsewhere.

Does the Artistic Word Ever Quite Become Flesh?

There are clearly all sorts of ways in which Plato's account of art here might be objected to. One important response has been the appearance of theories of art which see its products precisely as imaginative tools facilitating our imaginative ascent from the mere physicality of nature into some 'higher' non-sensory realm, rather than immersing us more fully in the material world. While such accounts demur from Plato's view of the nature of the work of art as representative, though, they uncritically endorse his reluctance to ascribe lasting meaning to the particular physical object as such. The extent to which art is possessed of or evokes physical qualities, we might say, is held to be largely incidental to its aesthetic worth. Indeed, some views of art go further, and insist that we should not identify the physical phenomenon (the sounds, textures, colours etc. in which art is manifest in the world) with the 'work of art' at all, but should insist on differentiating carefully between the two.

Where is art?

So, for example, R.G. Collingwood (1889–1943) argues that the real 'work' of art exists first in the imagination of the artist, and then in the imaginations of those who appreciate his work.[7] It never actually exists as such in the realm of physicality. The sounds (in the case of a melody performed) or patches of colour (in the case of a painting) or carefully constructed phrases (in the case of prose or poetry) are not the true 'work' of *poesis* at all, but merely the material medium through which the artist's

imaginative vision is channelled, grasped and reconstructed by his audience. The real aesthetic event occurs at a level which utterly transcends the mundane physicality of print and paint and stone and the vibration of stopped strings. If we mistake the latter as such for the poetic product, then we shall risk missing the genuine article.

We must tread carefully here. At first blush this way of putting things seems somewhat odd, even outrageous to common sense. Does Collingwood really mean to suggest that when we listen to a CD of Mozart's *Requiem*, or watch a performance of Shakespeare's *Macbeth*, what we are hearing and seeing is not art, and that the real 'art' is located somewhere else than in the sound of the music, or the performance on the stage? Well, yes and no. The point he is making is one which deserves our consideration, even if he rather overstates it. We have already suggested that the artist sees more than is given in our ordinary experience of things, and renders the world back to us in some sense with added value. Insofar as we concede this, recognising that artistic imagination goes beyond the given rather than just replicating it, we must also concede that there is always *more* to a work of art than its physical manifestation in the world. Talk of 'going beyond' the given may sound rather abstract; but in more familiar terms we may refer to that space, for example, which calls for constant acts of interpretation of one sort or another on the part of those who view or participate in works of art. Artistic appreciation is not passive but active; we have a role to play in enjoying the arts, just as the artist has a role in furnishing works for our enjoyment. Clearly, then, the meaning or significance of art cannot be confined to the level of simple physical manifestation and perception. Art draws us deeper and further, takes us beyond the surface in some sense to see or experience something which otherwise remains hidden from us.

All of this grants Collingwood's point more force than its bald statement appears at first to deserve. None the less his particular way of stating the matter, driving, as it does, towards an effective divorce between the meaningfulness of art and its earthy, material situation in the world, remains problematic. To say that

artistic meaning *transcends* the physical may mean at least two things. It may mean simply that there is more to art than may be identified at the level of the 'flesh', that the 'eye of faith' beholds more than is physically perceptible. Or it may mean, as Collingwood's chosen phraseology suggests, that art belongs properly to another dimension altogether and is not to be identified at the level of the material artefact, even though it exists in conjunction with it. The difference between these two notions of artistic transcendence is significant.

Versions of the stronger claim, that art's significance wholly transcends its physical co-ordinates in the world, and risks being obscured by them, are not uncommon in modern theories of art. Attempts to locate the relevant transcendental sphere in which such significance actually resides, though, vary significantly. For Collingwood, as we have seen, the true work (and thus the true worth) of artistic creativity is to be identified as a product of and within the artistic imagination, and is by nature an expression and exploration of an emotion which the artist discovers within himself. Here, then, the aesthetic is closely tied to the sphere of the affectional, and the corresponding physical artefact or phenomenon is an accidental by-product of a creative/expressive event in the artist's inner life. Its physical presence in the world is necessary for others to enter into the inner vision which is the true 'work'; but it is finally necessary only in the way that a stepping stone is if we are to cross a stretch of water: we do not linger on it but pass quickly over it to the other side.

Beyond the bounds of experience

A closely related view to Collingwood's is the earlier, highly complex but equally highly influential, account of art offered by Immanuel Kant (1724–1804).[8] Whereas Collingwood sees art as the result of a creative interplay between the imagination and emotion, Kant views it rather as the product of a particular sort of exchange (what he calls a 'free play') between the imagination and the understanding. Yet, although the understanding is involved, Kant is very careful to differentiate artistic appreciation from knowledge of the sort which arises from our experience

of the world. When we consider something from an aesthetic perspective, he suggests, we effectively bracket out all considerations relevant to identifying its proper place in the world of phenomena (questions such as 'what sort of thing is it?' and 'what is it for?'), and consider it now instead in splendid isolation and with a view solely to the impact which it makes upon our sensibility. While this sounds (and in a sense is) highly subjective, Kant actually thinks that a 'beautiful' thing should affect everyone in a similar way, and he certainly does not intend that 'beauty' is relative to the particular likes and dislikes of individuals. None the less, it is a matter of 'subjectivity' in the sense that it has nothing whatever to do with the thing's situation in the world beyond our mind, and everything to do with the very specific affect which this thing has on the subject who considers it aesthetically. What, then, is it which has this affect?

Again it is not easy to pin Kant down on this; but various things seem to belong to an answer: first, what artistic genius (his phrase) does is to exhibit through phenomena 'aesthetic ideas' which in some sense satisfy us. These 'ideas' are, however, not located in the physical object or presentation itself; they arise from the ways in which the imagination and the understanding are stimulated by contemplation of it, and hence 'exist' only subjectively. Furthermore, since it is precisely the particularity of the object which must be attended to, these ideas themselves are radically particular. They are creations of the artistic imagination which in turn stimulate ours. Finally, the theme of mystery and the stretching of the cognitive faculties is one which keeps cropping up in Kant's account. Part, at least, of what art does is to present form or pattern which, while we recognise it as such, none the less refuses any attempt to classify it or subsume it under some concept, and hence drives us 'beyond the bounds of experience'. This formalism, though, rather than directing us outwards into a deeper engagement with the mysterious reality of the world, occurs at a level of deliberate abstraction and isolation from the physical, and serves only to drive us deeper inwards into the unexplored recesses of our inner mental experience. Once again, the real business of fine art (Kant carefully

distinguishes this from products designed to generate sensory rather than intellectual satisfaction which he dubs 'agreeable' art) is to be identified somewhere other than in the flesh and blood realities of our world.

Escaping into another world

That artists themselves have been affected in their artistry by views essentially similar to those of Kant and Collingwood can be shown by brief consideration of just two examples, a musician and a painter.

The music of Arnold Schoenberg (1874–1951) is notorious for its discordant qualities. The fact that, as we might say, it sounds bad or jars on the ear is directly related to the composer's own stated views on art and its relationship to the physical world.[9] Schoenberg was convinced that, while music inevitably has a sensory dimension, sensory pleasure as such is quite irrelevant to the question of its beauty or artistic significance. In fact, his essays betray a stronger prejudice even than this, suggesting that artistic worth and the capacity of music to please an audience necessarily exist in inverse proportion to one another. Schoenberg backed this claim up with a complex and coherent account of just where the real beauty of music is actually to be identified. Music, he insists, is concerned with the creation and development of innovative and distinctive artistic ideas, ideas which are fashioned as the artist plays in his head with ever new combinations of tones and relationships between tones, the complexities of which are themselves the source of great intellectual satisfaction (a similar sort of satisfaction, we might suppose, to that which some people get from the contemplation of mathematical patterns – there is no relevant sense experience attaching to it). It is this satisfaction which we call 'beauty', even though it may sound awful when translated into physical or sensory terms. For Schoenberg, the artist's task is precisely to lay hold of sound and to bend it into whatever contorted shape may be necessary to bring the abstract 'idea' to some sort of expression and render it available to those others who are capable of appreciating it. Art is a matter of doing things with physical realities (sounds, colours,

shapes, wood, words, etc.) which may not come at all naturally to them, but which force their conformity with 'the qualities of our intellect'. Here again, then, the significance of art is not to be identified at the level of the physical in any sense. Rather it lies in the realm of what Schoenberg calls the 'cold transparency of clear-cut ideas', a realm of intellectual abstraction to which the person of taste quickly ascends from the mere physicality of sounds (an ascent which doubtless comes as a considerable relief when it happens). To get stuck at the level of the physical, therefore, as well as being unpleasant is altogether to miss the true meaning of the piece as art.

The painter Wassily Kandinsky (1866–1944) also espoused a view of art which effectively isolates its proper locus from the physical co-ordinates of art's manifestation in the world.[10] Art, Kandinsky claimed, is an expression of something spiritual, something which he called the 'soul' of nature and of humanity. Against crass positivistic materialism (the view that nothing which cannot be verified by the evidence of the senses can exist or have meaning) he urged the view that all reality has a spiritual dimension and an inner meaning, and to be truly human is to fathom and resonate with this super-sensuous dimension of things. In his reaction, though, Kandinsky moved to the other pole of the dualism between matter and spirit and, like Plato before him, saw the former as distinctly unhelpful in many respects with regard to our discernment of the latter. This, he supposed, provides the artist with her challenge: to handle and fashion material realities in such a way that they become in some way transparent in spite of themselves, and open up a vista on the spiritual. To this end, physical forms must first be isolated from their everyday contexts, 'separated from nature', and treated with such a high level of abstraction that their particularity and physicality all but disappear and cease to obscure the inner meaning hidden within. Kandinsky's view is interesting because, unlike those of Collingwood, Kant and Schoenberg, the realm within which he perceives artistic meaning as rooted is not subjective. The 'inner need' (of artist and beholder) and the 'inner meaning' (of physical objects) to which he repeatedly alludes are

not products of human subjectivity, but means by which humans, as essentially spiritual beings, are meshed into or related to the wider spiritual network of the real. Artistic creativity, therefore, is for him not a matter of *sheer* creativity so much as a discernment of the true meaning of a world existing beyond the artist's subjectivity.

Views such as those we have been considering are certainly not the only ones available (as subsequent chapters in this book will make plain) but they have enjoyed a privileged influence in much modern western thinking about the arts. Curiously, they place the artist herself in an unenviable position. As one who either discerns or is capable of calling into being meaning which exists now within some transcendent realm, some 'other world' than the one which confronts us in our daily lives, she must, none the less, work with the materials which this more immediate world affords: carving wood, daubing paint onto canvas, orchestrating tones, marshalling words into order, or whatever it might be. She cannot in fact escape the flesh and blood dimensions of what it is to be human in the world. But she faces the problem that this (literal) material is recalcitrant, inherently unsuited to her purpose, intrinsically incapable of bringing to expression the artistic *logos* as such. Thus Kandinsky, for example, celebrates music as the least physical among the arts and the most naturally suited, therefore, to realisation of artistic vision. It is as if the artist must inevitably regret the inherent physicality of artistic manifestation in the world, and would prefer it if some direct transmission of the spiritual or intellectual opus between minds could be arranged, short-circuiting the messiness and crudity of mediation through fleshly realities altogether. That it cannot, that some sort of enfleshing of the work of art must occur, is a problem rather than something to be celebrated. The resultant phenomenal object is not itself the 'work' of art. The *logos* finally refuses to *become* flesh. There is at best a loose association of convenience between the physical and the ideal whereby the material artefact serves to translate us from the physical world into a spiritual one, to direct our attention quickly away from itself to some other, higher and more pure, object of consider-

ation. Kandinsky sums all this up by insisting that 'Art is higher than nature'. Perhaps it would be closer to his actual meaning to say that nature is lower than art, and incapable of bearing it within itself.

The Incarnation and Artistry

We have identified two key issues in discussions of artistic imagination, and the nature and significance of its works: first, the implications of art's aspiration to creativity for its relationship to truth and meaning; and second, the relationship of art to the physical. Both involve reflection on themes closely linked or analogous to those lying at the heart of the Christian doctrine of the incarnation. Our task in this final section, therefore, is to reflect explicitly (and I hope suggestively) on this cluster of issues from a perspective directly informed by the basic Christian claim that, in Jesus, God himself has 'taken flesh' and become a human being. First, we shall indicate how belief in the incarnation grants significant theological warrant for a human project of imaginative creativity such as all art involves. The God of Scripture, we might say, is the first and last patron of the arts, although this must be the premise for rather than the conclusion of a discussion about artistic merit and value. Second, we shall inquire whether the ways in which artistic imagination manifests itself may cast any light on the mystery of the Word who became flesh for our sakes.

I propose to take as a convenient point of departure one specific New Testament text:

> . . . when the fullness of time had come, God sent his Son, born of a woman, born under the law, in order to redeem those who were under the law, so that we might receive adoption as children. And because you are children, God has sent the Spirit of his Son into our hearts, crying, 'Abba! Father!' So you are no longer a slave but a child, and if a child then also an heir, through God. (Gal. 4:4–7)

Prometheus has sometimes been likened to Christ: a divine figure who seeks to liberate humans from their bondage in ignorance

by bringing down to earth fire from the gods. Perhaps there are some interesting parallels, but there are certainly rather more significant differences. As the apostle Paul reminds us, the gospel has at its heart not a motif of theft, but one of gift; not the story of an illicit black market in divine prerogatives recently fallen from the back of a cosmic lorry, but one of the free bestowal by God upon humans of an intimate sharing in his own life and activity, as 'children' and 'heirs' who know him now as 'Abba'. The God of Scripture grants us an inheritance in what is properly his alone, and 'earths' this by himself becoming a human Son, discovering what it means to share humanly in the life of God (as Jesus, the Son who knows and loves and corresponds to his Father in the activity and fellowship of Holy Spirit) so that we might do so too.

How does this fundamental difference of plot bear on our theme of artistic imagination? In several ways, only some of which can receive our attention here.

Art as participation in God's creativity

First, we might recall another way in which Jesus is described elsewhere in Scripture, as the Word of God, through whom creation itself was spoken into existence, and who in Jesus has 'become flesh' and dwelt in our midst (see John 1:1–14). This way of referring to Jesus is important for our purposes, for it links what God does in Jesus directly with his own mode of creativity. In Greek thought the divine *logos* (Greek for 'word') often tends to be pictured in relation to creation in rather static and highly abstract terms, referring precisely to the 'logical' principle which, in its eternal, unchanging perfection, underwrites the meaningfulness and truth of things. In relation to such a logos (which in Greek can be translated both 'word' and 'idea'), as we have seen, the appropriate human response is held to be essentially one of passive intellectual conformity. The sort of playful creativity and imaginative initiative associated with the arts presents an apparent challenge and even a threat to the divine copyright on the logical structure of things.

In Scripture, references to God's Word are of a wholly different

tone, cropping up, as they tend to, in relation to God's activity *within* the world and its history rather than alluding to some sphere beyond and detached from historical contingencies. Furthermore, the relevant image in the Bible is not that of an abstract divine idea, but rather of God's speaking, a speaking which is intended to elicit some response from the human side (hearing and acting). The biblical image of Word, therefore, is inherently dialogical, and generally has the created human other directly in view as a respondent. When John finally picks this image up and applies it to the theme of the incarnation, therefore, he pursues its natural momentum even further and suggests that here, the same Word which was formerly spoken to humankind in order to evoke response has now finally itself become human and, as it were, incorporated the response to itself within itself, becoming the one human in whose life a fitting response and correspondence to God's speaking may be seen.

It is not too much to claim that the high point of the Word's relatedness to humankind is to be identified here, in the free response of the human Jesus to his Father in the power of the Spirit. Christians have sometimes struggled with the idea that what Jesus does he does humanly, by virtue of a sharing to the full in our human condition. It is too easy for us to interpret the claim that he was 'God incarnate' to mean that he therefore did not suffer from or struggle with the same limitations and lacks as other humans. But this view is not well-founded biblically, and it was condemned early on in the Church's history as unorthodox and dangerous because it undercuts the saving significance of all that Jesus does 'in the flesh'. If, for example, Jesus did not struggle as we do with evil influences and impulses, then the fact that he remained 'without sin' is rather a shallow one in terms of its impact upon our situation. So the Bible takes great pains to hold on to a paradoxical tension between the fact that Jesus was fully human as we are (as Paul puts it, 'born of a woman . . . under the law'), yet in certain vital respects did things differently because of who he was. Both poles of the tension are important to hold on to.

If, then, the Word of God is fulfilled through a free and Spirit-filled participation or activity of Jesus as a human being, we are

compelled to think rather differently about how God views human activity in relation to his own creative Lordship, not least because Paul reminds us that this enhumanising takes place precisely that we might now be drawn in to share in its essential dynamics for ourselves. The God made known in Jesus Christ, we must suppose, is not automatically threatened by human activity in the world, but desires our active participation in his purposes for a world which has not yet reached its final goal. To this end he calls us to an obedient, Spirit-filled free response and correspondence to his own activity within history (of course not *all* activity or every expression of human freedom is desirable to him). The creative authority of the Word who becomes flesh is of a sort which, while it certainly sets boundaries to the legitimate and possible expressions of human freedom, none the less creates space for, facilitates, and deliberately seeks the responsible exercise of such freedom in every sphere of human life. Responsible creativity of an artistic sort is thus not only warranted, but may be viewed as an unconditional obligation laid upon us and called forth by God's gracious speaking to humankind in the life, death and resurrection of his Son. Indeed we may go further, and suggest that it is not only a proper response to, but also an active sharing in (albeit in a distinct and entirely subordinate creaturely mode) God's own creative activity within the cosmos.

Art and accountability

And yet such creaturely creativity manifests a freedom which is meaningful precisely because it exists and is exercised within given boundaries. There is little more unattractively Promethean than the contemporary vogue for what we might call 'sheer creativity' on the part of humankind, whether in art, ethics, religiosity, even science. The idea that the human imagination is and should be creative in any and all of these spheres *without accountability to any external standards or points of reference beyond itself,* that where truth and meaning are concerned we 'make it all up as we go along', is a characteristically modern (and now postmodern) one with identifiable roots in the ancient myth of the human usurping of divine prerogatives. Plato's basic

concern that the artist should be accountable to something, to sources of truth and meaning which pre-exist the poetic engagement with the world (that 'the world' itself is something with which art engages, rather than something which it can create, deconstruct and reconstruct at will and without consequences) is thus one with which Christians may happily concur.

A Christian account of the world called into existence by God's Word is bound to understand it as already laden with meaning and order (even 'beauty'). It will not be able to tolerate the suggestion (made, for example, in the nineteenth century by William Blake) that the physical world is naturally bereft of these until they are bestowed upon it by an activity of human imagining which transforms a bleak and barren 'nature' into a meaningful 'culture' fit for human indwelling. Cultivation, in Christian terms, must certainly involve a free creativity; but it will be of a sort which has a respectful openness first to listen and learn from nature, to discover from it something of its prior orderliness; and it will possess a restraint which recognises the limits of what can and ought to be done with and within the world. The Promethean spirit represented by a Schoenberg, for whom the task of artistic imagination was to lay hold of the material and to bend it to whatever contorted shape his intellect dictated, is, on such a view, best left behind. Instead, the artist may discover that true freedom is to be had by engaging in a creative dialogue with an artistry which both precedes and sets limits to its own. The artistic imagination ventures forth, as it were, into a world believed to be already rich with actual and potential meaning, lays hold of materials whose natural qualities encourage some modes of handling and resist others, and, through a creative exchange with all this, renders the fruits of its interpretative labours into form for the benefit of those who, as yet, lack the eyes to see and ears to hear.

The poetry of the incarnation

Again, there is reciprocal illumination here for our understanding of how we should and should not conceive of God's own venturing forth for the sake of human salvation in the incarnation.

We might suppose that it would have been easy for God, being God, to set aside the mess which humanity had amounted to, and to start over again with a clean slate. Some accounts of the incarnation seem actually to come close to such a view, with the result that the sort of 'humanity' which they ascribe to Jesus has relatively little in common with the sort of humanity we know ourselves to inhabit, being largely unscathed by its more recalcitrant and deep-rooted flaws. As a result, Jesus appears to us as a rather remote figure; he draws close by 'taking flesh', but not quite close enough, being distanced from us finally as one who does *not* know what it is like to be human *as we are human*, to live in the world under the condition of sin, to struggle with its various tragic foibles as we must, and so on. And it makes talk of his 'obedience' a bit of a sham.

The Greek fathers of the fourth century had a neat formula which sums this concern up in a nutshell. In the incarnation, they insisted, that 'what has not been assumed (in Christ) has not been healed.' Put differently and in positive form, in order for God to transfigure our broken humanity it was necessary for him to lay hold of it in all its brokenness, and not to 'assume' some other, problem-free humanity instead. Of course Jesus *was* different from all other human beings in important ways. Yet this was not because his humanity was, by his own divine choosing, free from the basic condition with which we all struggle, but because in his very struggling with it he redeemed it through a moment to moment Spirit-filled obedience, offering his humanity to his heavenly Father in a continuous sacrifice of praise and worship which culminated in the cross and resurrection. So we must never allow the truth that he was 'without sin' to obscure the equally vital truth that he was 'tempted as we are in all things'. Otherwise, we risk undermining the very redemptive force of the difference which his humanity manifests. He takes our 'flesh', together with all its limiting factors and inherent flaws, and through a work of supremely 'inspired' (Spirit-filled) artistry, transfigures it, before handing it back to us in the glorious state which its original maker always intended it to bear. At this level

creation, redemption and re-creation are shown to be interwoven as activities of the same divine Poet.

If art may be thought of as dialogical, and even as a sharing in God's own creative activity within the world, then the question of art and morality must be faced sooner rather than later. Put differently, in terms of our account thus far, what sort of creative work does and does not correspond appropriately to God's creative speaking? We cannot even begin to answer this question here, but must note its importance for any Christian theological reckoning with the arts. It is related to another – namely, how is the transfigurative dimension of art (the way in which art hands back more than nature initially grants it) to be understood in relation to the theme of the redemption or transformation of our broken and fallen humanity and world in Jesus? Is there any sense in which art itself, through its capacity to transform our vision of and response to the world, shares in or corresponds to that redemptive activity of God? These are important questions, but ones lying beyond the scope of this chapter.

Recognition that, in Jesus, God's own Word has taken flesh and dwelt among us humanly clearly raises difficulties for any denigration of the physical in accounts of artistic meaning and creativity. It is difficult to maintain that nature is lower than and cannot bear *artistic* meaning when, here, through a recreative adaptation and transfiguring, it becomes the site of God's own Word and habitation. Reciprocally, though, reflection on the ways in which art is bound to and yet transcends its own physicality may shed light on some implications of the claim that in Jesus we have to do with a fully human person about whom there is yet much more to be said than can be made sense of in purely human categories: in traditional terms, here we have to do with one who is both fully God and fully human.

Only human?

To be sure, the Christian tradition has always differentiated carefully between the humanity of Jesus and his existence as God (his 'deity' as it is sometimes put). To confuse these would be to blur the boundary between Creator and creature in a dangerous

way. But the tradition has equally clearly refused to separate the humanity and deity of Christ. It has insisted that here God is actually present in the sphere of nature and history, not now in his transcendence as 'wholly other' (i.e. the way in which God may be said to be 'present' to the world more generally) but as a human being. This is important, for it insists that this incarnate presence is of such a sort that God has, so to speak, stepped over the limits which ordinarily separate him from his creation and earthed his own way of being (as Father, Son and Holy Spirit) within the sphere of creaturely realities. Furthermore, if we remind ourselves of the text from Galatians, in doing so God has invited and drawn us, as creaturely beings, to share in this same matrix of divine meaningfulness without ceasing to be human.

Quite apart from the clear indication of how much God values and sets his seal upon the material dimensions of his creation (remember that the Christian hope looks forward to a *new creation* of which the pledge is resurrection of the body, not an escape from physicality) there are yet more profound implications in this for our reflection on the relationship between the bodily and meaningfulness, and these pertain to artistic meaning as much as, and perhaps more than, any other.

We need to take care to see just where the analogy here does and does not lie. There must be no suggestion that the 'deity' of Christ belongs to the same category as the 'spiritual' (or other super-sensuous) dimensions of art. In biblical terms human 'spirit' is as much a part of that 'flesh' which the prophet Isaiah refers to as being 'like grass' as our bodies are. None the less, the claim that God has taken 'flesh' (in all its physical and spiritual/ psychical aspects) does entail the blunt refutation of any suggestion that the physical as such cannot bear or become the locus or theatre of certain sorts and levels of meaning. Here, the body of Jesus and his physical existence in history are a vital locus and component of God's self-manifestation in the world, and this must surely count as the highest sort of meaning available to us?

Of course, in the epiphanies which art grants us through its transfigurations of the commonplace, we know *more* than is presented to us at the level of the physical or historical. The eye of

artistic imagination sees more than other eyes, and its ears hear more. Here Collingwood and Kant have their proper point to make and we must attend to it. If we do not see or hear or feel more than is ordinarily presented to us, then our artistic imagination is failing us, and we are missing out on poetic presence. But, vitally, these same eyes and ears do not see or hear *less* than what is presented physically, and what they see and hear is bound up inextricably with the 'more' that is there to be discerned.

The claim that Jesus is 'God in human form' can easily be and has often been misunderstood in one of two equally pernicious directions. Sometimes it has been supposed that what we are offered in Jesus is a 'scaled down' version of God, a rendering of the basic pattern of divine existence in the form of human reality. At first blush this is a reasonable supposition. That God has, in the incarnation, accommodated himself in order to know and be known by those who otherwise could not know him is, after all, a basic tenet adhered to by faith in the incarnation. It is important, though, that we should not mistake it for the whole story. When God gives himself to be known in Jesus, he does so not simply by furnishing us with a 'fleshly' visual aid at the human level. Theologians have sometimes supposed this to be so, and have consequently located the 'revelation' of God in Jesus' human character, or in his teachings, or in his actions. While all these are vitally important, they are not the ultimate but only the penultimate level of God's self-giving to us. What is given finally transcends Jesus' historical existence in a manner analogous to that in which art transcends its physical manifestations, for God cannot be captured in any this-worldly phenomena, and it is God himself (i.e. a 'knowing' of or personal relatedness to God as our Father, through the Son and in the power of the Holy Spirit) which is granted us in Christ. This is clear enough already in the Gospel stories. Thus, 'flesh and blood' is not sufficient to reveal the secret of Jesus' true identity and significance to the casual onlooker. There are those who look, and hear, and even touch, but whose eyes remain blind to the truth. So the mystery of God in human form cannot be reduced to the physical co-

ordinates which locate it in history, any more than the meaning of a work of art can be accounted for in terms of a purely phenomenological analysis. Both require penetration beyond the empirical through a mode of vision which is carefully adjusted to see more than at first meets the eye.

Touching the Word of Life

If Christian faith apprehends *more* than the humanity of Jesus, though, it certainly apprehends nothing *less*. Theology over the centuries has had repeatedly to learn the lesson of the fruitlessness and the dangers of attempts to abstract the meaning of God's self-revealing in Christ from the particular concrete details of Jesus' ministry as Scripture relates them. Christology has all too often trespassed beyond the range of scriptural control, and opted instead for some set of (undoubtedly often 'spiritual') truths about human beings in general ('human nature'). The result has usually been a failure to permit the character, actions and passion of Jesus to exercise its devastating effect on received understandings of God and humanity alike. The implication of the strong claim made in the Nicene Creed that Jesus, as the incarnate Son of God, is *homoousios* (one 'substance' or reality) with the Father is precisely that this particular flesh and blood presence is an indispensable part of the overall meaning event in which God gives himself to be known. 'No one comes to the Father except through me' (John 14:6). The same vital point is made in the opening verses of 1 John: 'We declare to you what was from the beginning, what we have heard, what we have seen with our eyes, what we have looked at and touched with our hands, concerning the word of life' (1:1). Claims made about the Christian God, or the Son of God, which are not identifiably rooted in and continuous with the stories which Scripture tells about Jesus, should therefore be treated with great suspicion. That God has graciously placed himself in our midst for touching, hearing and seeing means that this same 'physical' and historical manifestation must always be the place where we put ourselves in our repeated efforts to know him again and ever more fully. We cannot appreciate Mozart's artistry unless the sound of his

music remains our constant companion; we may appreciate more than the sounds themselves, but never less. There is something more than the 'flesh' to be considered, but the two levels must be held together inseparably if the essential significance of each is not to slip from our grasp.

FURTHER READING

Jeremy Begbie, *Voicing Creation's Praise: Towards a Theology of the Arts* (Edinburgh: T & T Clark, 1991).

Hilary Brand and Adrienne Chaplin, *Art and Soul: Signposts for Christians in the Arts* (Carlisle: Solway, 1999).

Denis Donoghue, *Thieves of Fire* (London: Faber & Faber, 1973).

William Dyrness, 'Art', in *The Earth is God's: A Theology of American Culture* (Maryknoll, NY: Orbis, 1997), pp. 135–58.

Nicholas Wolterstorff, *Art in Action* (Grand Rapids: Eerdmans, 1980).

NOTES

1. I should like to record at the outset my gratitude for the practical assistance and frequent opportunities for intellectual exchange on themes in this chapter offered by my research assistant, Mr Steven Guthrie. In particular, what follows has benefited from reading his as yet unpublished paper entitled 'Arnold Schoenberg and the Cold Transparency of Clear Cut Ideas'.

2. For what follows see, suggestively, Denis Donoghue, *Thieves of Fire* (London: Faber & Faber, 1973).

3. See Plato, *Protagoras and Meno*, tr. W. K. C. Guthrie (London: Penguin, 1956), pp. 52f.

4. Susanne K. Langer, *Philosophy in a New Key* (New York: The New American Library of World Literature, 1948), pp. 20f.

5. See Arthur Danto, *The Transfiguration of the Commonplace* (London: Harvard University Press, 1981).

6. See Plato, *The Republic*, tr. Desmond Lee (London: Penguin, 1955). In Book 3 Plato offers another substantial argument in which he focuses on the effects of the sort of imaginative engagement with morally inadequate or dubious emotions, activities and characters which participation (whether as author, actor or reader/member of the audience) in works of literature and drama involves. While this is an important part of his overall critique of the representative arts (and its existence should be noted), there is not space to consider it fully here. For a full account of Plato's argument in Book 10 and its significance for a view of human imagination, see Richard Kearney, *The Wake of Imagination* (London: Routledge, 1988), pp. 79–105.

7. See R. G. Collingwood, *The Principles of Art* (Oxford: Oxford University Press, 1938), pp. 139f.

8. See Immanuel Kant, *Critique of Judgment*, tr. Werner S. Pluhar (Cambridge: Hackett Publishing, 1987).

9. See various essays in Arnold Schoenberg, *Style and Idea*, ed. L. Stein (Berkeley and Los Angeles: University of California Press, 1984).

10. See Wassily Kandinsky, *Concerning the Spiritual in Art*, tr. M. T. H. Sadler (New York: Dover Publications, 1977).

THROUGH LITERATURE:
Christ and the Redemption of Language

MALCOLM GUITE

To claim that the Word became a human being is to claim that the Word became a word-user. Human language has been taken up and transformed in the incarnation. Malcolm Guite, through dialogue with various pieces of modern literature, demonstrates the ways in which literature can penetrate the depths of the mystery of the incarnation, not only by virtue of what the words directly address and express, but by virtue of the redemptive way in which they can operate.

At first sight it might seem that there is an inherent contradiction in approaching the mystery of the incarnation through a *literary* art form. For in the incarnation the inadequacy of all our word-weaving, the partial truths and ambiguities of all religious utterances are met and judged by God's own utterance of himself in an eternal Word, spoken once and for all in time, and spoken not simply in *words* but in *flesh*: 'the Word became flesh and lived among us' (John 1:14). This sense of the incarnation of the Word as a standing rebuke to our many words about God is very powerfully expressed in Edwin Muir's moving poem 'The Incarnate One' in which he rebukes the preachers of his youth in the unforgettable lines:

How could our race betray
The Image, and the Incarnate One unmake
Who chose this form and fashion for our sake?
The Word made flesh here is made word again
A word made word in flourish and arrogant crook[1]

Any account of how a theology of the incarnation might be approached through literature must begin by acknowledging the danger to which Edwin Muir is pointing, the danger, as he goes on to say in this poem, that the 'Mystery' becomes 'impaled and bent into an ideological argument'. However, even as Muir persuades us to acknowledge this danger, we are aware of the paradox that this poem is itself a beautiful pattern of words about the Word made flesh, that this poem, far from bending or impaling the mystery, deepens and sets it free. To read the poem is to be brought again to the brink of the mystery. Muir is fighting fire with fire. Because a certain kind of 'bloodless' and abstract theology used words in such a way as to alienate people from the incarnate Word, so now it falls to the artist to redeem language, to use imaginative language to restore what a language devoid of imagination has destroyed.

This essay will begin with Muir's poem taken as a whole and show how we can re-imagine a too-familiar theology through his art. Then we shall examine how principles apparent in this particular example might apply to the broader sweep of literature, helping us to see it as a means, not of explaining or decoding the mystery of God's incarnation, but rather of allowing it to penetrate even more deeply into our understanding of ourselves and our world.

The Incarnate One

The windless northern surge, the sea-gull's scream,
And Calvin's kirk crowning the barren brae.
I think of Giotto the Tuscan shepherd's dream,
Christ, man and creature in their inner day.
How could our race betray

The Image, and the Incarnate One unmake
Who chose this form and fashion for our sake?

The Word made flesh here is made word again
A word made word in flourish and arrogant crook.
See there King Calvin with his iron pen,
And God three angry letters in a book,
And there the logical hook
On which the Mystery is impaled and bent
Into an ideological argument.

There's better gospel in man's natural tongue,
And truer sight was theirs outside the Law
Who saw the far side of the Cross among
The archaic peoples in their ancient awe,
In ignorant wonder saw
The wooden cross-tree on the bare hillside,
Not knowing that there a God suffered and died.

The fleshless word, growing, will bring us down,
Pagan and Christian man alike will fall,
The auguries say, the white and black and brown,
The merry and the sad, theorist, lover, all
Invisibly will fall:
Abstract calamity, save for those who can
Build their cold empire on the abstract man.

A soft breeze stirs and all my thoughts are blown
Far out to sea and lost. Yet I know well
The bloodless word will battle for its own
Invisibly in brain and nerve and cell.
The generations tell
Their personal tale: the One has far to go
Past the mirages and the murdering snow.

This is a beautiful and disturbing poem, and anyone looking for
orthodoxy nicely re-packaged with a poetical flourish will have

to look elsewhere. But Christians, especially those called to preach or share the word, should take a special interest when those 'outside' the faith are drawn to deal with its mysteries and should listen closely when they tell us what our orthodoxy has sounded like to them.

Theologians, therefore, should not see this poem as an attack on Calvin as *they* read him in the study, full of the liberating grace of God, but as an attack on the kind of *Calvinist culture*, full of condemnations, bristling with suspicion of every human grace and beauty, which was experienced by an imaginative child in a cold, bare, wordy kirk. For many this kind of experience could and did lead to a complete rejection of Christ as well as the form of Christianity in which they encountered him. They threw out the divine Baby along with the cultural bath-water. But not this poet. Instead his art and his imagination distinguish between the culture of the 'kirk crowning the barren brae', and 'the Mystery' (significantly with a capital M) of Christ. Thus the poem is able, in its second movement, to see beyond the wordy 'ideological argument' which Muir rejects, and to glimpse at least the possibility of a 'better gospel' and a truer sight on 'the far side of the Cross'.

> There's better gospel in man's natural tongue

This line might well stand as the watch-word for anyone trying to do their theology through the art of writing, and indeed the poem moves at this point from the rejected abstract language of words like 'ideological argument' towards the concrete and simple image of:

> The wooden cross-tree on the bare hillside

Glib knowledge of bad theology has destroyed the mystery and taken away the poet's sense of wonder and this leads him to plead for 'not knowing', for a restoration of 'ignorant wonder'. He wants us to see the Word made flesh in all the particular agony of the cross before we start to have any theories about it at all, and his poem helps us to do that. He is not denying the truth of the incarnation, the staggering truth that 'there a God suffered

and died', but he is trying to protect it from a too easy or abstract formulation in order to restore to us a 'truer sight':

> And truer sight was theirs outside the Law
> Who saw the far side of the Cross among
> The archaic peoples in their ancient awe,
> In ignorant wonder saw
> The wooden cross-tree on the bare hillside,
> Not knowing that there a God suffered and died.

After giving us this imagined glimpse of those who, paradoxically by their very ignorance of the theology, glimpse in awe the truth of the incarnation, he goes on to contrast the beauty and mystery of God's Word made flesh with the 'fleshless word' of human invention.

> The fleshless word, growing will bring us down,
> Pagan and Christian man alike will fall

Muir warns us against the denial of our flesh, the refusal of our own incarnateness, the flight from life into fleshless and bloodless words, a flight and refusal he characterises as 'abstract calamity'. This is the fall and hell from which Christ in his incarnation saves us. The salvation is not *from* the flesh, but *of* the flesh. The danger is for the theologians and the theoreticians who are refusing Christ in his incarnation, preferring their own fleshless and bloodless versions of his saving work. In this poem God's incarnation is his point of contact with the flesh of all humanity. We are called to live within our own flesh and to meet God there too. Muir might have ended with despair at our betrayal of the incarnate one, and our refusal even of our own incarnateness, but instead he ends with a return to the action of Christ, the 'Incarnate One . . . who chose this form and fashion', becomes at the end of the poem: 'the One' who 'has far to go',

> Past the mirages and the murdering snow.

This last image makes the incarnation something which not only happened uniquely and fully in the birth and life of Christ, but, because he has never laid aside his humanity, it is something

which in another sense is still happening as God in Christ jour-
neys towards us, passing through the cold empire of our
abstractions and the endless mirages our empty culture throws
up, until at last, on the far side of the cross, his humanity touches
ours.

... the One has far to go

One reason why it is so essential that we begin again to do our
theology through the arts, is that the arts are never *discarnate*,
they always begin and end in the realm of time and sense,
however much they give us glimpses of another realm which
transcends it. This is as true of literature as of other more appar-
ently concrete and physical arts like sculpture and painting. The
movement from initial vision to the creation of story, poem and
play is a movement from the abstract to the concrete, from the
timeless to time, from spirit to flesh. It is, under its own analogy,
a movement towards incarnation. By struggling, as it were, to
incarnate an abstract or momentary vision into the ambiguous
medium of a living language, we are constrained to be particular,
to give our vision flesh and blood, and are drawn away from the
'abstract calamity' of the fleshless, bloodless 'ideological argu-
ment'. Of course once we are engaged in this struggle w⁻ discover
that, miraculously, the movement is also the other way – that the
particularity, the 'thisness' of the medium with which we struggle,
has something new to teach us about the 'abstract truth' we were
in the first instance trying to embody.

It may be that language itself, and the very possibility of com-
munication through words, bears witness to the primal act of
communication in the incarnation of the eternal Word: every
effort to incarnate our own thoughts in the web of language is
underwritten by God's expression of his Word in Christ. In that
sense all literary art, even self-consciously atheist literary art, is in
some way, consciously or unconsciously, modelling and bearing
witness to the mystery of incarnation. This also accounts for the
way in which we learn from our very attempt to express what we
thought we knew, for the words we use are older and wiser than
we are. Embodied in the mysterious gift of language, our thoughts

are reflected back to us in a way that reveals truths that were, until the moment of composition, hidden from us. Like the echoes from a well in Heaney's poem 'Personal Helicon',[2] the act of composition 'gave back your own call with a clean new music in it'. So in the incarnation itself, when the Word is made flesh: it is not simply the perfect expression or reiteration of what was already known of God (in the Old Testament, for example), but the revelation of who God is, in that very medium of flesh, teaching us things which could be revealed in no other way.

In the remainder of this essay I want to draw out two fundamental ways in which the mystery of the incarnation is bound up with and may be explored through the mysteries of imaginative language. The first is concerned with the particularity of Christ's unique incarnation, coming to life through the womb – through infancy, through the medium and community of a particular learned language and tradition. The second concerns the way in which what was assumed at Bethlehem was not temporarily the flesh of one individual man, but fully the flesh of all humankind. He is the second Adam and his incarnation includes our flesh and that of all humanity.

Christ's Unique Incarnation

Beginning first with the unique particularity of his incarnation, without which the second sense of his assumption of all humanity would not be true at all, I want to focus on his weakness, on his need to learn and particularly on his need to learn language. The Word was made flesh, and not simply words, and yet the particular flesh in which the fullness of God was pleased to dwell was the flesh of our humanity. The oldest term in English for a human being is 'reord-berend' or 'word-bearer' and we are, of all the creatures of the flesh, especially the word-bearers. It is to human beings that the mystery and the gift of language has been entrusted. Our language is bound up not only with our knowledge of the world and ourselves but with our very being. If our being and our knowledge are corrupted and fallen, then by the same token so is our language, and if there is redemption for

us in the depth of our being, then language too must be redeemed. What is not assumed is not redeemed, and therefore a part of the whole meaning of the incarnation is the story of the Word coming into his world as one who will learn and use, and in taking it up, *redeem language.* The concern of literature to use language well, to cleanse and purify it, to redeem its words from the captivity and abuse to which the powers of this world continuously subject them, is bound up with the redemptive purposes of God who chose that his Word should be born as one who had to learn to use words. As we shall see, the literature of the twentieth century, from the poetry of Eliot through the novels of Orwell, to the critical theories of Steiner and others, has been, in an age of tyranny and propaganda, especially concerned with the problems of the degradation and redemption of words.

The story of how the Word of God came to redeem humanity begins not with speech but with silence. The first and deepest paradox of the incarnation is the self-emptying of Christ, the power of his powerlessness, the strength of his weakness. The seventeenth-century preacher Lancelot Andrewes seized upon the strange contradiction in terms with which the Word could be an infant: *verbum infans*[3] for, of course, the Latin term *infans* means 'without speech'. And he exclaims with astonishment: 'the Word without a word. The eternal word not able to speak a word'. Just as our wounds are healed by his stripes, so our empty wordiness, hollow at the centre, is met and redeemed by Christ himself, becoming in his *infancy* a centre in which is hidden the Word that maintains the world, and *yet* a centre which has still to learn speech. In 'Ash Wednesday', a poem especially concerned with the redemption of what is lost, T.S. Eliot quotes and develops Andrewes' phrase 'the Word without a word'.

> If the lost word is lost, if the spent word is spent
> If the unheard, unspoken
> Word is unspoken, unheard;
> Still is the unspoken word, the Word unheard,
> The Word without a word, the Word within
> The world and for the world;

And the light shone in darkness and
Against the Word, the unstilled world still whirled
About the centre of the silent Word[4]

So much of Eliot's poetry up to this point, especially 'The Waste-
land' and 'The Hollow Men', had been concerned with what is
lost, with the sense of disjunction between ourselves, our world,
and our words. For this reason his discovery in the midst of such
lostness, of a still and hidden centre, comes with great dramatic
force. He sees the Word as abiding with power even when it is
unspoken and unable to speak itself. It remains nevertheless the
Word within the world and for the world. The key word here is
'within', for it directly answers the nightmare suppositions of the
hollow men. In the 'Hollow Men' there is nothing at the centre
and voices can never do more than make meaningless sounds.

Our dried voices, when
We whisper together
Are quiet and meaningless
As wind in dry grass
Or rats' feet over broken glass
In our dry cellar.[5]

In 'Ash Wednesday' it is as though the hollow men had stumbled
across another dry cellar, with a manger in it, expecting to find
it, like everything else, empty; and had found instead in the
wordless infant, that Word which gives everything including
themselves centre, stability and coherence. This wordless Word
is both the light that shone in the darkness and the still centre
of a turning world without whose presence there could be no
movement at all.

And the light shone in darkness and
Against the Word, the unstilled world still whirled
About the centre of the silent Word[6]

As Jesus grows and learns speech and takes up the great task of
redeeming all things, language included, as he begins to express
in the language of time, in the syllables of events that begin and

end, what he eternally is, we have a sense that the still Word remains a source and centre within him, giving form and meaning to the individual words he uses in the particular language he has learned. We sense this very strongly in the little glimpse Luke gives us of the child in the Temple.

> After three days they found him in the temple, sitting among the teachers, listening to them and asking them questions. And all who heard him were amazed at his understanding and his answers. (Luke 2:46–7)

The people who witnessed these events were 'amazed at his understanding and his answers', already sensing the authority of the Author, the latent power of the 'Word' which underpins all words in his speech. But we should be equally amazed that he was 'sitting among the teachers, listening to them and asking them questions'. For Luke is showing us both sides of the paradox of the incarnation – Jesus speaks as one with authority, but he comes also as a child who needs to learn. There is a development throughout Luke's narrative of Christ's appearances in the Temple, each giving us a glimpse of who Christ is. He comes first to the Temple as the wordless infant and yet fully manifesting what he is, the light in darkness, to those who are prepared by the Spirit to see. So Simeon takes the infant into his arms and praises him as the light that lightens the Gentiles. Then he comes this second time to the Temple as a boy in the midst of the first quickening thrill of the learning of language and reason, and manifests himself to his hearers as the Word, the one to whom ultimately every question is addressed, and from whom every answer comes. Finally, he comes to the Temple a third time as a grown man and manifests himself as the light that shines in darkness, the Word who is a teacher, but also as the true owner of the House which is the Temple and the one who has the authority to cleanse, renew and redeem it.

> Then he entered the temple and began to drive out those who were selling things there; and he said, 'It is written, "My

house shall be a house of prayer"; but you have made it a den of robbers.' Every day he was teaching in the temple. The chief priests, the scribes, and the leaders of the people kept looking for a way to kill him; but they did not find anything they could do, for all the people were spellbound by what they heard.' (Luke 19:45–8)

The people hung on his words. As a man Jesus is using the language he learned from his elders, from the teachers of the law, to new and powerful effect. In a sense, Luke's account of Christ as the wise child who asks searching questions is part of what gives authority to the Christ who returns to the Temple as an adult to cleanse it. Indeed, the Gospel emphasis in Luke and in the other evangelists, both on Christ's having been an infant and a child, and on his teaching about children and the Kingdom, gave rise to an entirely new possibility for literary narrative, which became a distinctively Christian form of literature – that is, the child's eye narrative. It is well known that many other cultures do not have the distinctive sense of what is particular and special to childhood found in Christian culture. In many cultures children are seen either as miniature adults or not really as people at all, only as 'potential' adults. But when Christ set a child in the midst and said, 'it is to such as these that the kingdom of God belongs . . . whoever does not receive the kingdom of God as a little child will never enter it' (Luke 18:16, 17), he was reclaiming and redeeming the very word 'child'. Likewise, the word 'father' – which might always have meant a stern and lordly person, immovably at home being waited upon by dutiful offspring – is redeemed in the astonishing story of the father who abandons his dignity and runs through the streets to meet his son while he is still a long way off (Luke 15:11–32).

This task of redeeming language exemplified in the gospel continues to this day. It is the special task of poets and writers to find again those words which have been corrupted and exploited and to restore them to better use, as Eliot says in 'Little Gidding',

> our concern was speech, and speech impelled us
> To purify the dialect of the tribe
> And urge the mind to aftersight and foresight[7]

Earlier in the *Four Quartets*, in the final section of 'East Coker', Eliot talked frankly about the artist's struggle to incarnate meaning in the medium of language and how this too is part of the business of redemption, 'the fight to recover what has been lost'.

> Because one has only learnt to get the better of words
> For the thing one no longer has to say, or the way in which
> One is no longer disposed to say it. And so each venture
> Is a new beginning, a raid on the inarticulate
> With shabby equipment always deteriorating
> In the general mess of imprecision of feeling[8]

What writers have to contend with is more even than what Eliot calls the 'the general mess of imprecision of feeling', or with the problem that, as he puts it earlier still in the *Four Quartets*,

> Words strain,
> Crack and sometimes break, under the burden,
> Under the tension, slip, slide, perish,
> Decay with imprecision[9]

The deepest problem is that words not only decay naturally, but are deliberately subverted by sinful people. We are alienated from God and from one another and we press language into the service of that alienation. We want to diminish and dismiss the humanity of others to ignore their claims on us, and we use language as one of our weapons. In his collection of essays *In Bluebeard's Castle*,[10] and in his later work *After Babel*.[11] George Steiner offers a powerful analysis of this process. We have all been made aware of how under the Nazis words like 'vermin' were systematically applied to Jews to diminish their claims to humanity; how the language of cleansing and pest control was then used to describe, but to disguise in describing, the establishment of the death camps. It is this dark side of the power of

language in the hands of fallen humanity which is the central concern of novels like George Orwell's *Nineteen Eighty-four*. 'Newspeak' in its very purpose of controlling thought by diminishing the possibilities of expression witnesses, if only negatively, to the possibility that language holds of liberating thought provided that forgotten or degraded words can be redeemed. Neither Steiner nor Orwell are Christian writers but their work bears witness to the need for a redemption of language. Indeed, Steiner goes on in his thought-provoking book *Real Presences* to suggest that only a transcendent meaning, a 'Word', as it were, beyond and behind all other words, can account for the possibility that, in spite of decay and abuse and by an astonishing grace, our words can still incarnate real meanings: 'any coherent understanding of what language is and how language performs . . . any coherent account of the capacity of human speech to communicate meaning and feeling is, in the final analysis, underwritten by the assumption of God's presence.'[12]

If the Word's being made flesh, and God's becoming a child, is itself part of the redemption of the word 'child', then one can go further and say that the whole Gospel narrative in all four evangelists represents a point of renewal for literature. There is nowhere in the world of literature, prior to the writing of the Gospels, a story in which a child's viewpoint or understanding is taken seriously and made central, let alone a story in which the child is the judge and teacher of the adult. Gospel literature made possible the child's eye narrative, and, conversely, the child's eye narrative is a medium through which we can come to a deeper knowledge of the incarnation. To take a modern example, the extraordinary power of Harper Lee's novel *To Kill a Mockingbird*[13] depends directly on the story's being told by a child. Her (the storyteller's) clear gaze, at once wonderfully open and impartially critical, tries and tests everything in the culture in which she grows up. At first, the judgements of the child are gentle and humorous, such as the wonderful account of how a school teacher insists on teaching her to read when she obviously already knows how, but has learned in a way which does not fit with the teacher's system. But this is just a gentle preparation for

the real dissonance which is at the heart of the book, which is Scout's gradual discovery of the racism at the heart of the deep South. Nobody can explain it to her. The adults can deceive each other with long-sounding words, they have learned to live with their sin and compromise, to gloss over their gross injustices, but they cannot explain it to a child. The phrase 'even a child could see it' is in a sense the key to the novel, and to the dramatic courtroom scene in which the children against their adults' orders sneak in and watch 'twelve good men and true' deny the facts that are staring them in the face and find Tom guilty simply because he is black. And they cannot even see the enormous lie they have just perpetrated, the deep insult they have offered to Truth, but the children standing in the gallery as Christ once stood in the Temple see it all as it really is. We are weighed in their balance and found wanting.

His Humanity and Ours

Looking over the panorama of English literature written since the gospel of God's incarnation first dawned on speakers of our language, we can see the way in which the mystery of the incarnation became both the subject itself of literary art and the medium through which writers viewed other subjects. In what remains of this essay we can only touch on one or two further examples of the ways in which the incarnation is brought into focus through the lens of literature; this time dealing with the second sense of Christ's incarnation, the sense that beyond the particularity of Bethlehem and yet because of it, Christ assumes, so that he may redeem, the whole of our humanity. Indeed, because literature is the art form in which the 'generations tell their personal tale' (Muir), it is especially fitted to develop and deepen the link between the once and for all story of Christ in Palestine and the story of Christ in us, in our humanity now. For this reason it is not just explicitly Christian literature which unfolds for us the mystery of the incarnation. When we journey into darkness or despair, when we struggle to hope against hope, when we go on, even when we can't go on, it

is Love incarnate who bears all these things with us. Thus writers who claim to have no faith, who are only chronicling the human heart and delineating for us our common human condition, are also teaching us about the incarnation. Before becoming a Christian I was deeply moved by the writings of Samuel Beckett, especially the great trilogy *Molloy/Malone Dies/The Unnameable*,[14] which give a bleak but courageous first-person account of isolation and descent into hell, the bearing alone of the unbearable. When I read these books again as a Christian, it was not to say: 'Ah, but I know better now I've got the answer', but rather to feel that Beckett, that modern desert father, had mapped out for me even more clearly the darkness through which Christ walked to the cross and which he redeems, by bearing. The words that end the trilogy, 'I can't go on. I'll go on'[15] could have been spoken from the cross. If the mystery of the incarnation is true, they were.

Whilst some literature, like the Gospels themselves, dealt directly with the King of Heaven found as a child in the cradle, exposed to the worst of the world, the truth of the incarnation can be apprehended in less direct ways. Once the great story of Bethlehem has been told, the story of the King hidden in the flesh of the pauper, it never ceases to inform and give sudden depth and resonance to all the subsequent stories that have been told in its light. A great deal of our best literature is lit from within by the memory of the gospel and in its turn sheds light on that gospel.

Take for example the unforgettable scene in Shakespeare's *King Lear*, in which the king is exposed to the storm. Among the many themes developed in *Lear* is the idea of the privileged learning to feel the condition of the weak – not just to see things from the outside but to feel them from the inside. The great storm in *Lear* is not only an outer manifestation of the emotional turmoil of the characters, but also in a sense a cleansing element, which strips away pretensions and exposes the heart. All these themes are gathered together at the turning point when Lear is suddenly moved beyond self-obsession and self-pity to empathy with his

poor subjects, and at this point, instead of rejecting his pain and
exposure, he embraces them as a necessary part of his kingship:

> Poor naked wretches, wheresoe'er you are,
> That bide the pelting of this pitiless storm,
> How shall your houseless heads and unfed sides,
> Your loop'd and window'd raggedness, defend you
> From seasons such as these? O, I have ta'en
> Too little care of this! Take physic, pomp;
> Expose thyself to feel what wretches feel,
> That thou mayst shake the superflux to them
> And show the heavens more just.[16]

For a moment the figure of the king in poverty and exposed to
feel what wretches feel, catches the echo of Christ's words 'The
son of man has nowhere to lay his head'. The 'poor naked wret-
ches' are not just the poor of Shakespeare's imaginary pre-
Christian Britain, nor even the houseless heads and unfed sides
of the new Elizabethan poor driven from their land by the first
wave of enclosures, whose desperation may have inspired these
lines. Lear's cry echoes to Bosnia and Kosovo, to war-torn Africa,
and everywhere that sin has forced its victims to drag their
looped and windowed raggedness. Standing behind this mythical
king who has come out of his palace and into the storm so as to
expose himself to feel what wretches feel, is another King who
left the palace of heaven, and whose journey, beginning at
Bethlehem, ended in the final exposure of the cross. We cannot,
and should not, say Shakespeare intended this or that Christian
allegory, but we can certainly say that in the prism of his art
and imagination, truths which might have become Muir's mere
fleshless words are given flesh again.

The works of Shakespeare are part of the historical canon of
classic works of English literature, but what of the new ways
of thinking and writing which followed the carnage of the First
World War? Can they offer any help in focusing the mystery of
incarnation?

In Parenthesis was David Jones' first great work of literature,[17]
though he was by then already an accomplished painter. First

published in 1937 it has been recognised as 'the most extended epic record of the Great War in English', containing 'the most vivid description of everyday life in the trenches'.[18] T.S. Eliot, in his introduction, called *In Parenthesis* a work of genius, but what distinguishes it from the many other works of genius to emerge from that terrible war was that, unlike his contemporaries Wilfred Owen and Siegfried Sassoon, Jones enlisted as a private. He endured and described the war from the standpoint of the ordinary foot soldier. The sudden transition from the world of Camberwell Art School to the horrors of trench warfare led Jones, through the very experience of those horrors, to a deeply embraced Christianity. He has a special insight into the connection between Christ's incarnation, celebrated in the liturgies of the Church, as a hidden presence in the sacraments, and one major consequence of that incarnation, his hidden presence in the wounded and the dying. Jones uses the modernist techniques of allusion and juxtaposition, pioneered by Joyce and Eliot, to bring together the potentially fleshless world of liturgy, and the far from bloodless world he shared with his fellow soldiers in the trenches.

Part Three of *In Parenthesis*, which describes the men being moved by night up to the front line, begins, not with the sergeant's orders, which come later, but with the rubric for the Good Friday liturgy:

> Proceed . . . without lights . . . prostrate before it . . . he begins without title, silently, immediately . . . in a low voice, omitting all that is usually said. No blessing is asked, neither is the kiss of peace given . . . he sings alone.[19]

Then come the soldiers moving, low-voiced, and the officer's words:

> Move on . . . move em on
> Get on . . . we're not too early.
> Informal directness buttressed the static forms ritual words made newly real.[20]

In every way the ritual words of the familiar liturgy of Christ's

passion are made newly *real* as Christ walks with the men up the
line to death. All of which prepares us for the climax of the book
in Part Seven in which we are given a simultaneous vision of a
soldier in the agonising moments before he will be ordered over
the top, and the agony of that soldier's Saviour in the garden:

> Perhaps they'll cancel it . . .
> Or you read it again many times to see if it will come
> different:
> You can't believe the cup won't pass from
> Or they won't make a better show
> In the garden.
> Won't someone forbid the banns?
> Or God himself will stay their hands[21]

The vision which made *In Parenthesis* an account not just of his
own suffering but of the suffering of the body of Christ, developed
in David Jones' later work into a deeply incarnational and sacra-
mental vision of the world. He is perhaps the only modern writer,
with the exception of Teilhard de Chardin, to have taken seriously
both the doctrine that all things were made in Christ *and* the
story of the earth's development over time which science was
beginning to tell. This double vision of both the outer develop-
ments mapped by science and history, and the inner coherence
and meaning revealed by faith, are woven together in the *Anath-
emata*.[22] which W.H. Auden called 'probably the finest long poem
written in English in this century'.[23] In *Anathemata* the geological
formation of the earth, the evolution of species leading to human
beings, and our own prehistory are all described in terms of the
coming of Christ and the gathering into him as both man and
God, the meanings and purpose of all creation. The alternate
periods of intense heat and cold, which swept our world, are
described in musical terms as the 'introit', to the liturgy of history,
so that just as the liturgical introit[24] prepares for the appearance
of the priest, so the geological formation of the earth prepares
for the appearance of humankind and so for the coming of Christ
'robed in flesh' as our great High Priest.

In the opening section of 'Rite and Foretime' he traces the

signs and foreshadowing, the preparations, for the fullness of time when God should be incarnate, whilst making a wonderful, musical poetry out of the Latinate language of science. As in this passage where the light of Christ picks out the first-found fossil of a fish as a fore-sign of Jesus Christ our Saviour:

> From before all time
> The New Light beams for them
> And with eternal clarities . . . era, period, epoch, hemera
> Through all orogeny:
> Group system series zone,
> Brighting at the five life-layers
> Species, species, genera, families, order.
> Piercing the eskered silt, discovering every stria, each score
> And macula, lighting all the fragile laminae of the shales . . .
> glorying all the under-dapple.
> Lighting the Cretaceous and the Trias, for Tyrannosaurus
> Must somehow lie down with herbivores, or, the poet lied,
> which is not allowed, . . .
> As down among the paleo-zoe
> He brights his icthyc sign[25]

As this complex and beautiful poem moves from the fore-time of prehistory, through the history and Arthurian legends of these islands, to Christ's saving presence in the present day, it gathers up into Christ and his incarnation all that would otherwise be separate and in need of redemption, in much the same way that the poet of the 'Dream of the Rood', an Old English Poem which deeply influenced Jones, gathered up his pagan past, the 'axile tree of Odin', and let the light of God in the face of Jesus Christ transform it into the tree of victory. A literary imagination, open to the light of Christ, has the power to move us beyond the limitations of ideological argument, and take us to the far side of the cross, on a journey with the One who was incarnate into every part of the world and every corner of the human heart.

FURTHER READING

Paul Fiddes, *Freedom and Limit: A Dialogue between Literature and Christian Doctrine* (London: Macmillan, 1991).

Nigel Forde, *The Lantern and the Looking Glass: Literature and Christian Belief* (London: SPCK, 1997).

John C. Hawley (ed.), *Through a Glass Darkly: Essays in the Religious Imagination* (New York: Fordham University Press, 1996).

David Jasper, *Postmodernism, Literature and the Future of Theology* (London: Macmillan, 1993).

Leland Ryken, *Realms of Gold: The Classics in Christian Perspective* (Wheaton: Harold Shaw, 1991).

NOTES

1. Edwin Muir, *Collected Poems* (London: Faber, 1960), p. 228.
2. Seamus Heaney, 'Personal Helicon', in *Death of a Naturalist* (London: Faber & Faber, 1969), p. 57.
3. Lancelot Andrewes, Sermon preached Christmas 1618, in *Works*, Vol. I, ed. Wilson and Bliss (Oxford: John Henry Parker), p. 204.
4. T. S. Eliot, *Collected Poems* (London: Faber & Faber, 1963), p. 102.
5. ibid., p. 89.
6. ibid., p. 102.
7. ibid., p. 218.
8. ibid., pp. 202f.
9. ibid., p. 194.
10. George Steiner, *In Bluebeard's Castle: Some Notes Towards the Redefinition of Culture* (London: Faber & Faber, 1971).
11. *After Babel: Aspects of Language and Translation* (Oxford: OUP, 1998).
12. *Real Presences: Is there anything in what we say?* (London: Faber & Faber, 1989), p. 3.
13. Harper Lee, *To Kill a Mockingbird* (London: Heinemann, 1960).
14. *The Beckett Trilogy* (London: Pan, 1979).
15. ibid., p. 382.
16. Act III, scene iv, lines 28–36.
17. David Jones, *In Parenthesis* (London: Faber & Faber, 1937).
18. Desiree Hirst, 'Private David Jones and Private Isaac Rosenberg', in *The Chesterton Review*, XXIII (February/May 1997), p. 139.
19. Jones, *In Parenthesis*, p. 27.
20. ibid., p. 28.
21. ibid., p. 158.
22. David Jones, *Anathemata* (London: Faber & Faber, 1952).
23. Quoted on the flyleaf of the second (1972) edition.
24. Jones, *Anathemata*, p. 63.
25. ibid., pp. 73–4.

CHAPTER 3

THROUGH POETRY:
Particularity and the Call to Attention

ANDREW RUMSEY

From many forms of literature we move to poetry in particular. And 'particular' becomes the key word. The poet Andrew Rumsey explores the striking capacity of poetry to elucidate and celebrate the particularity of the incarnation – that God should choose to encounter us as a singular human being at a specific time and place.

It is, we are often told, the small things which matter – the lock of hair, the reassuring word, the last piece of the puzzle pressed home. Particular details drive our lives, for life is a parts department with countless components and a breathtaking scale of operation. If I consider my ageing Triumph Dolomite, particularity lies unseen in its minute atomic make-up; it abounds in the thousand oily items that help it run; it meets the eye in that peculiar shade of puddle-brown and unique number plate; it lingers in the memory of many different trips.

Particularity is the crystallisation of life, reality given distinction and definition. It is the essence of creation, born in God's delight 'that there should not be nothing' as George Steiner puts it. In the beginning there is a frenzy of particularity – 'let the water *teem* with living creatures' – a divine, almost childlike revel in

the endless possibility of variety. In the generosity of God, humankind too takes part and is given the honour of naming and ordering each creature; making sense of such abundance.

How are we to catalogue Jesus Christ? The incarnation asks us to cope with the Creator's complete immersion into this teeming world – the One becoming one. It assaults us with the singular and sends the poets spinning from such paradox. It is this particularity of Christ that concerns us in the present chapter, where I will suggest that among the arts, poetry has a unique capacity to release a theme which itself can hold to ransom much of modern life and thought.

Particularity in Crisis

At the dog-end of the millennium, western society eyed particularity with uncertainty, worrying it like a bone. We dared not step on a butterfly in Barking for fear it might start an avalanche in Val-D'Isère – but neither did we dare *not* step on it for fear such preference might offend the caterpillar. The consequent paralysis of choice, coaxed on by global capitalism, is everywhere apparent, from the inability to choose Christ over Krishna to the hollow stare of the supermarket shopper facing two dozen types of margarine. Hence the societal response is often to flatten out particularity and difference, so that, in effect, all the flowers are painted grey in that way so beloved of primary school hymn re-writers in recent years. The artistic community arguably lost its nerve much earlier in this respect and since the Romantic movement has retreated into a sound-proof booth where it is safely separate from questions posed by the quiz-masters Meaning and Truth.

There are deep roots to what one might call the Problem of Particularity – space prevents us from unearthing them too thoroughly as it has exercised pedigree minds since Socrates.[1] This said, centuries of debate may be helpfully viewed as humanity's exploration of his creation mandate to name and order each creature. This has involved a coming-to-terms with two pivotal questions – the essential Platonic poser, 'What kinds

of things are there?' and its Enlightenment correlate, 'What can be known?' Plato's world housed two groups living in a rather one-sided relationship: varied and transient particular things and changeless, original *forms*, with the latter clearly ruling the roost. Thus a particular beautiful thing – a rose, for example – relates to the form *beauty*, but only as an imperfect copy of that form. *Particulars* might then be likened to ever-changing tenants while *forms* appear as landlords who would remain even if no tenants were to be found.

Plato's pupil Aristotle took this classification a stage further, siding with the particulars rather more and identifying among them *substances* which he took as the individual essence of each thing. Significantly, these substances are to be distinguished from *accidents* – properties of an item which do not belong to its essence. As for forms, or *universals* as he called them, these lived in co-dependence, not independence, with particulars, for what qualifies a universal is that it may be 'said of' some actual thing. While there may be a universal 'horse', for example, there may not be a universal 'unicorn' for 'unicorn' cannot be *said of* a particular specimen.

This might all appear as merely the splitting of rather white and learned hairs, but for the great influence these categories have had over the way in which we see things. Their quest appears as one concerning the nature and knowledge of *reality*, and notably for some reliable way of finding coherent meaning amid diversity. Successive members of the philosophical search party have continued to seek such universals amongst the particulars, but the present century has all but given them up for lost. Postmodern thinkers now stress *difference* above all else.

For Christian theology, this pursuit is pioneered by the incarnation. The conclusion of the early Church as it reflected on Christ in life and worship, was that this man was not only a revelation *from* God, but *of* God – not just a manifesto for God's Kingdom, but the Kingdom made manifest. For believers then as now, Christ came to be understood as primary reality, 'the word that was in the beginning'. As such the incarnation keys open the

problem of particularity, for it grounds the universal reality of God within the 'changes and chances of this world' and correspondingly gives dignity and value to all created 'substances', whether cabbages or kings. In philosophical terms alone this was a staggering confession and one to which the church fathers were impelled to give credal expression in a way which engaged with prevailing categories while not being captive to them. Thus we find the Nicene definition of Christ within Greek terminology as being *homoousios*, of *one substance* with the Father, by whom all things were made.

Despite this deftness of touch when framing the creeds, the Church has often fumbled when appreciating *how* God can be present in the person of Christ. How can the eternal God 'make room' for himself in temporal creation? How can such universality be contained within such particularity? Late medieval and Reformation disputes over the nature of Christ and his 'real presence' at the eucharist typify the confusion which periodically bubbles to the surface.

The Church has perhaps concentrated too much on the *how* of the incarnation, and in so doing invoked the ghosts of Plato and Aristotle, who persistently haunt such enquiry. The Platonic spirit shows itself in the dualism we noted above, where the visible world is mistrusted as a bearer of truth, being only an imperfect copy of the 'real' world of forms. When Aristotle's theory of substance joins the fantasy, it is all too easy to disregard Christ's particular humanity as an 'accident' of little consequence. As T.F. Torrance displays in his slender classic *Space, Time and Incarnation*, Aristotle has also lingered in an understanding of spatial presence in terms of volume or quantity, such that space is defined and limited by the receptacle which 'contains' it. For the inherently dynamic concept of the incarnation, such a rigid framework is riddled with problems. Thus, when Reformed theologians spoke of Christ's incarnate presence not negating his eternal, heavenly reign, Lutherans could parody this as 'the Calvinist extra' – as the incarnation having to 'leave behind' something of Christ in heaven.[2]

Though we might hope Aristotle can be safely brushed under

the medieval carpet, the particularity of the incarnation is just as mind-bending today as it ever was. For many within and without the Church, the idea of one man 'containing' a creator God is, to borrow Bob Dylan's lyric, 'like a mattress balancing on a bottle of wine'. What is equally clear, however, is that contemporary society urgently needs some way of doing almost that – of regaining confidence that particulars *can* hold a universal volume.

The Particular Genius of Poetry

Though not always affable flatmates, the poet and the Christian theologian essentially share the same living room. Conversation between them is crucial, for if the latter is to get to grips with the slippery shape of the incarnation he must employ a medium which excels in the small glories of particularity. The genius of poetry in this respect has perhaps three key dimensions which we shall address as *attention*, *presence* and *resonance*.

Attention

'If a poet looks through a microscope or a telescope', asserts the French philosopher Gaston Bachelard, 'he always sees the same thing'.[3] Viewing the large in the small is the currency of poetry, for it is the grasp of significant detail that brings a poem alive. Poets are driven – albeit in many different ways – by the desire to *really see* what is before them, to *attend* to particulars in all their uniqueness and diversity.

Such was the abiding concern of twentieth-century American poet William Carlos Williams, who wrote of lifting before the imagination those things which lie 'close to the nose.' His often sparse poetic style sought to isolate particular images rather like a naturalist pins insects on a board; to observe and highlight them, aiming 'to refine, to clarify, to intensify that eternal moment in which we alone live'.[4]

This concern is captured in his brief, fragmentary poem 'The Red Wheelbarrow':

so much depends
upon

a red wheel
barrow

glazed with rain
water

beside the white
chickens.[5]

By cutting compound words into their separate elements (wheel/ barrow; rain/water) and separating an object from its description (barrow/glazed with rain) we attend to each distinctive component of the scene. But, equally, it is the *arrangement* of these particulars together that is crucial; their unique relationship in space and time, upon which so much depends.

Williams' pared-down style condenses a rich theme in poetry. The Metaphysical poets of the seventeenth century, for all their lofty phrasing and imagery, were rooted in attention to everyday life and it is often particular occasions which prompt their devotional flights, such as George Herbert noticing with dismay his greying hair, in 'The Forerunners'. Similarly, for the Romantics, a prayer-like *contemplation* of the mundane – a Grecian urn, or a nightingale – can be the springboard for soaring reverie. As Wordsworth observes:

To me the meanest flower that blows can give
Thoughts that do often lie too deep for tears.[6]

The poet's first response to the world is stillness and wonder, passive reflection before active exposition. Poetry 'takes in' before it 'gives out', and considers itself addressed by creation, called to attention. Response to the incarnate Christ frequently starts the other way around – our questions, our interrogative analysis. So often in the Gospels, our Lord turns the tables – 'Now I have a question for you'! What begins as our Zacchaeus-

like quest for God soon becomes God's Christ-like quest for us.

Far more than we need to address God we need him to address us, which is precisely what he does in Jesus. Dietrich Bonhoeffer aptly refers to *Christ pro me* – God's being in relation towards me, for me – a matter of *who* more than *how*. Before it is anything – our idea, our principle, our doctrine – the incarnation is God's initiative, *his* word addressing *us*, to which our first response must be what the late Denise Levertov beautifully describes as 'Primary Wonder':

> Days pass when I forget the mystery.
> Problems insoluble and problems offering
> their own ignored solutions
> jostle for my attention, they crowd its antechamber
> along with a host of other diversions, my courtiers, wearing
> their colored clothes; cap and bells.
> And then
> once more the quiet mystery
> is present to me, the throng's clamor
> recedes: the mystery
> that there is anything, anything at all,
> let alone the cosmos, joy, memory, everything,
> rather than void: and that, O Lord,
> Creator, Hallowed One, You still,
> hour by hour sustain it.[7]

Poetry and incarnation both begin with annunciation. Not for us to say how it will be, what form and time God will take for his creative work. Only for us to receive and say, 'Let it be to me according to your will'.

Presence

Little 'annunciations' bombard the poet, catch her attention. Why else the urge to express what 'lies under the nose' but to make sense of an 'otherness' that has arrested us, an undeniable 'presence' in a particular tree or face that demands an enlargement of description? For the poet confronted by reality, ordinary

phrasing is insufficient to capture the impression that things make – for Keats, bubbles must be '*beaded* bubbles winking at the brim'; for Eliot, fog must be 'yellow fog that rubs its back upon the window-panes'. In a manner doubtless maddening to the non-poet, each flavour and colour of a scene is enhanced to convey the pulsing reality therein.

Such heightened sensitivity abounded in the frail Jesuit priest and poet Gerard Manley Hopkins, whose poems and prose reflect the overwhelming sense of 'presence' he detected within creation. He coins two terms to express this – *inscape*, which denotes the intrinsic, individual form of each natural object, and *instress*, the unifying energy which both sustains the inscape and 'shines' from it to act upon our senses. Thus, Hopkins can write in his journal: 'there is one notable dead tree . . . the inscape markedly holding its most simple and beautiful oneness up from the ground'.[8]

This wonderment at singularity within nature was greatly funded by the ideas of the medieval theologian Duns Scotus, who held that the witness of God in creation was heard not first in its generality but in the *haecceitas*, the essential 'thisness' of each creature. Duns Scotus' theology allowed Hopkins to integrate faith and fascination in his poems: 'Pied Beauty' below shows the sense of praise which often ensued.

> GLORY be to God for dappled things –
> > For skies of couple-colour as a brinded cow;
> > > For rose-moles all in stipple upon trout that swim;
> > Fresh-firecoal chestnut-falls; finches' wings;
> > > Landscape plotted and pieced-fold, fallow, and plough;
> > > And all trades, their gear and tackle and trim.
>
> All things counter, original, spare, strange;
> > Whatever is fickle, freckled (who knows how?)
> > > With swift, slow; sweet, sour; adazzle, dim;
> > He fathers-forth whose beauty is past change:
> > > > Praise him.[9]

As Hopkins himself was all too aware, such presence within

creation is not uniformly beautiful. Particularity can trap and oppress as well as liberate, as any parish priest finds who tries to remove old pews or control the power of church keys! For the late Poet Laureate Ted Hughes, objects did not merely signify presence but took on occult power and significance – for good and ill. As his obituary in the *New Statesman* explains, 'Hughes would latch onto [certain details] and declare them augurs, omens, curses. The telephone that brought him news of so many personal hurts became . . . the cause of all tragedies, a "bad god" '.[10]

For the poet, presence must always contend with *ab*sence, with not-seeing – with death. Indeed, poetry gains definition from this contrast, for in an absent world, the presents are all the more vital, as the work of the senior Welsh poet R.S. Thomas exemplifies. Thomas attests both to the gloomy grind of mundanity and its occasional transfiguration. The latter makes a captivating vision, as shown masterfully in 'The Bright Field'.

> I have seen the sun break through
> to illuminate a small field
> for a while, and gone my way
> and forgotten it. But that was the pearl
> of great price, the one field that had
> the treasure in it. I realise now
> that I must give all I have
> to possess it. Life is not hurrying
>
> on to a receding future, nor hankering after
> an imagined past. It is the turning
> aside like Moses to the miracle
> of the lit bush, to a brightness
> that seemed as transitory as your youth
> once, but is the eternity that awaits you.[11]

Here the fleeting, blink-and-you'll-miss-it nature of the 'bright field' increases its value for the observer. This is a paradox the poet feels deeply – just because it is so slight, so hidden, it holds special rarity and worth. Facing the fact that, in some sense,

eternity comes to us wrapped in the temporary, is poetry's task. The fruit of its labour is to show that, as T.S. Eliot affirmed in 'Ash Wednesday':

> And what is actual is actual only for one time
> And only for one place[12]

Without this vital role, meaning itself becomes redundant. The question of 'actual presence' is the question of Christology. Classical heresy swings the needle between 'fully man' and 'fully God' and resists a precarious balance of both in the person of Christ. It either tends towards Arius and opts for his 'creature-liness', or with Apollinaris, for a docetism by which he only 'seems' to be one of us. The genius of the incarnation is instead the integrity of God and man, an Olympic event which exhausts the unfit imagination. The conclusion of Gregory of Nazianzus that 'what has not been assumed (in Christ) has not been healed' is the poet's cue. It signifies actual creative, redemptive presence in this life – the sort of accidental life where death from a terrorist bomb hangs on which shop you happened to enter, where at that wedding you just *might* meet the man of your dreams.

It is common to find the incarnation presented under laboratory conditions – as a white-coated, test-tube blend of two unlike quantities. An experiment made in a vacuum and proved to be correct. If however God is fully present in our brief encounter with Christ then the fearful and wonderful consequences need poetic expression, for poetry rehearses us, verses us in seeing the curses and blessings of presence in such a world as this. She calls attention to the woman reaching for Christ's hem as he passes; to the one who reached but was not noticed; the man who, though straining, only half-heard the words of the Lord. *Emmanuel* means accepting, indeed glorying in the particularity of life, for here we have been met by Christ, the precision of God.

For Jesus' disciples, attention followed by recognition of presence led to the transfiguration. On the mount, they *really saw* for the first time, and Christ shone with that reality. Their subsequent descent is directly (and one presumes, deliberately) into the loud

crowd around an epileptic boy whom Jesus then heals, earthing his glory. It is this earthed glory Edwin Muir envisages in his poem 'The Transfiguration',[13] where he sees:

> Our hands made new to handle holy things
> The source of all our seeing rinsed and cleansed
> Till earth and light and water entering there
> Gave back to us the clear unfallen world.

And asks:

> Was the change in us alone
> And the enormous earth still left forlorn,
> An exile or a prisoner? Yet the world
> we saw that day made this unreal, for all
> was in its place

Salvation is not in abstraction. Poetry draws us into the action, lets us realise our Lord. Indeed, the incarnation *must* be realised before it is idealised, and we have missed the point if we cage it away from its natural habitat as the main exhibit in the theological zoo. Christ belongs in the wilderness, for that is where we are.

Resonance

Because a real or universal presence has in some sense addressed us in the particular subject, our poem 'works' by helping the reader also to recognise that presence; by resonating with their own experience. The poem *communicates* and as such operates in the tension between being true to its subject and truly revealing that subject to others. At one level then, it shares the same space as comedy and popular music, both of which are designed with universal resonance in mind. The popular artist wants the reaction 'ah yes, *that's* how it is!' from the widest possible audience and invariably does so by homing in on common experience. Interestingly, it is apparent that the more precise its detail, the greater the popular resonance – an irony present in the very phrase 'pop single'. Take, for example, Bacharach and David's evergreen 'I Say a Little Prayer':

I run for the bus now
and while running I think of us now
I say a little prayer for you

And at work I just take time
and all through my coffee break time . . .

But, crucially, poetry also has to go *against* the popular grain in
order to keep faith with particularity. It is concerned with the
*in*accessible, hidden things as much as the accessible. It is
engaged in an imaginative re-viewing and re-ordering of the
world about us which, while seeking resonant communication of
that vision, may involve the possibility of 'not getting', or indeed
'not liking' it!

God's coming 'in the likeness of sinful flesh' (Rom. 8:3) is a
surrender to what Bonhoeffer calls the 'incognito' of humanness.
This is his religious offence both then and now – not that a divine
being should forgive sins, but that the *Son of Man* should do so.
The incarnation has then an intrinsic ambiguity to it. It lies
between the 'getting' and the 'not-getting', and is best cloaked in
parable or metaphor, whereby Jesus is Light of the World, Good
Shepherd, True Vine and so on. To be saviour, he must bear his
particular limitations, a tension which in the wilderness means
resisting the temptation both to super-stardom and super-
kingdom. It is these twin constraints which give the passion
drama such immense creative torque and put the dread behind
the triumphal entry, the hope beneath the cross.

I suggest metaphor as the appropriate carriage for such
meaning, a claim which needs a little more unpacking. Poetry's
focus on the distinctive presence of each particular experience
or object leads, as we noted in the poem 'The Red Wheelbarrow'
above, to a concern for their relation with other particulars. As
the lovestruck would-be poet notes the elegant curve of the
beloved's nose, he is at pains to describe both its intrinsic perfec-
tion – the sufficiency of this nose alone, its necessity for his future
well-being, *and* its agreeable setting amongst the other, no doubt
equally sublime, features. To do justice to both he will almost

certainly resort to comparison, to the search for 'resemblances'.
For such nasal beauty 'the way it fits your face' is utterly inade-
quate – it must be a cathedral set on a hill, the mouth must be
the river's curve, and so on.

Metaphors are vital to a poem's growth: they are runners,
fruitful new shoots that increase the yield of meaning. The poet
does not – unless hopelessly lovelorn – seek to *exaggerate*, but to
reflect accurately what he really does see. A slim green seedling
splitting the asphalt is a remarkable 'presence' to behold. Meta-
phor contends with such transfixion by setting off resonance with
a network of other, perhaps contradictory, images, that spring up
with something of the subject's force.

Resonance thus has a wonderful *suggestive* capacity. When
Herbert speaks of prayer as 'the land of spices' (in 'Prayer'), how
our boundaries and expectations of prayer are blown open with
infinite suggestion: adventure, sensation and mystery all rush in.
Such allusion works best when leaving the 'top end' of the
meaning open. By this I mean the paradox by which metaphor
captures a subject while at the same time setting it free. It reveals
the particular to us almost *by* releasing it to mean more than we
can express.

Elizabeth Jennings' lovely poem 'In Praise of Creation'[14] opens
by celebrating the particular:

> That one bird, one star,
> The one flash of the tiger's eye
> Purely assert what they are,
> Without ceremony testify.
>
> Testify to order, to rule –
> How the birds mate at one time only,
> How the sky is, for a certain time, full
> Of birds, the moon sometimes cut thinly.

And closes with wonderfully evocative suggestion:

> Then quiet, and birds folding their wings,
> The new moon waiting for years to be stared at here,

> The season sinks to satisfied things –
> Man with his mind ajar.[14]

Having praised the satisfying singularity of things, the last line gives both resolution and the anticipation of more. In this sense, metaphor should always get us moving – stimulate a yearning or a restlessness for further revelation. Because we glimpse something glorious, we strain ahead to what may yet be. Metaphor tantalises with promise.

The incarnation is in this sense the great Metaphor and as such is the true end of poetry.[15] The constraint of Christ to time and place both reveals and conceals, is an 'open secret', to use Lesslie Newbigin's potent phrase. Crucially, however, it sets up an irresistible sense of 'more to come'. The incarnation is eventual. It is the occasion which takes time. In the events of the gospel, immediate messianic hopes are increasingly dashed as Christ sets about spreading a new rumour of Kingdom glory beyond this place, beyond the grave even. At the transfiguration this breath-taking possibility is briefly held in camera. The cross – glory in negative – is the cost of realising such a Kingdom and entails surrender to the curse of particularity, its absurd demons.

Calvary appears to be the victory of absence, of not-seeing. It is the reality I cannot do justice to; the Word I can neither read nor write. It is our unfulfilled promise, the pathetic

> falling

> short of our creativity.
> The death of metaphor.

> But

> Christ is Risen
> indeed ascends
> and sends up a flare
> of bright relief
> over all
> flat maps

and scare-spent
moments

showing
hope to be

the suspension of belief

Metaphor is adept on the ground and in the air. In Christ it can gather us up in its ascent so that on a clear day we may just sense the end of the world.

Conclusion

The power of particularity in creation both fascinates and confounds us. We are drawn to special moments or things – Geoff Hurst's hat-trick in 1966; a string from Jimi Hendrix's guitar put up for auction – which seem to be 'more than just'. Indeed, it is their very transience and triviality that imbues them with greater worth, as these words from the dying playwright Dennis Potter bear witness:

> That nowness becomes so vivid to me now . . . Below my window in Ross, for example, the blossom is out in full. And instead of saying 'oh, that's nice blossom', looking at it through the window when I'm writing it is the whitest, frothiest, blossomiest blossom that there ever could be. (In the face of death) Things are both more trivial than they ever were, and more important than they ever were . . . the *nowness* of everything is absolutely wondrous.[16]

Such potency is wondrous and horrific by turns, as this century has borne awful witness. The period of the two world wars is book-ended by crass particularity – killing an obscure Balkan archduke sends millions to the muddy hell of the Somme, sowing one split particle harvests a Hiroshima. In the acorn of particular incidents broods the oak of universal implication – this is the

reality of creation which makes life so fragile and tragic, so hilarious and precious.

We have found poetry to help us on two levels here, firstly by giving voice to this reality and empowering us as we try to make our way within it. When we do so, Plato dogs our steps more than we realise, dissuading us of the plain fact that each footfall shapes our destiny, here and hereafter. As this speech by Nelson Mandela sharply observes:

> Our deepest fear is not that we are inadequate. Our deepest fear is that we are powerful beyond measure. It is our light, not our darkness that most frightens us. We ask ourselves, who am I to be brilliant, talented and fabulous? Actually, who are you not to be? You are a child of God. Your playing small doesn't serve the world.[17]

But poetry not only brings home the reality of our ordinary world. Crucially, it also brings home the extraordinary reality of that world's judge and saviour, who assumes particularity in his very self at the incarnation. In the extract below, T. F. Torrance imagines a reporter attempting to make sense of all this in the light of the resurrection of Christ:

> Then gradually as the material takes shape under his pen in a remarkable inherence of words and events, he is aware that under the creative impact of the resurrection something like a new literary form is struggling to come into being. His reporting has to take on a new character to do justice to its subject-matter; and yet that is precisely what it cannot really do: it has to be shaped in such a way that it indicates and bears witness to more than it can formally express.[18]

Without wishing to over-realise its powers, poetry comes uncannily close to realising this 'new literary form'. But in attending to Christ and closely following him to the cross, the poet finds even his own art transfixed in cruciform: deconstructed and meaningless. Resurrection – the reconfiguration of the word – is the possibility of poetry, and it calls for fresh attention to that which the world might overlook. Jean-Marie Le

Pen once abhorrently described the Nazi death camps as 'a detail of history'. Thank God that, once and for all, Jesus Christ is the detail of history.

FURTHER READING

Gaston Bachelard, *The Poetics of Space* (Boston: Beacon Press, 1994).

Dietrich Bonhoeffer, *Christ the Center* (San Francisco: Harper Collins, 1978).

David Brown and Ann Loades (eds.), *Christ: The Sacramental Word* (London: SPCK, 1996).

Colin E. Gunton, *The One, The Three, and The Many* (Cambridge: CUP, 1993).

Michael Mayne, *This Sunrise of Wonder* (London: Harper Collins, 1995).

George Steiner, *Real Presences: Is there anything in what we say?* (London: Faber & Faber, 1989).

T. F. Torrance, *Space, Time and Incarnation* (Oxford: OUP, 1969).

NOTES

1. For a penetrating study of this see Colin E. Gunton, *The One, The Three, and The Many* (Cambridge: CUP, 1993) especially ch. 2. Also, Jeremy Begbie, *Voicing Creation's Praise: Towards a Theology of the Arts* (Edinburgh: T & T Clark, 1991), ch. 3. For a concise study of 'the problem of particularity' in philosophy, see Hilary Staniland, *Universals* (London: Macmillan, 1972).
2. T. F. Torrance, *Space, Time and Incarnation* (Oxford: OUP, 1969).
3. *The Poetics of Space* (Boston: Beacon Press, 1994), p. 172.
4. *The William Carlos Williams Reader* (New York: New Directions, 1966), p. 322.
5. ibid., p. 21.
6. 'Intimations of Immortality from Recollections of Early Childhood', line 106. Cited by Peter Phillips in *Christ: The Sacramental Word*, ed. David Brown and Ann Loades (London: SPCK, 1996), p. 206.
7. *Sands of the Well* (Newcastle: Bloodaxe), p. 129.
8. Gerard Manley Hopkins, *A Selection of his Poems and Prose* (Harmondsworth: Penguin, 1953), p. xxi.
9. ibid., p. 30.
10. Ra Page, *New Statesman* (6 November 1998), p. 55.
11. *Laboratories of the Spirit* (London: Macmillan, 1975), p. 60.
12. T. S. Eliot, *Collected Poems* (London: Faber & Faber, 1963), p. 95.
13. Edwin Muir, *Collected Poems* (London: Faber & Faber, 1960), p. 198.
14. *Selected Poems* (Manchester: Carcanet, 1979), p. 64.
15. To explore further the territory of metaphor, art and faith, see Begbie, *Voicing Creation's Praise*, ch. 5, and the seminal study by Janet Martin Soskice, *Metaphor and Religious Language* (Oxford: Clarendon Press, 1985).
16. Interview with Dennis Potter (Channel Four Television, 1994), p. 5.
17. Public address, 1994.
18. *Space, Time and Resurrection* (Edinburgh: Handsel Press, 1976), p. 166.

THROUGH DANCE:

Fully Human, Fully Alive

SARA B. SAVAGE

Sara Savage, writing as a psychologist and former professional dancer, speaks of the ways in which the activity of dance, so often shunned in the Church, can serve to 'bring back more of ourselves' and 'more of Christ', the truly human being, so as to draw out more fully the meaning and ramifications of the incarnation. Our 'person knowledge' of Christ is expanded and intensified. This is not to marginalise intellectual understanding, but rather to enrich it by refusing to separate it from the rest of our humanity. Dr Savage concludes her chapter with a description of a dance in which the theological resonances of a piece of music are challenged and deepened through bodily movements which depict the degradation of the incarnate Son, who for us was crucified, 'dead and buried'.

We only see the stone after we have stumbled. Dance in a Christian context stumbles over taken-for-granted ways of thinking, and makes them highly visible. Recumbent for centuries, these underlying ways of thinking impair our understanding of the incarnation. Dance can 'open up' our vision of Christ, sidestep some of these obstacles, and enable us to flesh out our attenuated knowledge of him. That is the thrust of this chapter.

Intellectualism and 'Person Knowledge'

In the West there has been a tendency to exalt and isolate the intellect while demoting and marginalising other aspects of our humanity. This intellectualism has taken many forms. It finds one form in ancient Greek philosophical culture, it finds a related form in the dualism of the philosopher Descartes. It finds another in some types of Enlightenment philosophy, when a certain kind of rationality gained an impressive record of establishing scientific and technological advances. In whatever form it has appeared, under its reign, we often fail to become fully human. One major casualty has been our understanding of our emotional life. Our emotions, and our physical bodies which register those emotions, have often been regarded as messy hindrances to the pursuit of truth.

This kind of intellectualism has had a marked influence on the Christian Church, and, not least, its approach to the person of Christ. At times it has encouraged an attitude to Christ which gives excessive weight to what can be expressed in propositions, apprehended by the mind. This has limited the resources with which we hold together the divine and human natures of Christ. Two extremes typically result: Christ is all/only divine or Christ is all/only human.

What is becoming clear is that the cognitive tools we have inherited in our culture are often severely inadequate to the task of exploring the mystery of the incarnation. It is my conviction that our propositional knowledge must be set in the wider context of what I shall call 'person knowledge', the kind of knowledge we have of other persons, which involves our whole being, including our emotions and bodies.[1] I am not asserting that this 'person knowledge' is better than, or a replacement for, propositional knowledge, only that to enrich our understanding of the incarnation, we need to steep our propositional statements about Christ within a matrix of person knowledge.[2] Dance is one way of resourcing such knowing. Dance is especially adept at expressing human emotion, and, of course, it is supremely a bodily activity.

Person Knowledge through the Language of Movement

Movement is our first language. We move in the womb, and experience the movements and heartbeats of our mothers. Rhythm, well-being, joy, anxiety, distress are all communicated through these early movement experiences.[3] We then spend the first two years of life discovering the world through our senses and movements. The developmental psychologist Piaget calls this mode of thinking 'sensori-motor'.[4] It precedes the ability to symbolise in words or abstractions. Through it, many major cognitive feats are accomplished. We figure out that we are not the universe, that we are located within a body that has discrete boundaries. We discover that our carers may or may not respond to our cries and demands – that they are separate entities. We discover that although they may leave the room and disappear from view, they do return. Also, our favourite objects are found to have 'permanence'; even when out of view, they still exist. What we can move, feel, taste, and see becomes the sensori-motor building blocks of our thinking. The world becomes real; we become real.

Before language even starts to develop, our bodily interaction with our carer(s) gives us the necessary scaffolding to develop person knowledge. Through it, we become social beings ourselves. As we play with others, we become inter-subjective beings who gain definition through the responses of those around us. We begin to understand cause and effect through the regularity of our interactions with others. This social knowledge is far from being subsidiary to 'real' knowledge. As the psychologist Vygostky cogently argues, social knowledge, or knowledge of persons, provides the very building blocks of rational thought.[5]

Movement is thus one of the first languages through which we gain person knowledge, and as a result, the capacity for propositional knowledge. Hence it is appropriate (perhaps even necessary?) that we use movement to enrich our person knowledge of Christ (whom we must approach by faith with our whole selves, not only our intellect). Movement is a language that con-

nects us to our bodies, and to our emotions which resonate within our physical bodies. Our bodies and emotions necessarily contribute to our self-knowledge and knowledge of others. This is not the 'soft option' it may sound; to have 'person knowledge' of God, and his son Jesus Christ, is intrinsic to salvation itself: 'And this is eternal life, that they may know you, the only true God, and Jesus Christ whom you have sent' (John 17:3). What dance can do is to confer upon us *more of ourselves* with which to resource this knowledge of the Son who has become incarnate.

Here I am suggesting that movement – and its concentrated, stylised form, dance – can enrich our knowledge of the person of Christ.[6] And yet historically, this enrichment has been shunned, with the result that both the full humanity of Christ and the necessity of knowing Christ with the whole of ourselves have been eclipsed. We have already pointed in a general way to an intellectualist tendency in our culture which has fostered this. Now we look more closely at some of the associated factors which have contributed to movement and dance becoming a 'problem' to the Church. By facing the problems that dance stumbles over in the Church, some of the Church's cultural raiments are brought into sharp relief. I suggest that dance has the potential to subvert some of the cultural (mis)understandings that have handicapped our understanding of our own humanity and rendered our approach to the incarnation over-intellectualised and barren.

Dance as a Stumbling Block

According to many anthropologists, dance is a universal religious expression of the rhythms and cycles of nature, and of the human desire to be connected with (and to control) these life-forces. A study of Scripture, the Talmud and historical sources gives ample demonstration that sacred dance was a normal part of everyday Jewish life, not as an attempt to manipulate natural life-forces (as with Israel's neighbours) but as worship of Yahweh. Yet movement and dance seem to sit uncomfortably with much of the tradition of the Christian Church.

Stillness and materiality

The antipathy the early Church developed towards movement and dance would seem to be imported not from Scripture but from Greek notions about the human body. As Trevor Hart has shown in his introductory chapter, certain dualist currents in Greek philosophy deeply shaped some of the early Church's thought patterns. The problem with the body was its *materiality*. The human body was all too easily thought of as an exemplar of this transience and corruptibility, and hence deemed the 'enemy of the soul'. Some of these attitudes crept into aspects of Christian liturgy. The rules of rhetoric, expounded by Cicero, and taken up by some of the Church fathers, sought to demonstrate the superiority of the spirit over the material. The movements that the science of rhetoric prescribed focused on the face and the hand, sparingly used. 'The emphasis was on moderation – the ideal gesture reveals the dominance of spirit over matter . . . Gradually, from antiquity down to the Middle Ages, the ideal of godlike immobility was preferred by the élite to body movement, the spirit to the body. Immobility was understood as the gesture of the "spirit" as opposed to motions of the "body" '.[7] The idea of God as impassable, the unmoved mover (a notion arguably more Greek than biblical), is thus reflected in human stillness. An *absence* of movement became the signifier of the ideal, the spiritual. Care was taken not to disturb the carnal life through motions of the flesh. Novices, when sworn into their orders, could be made to renounce their distinctive body movements and to take on the prescribed, restrained movements of their religious community.[8]

Stillness as a marker of the spiritual combined gracefully with a preference for the 'ideal' over the material. Dance as a form of worship was largely forbidden by the early Church, not least because of its associations in Greek culture with arousing certain forms of sensuality, and with the mystery rites. Although dance in the Church has continued to appear at a grass-roots level at various points throughout the centuries, there have been repeated clamp-downs on dance in worship since the time of the

early Church fathers.[9] Not infrequently, bodies are commanded to be still, physicality dormant.

Centuries later, Descartes further developed this demotion of the body as the physical container of the mind. This has been deeply incorporated into much of western modernity. The philosopher Ryle describes the outlines of this broad theory of mind like this: 'The human being consists of two distinct, yet separate kinds of *thing*: the body and the soul, or mind. The body acts as a host or receptacle for the mind, or perhaps even as a prison from which liberation may be sought through spiritual advancement or death'.[10]

Although the container metaphor may be of some use for certain purposes (for example, trying to conceptualise the existence of the soul after death), for other purposes, it is a faulty cognitive tool. One of the fundamental errors here, it would seem, is to consider the mind (or soul) as different in *substance*[11] from the brain (and body). Applied to Christ, the container metaphor and the lower epistemological status of emotions can easily restrict our understanding of the union of Christ's divine and human natures. Further, Christ, the object of our approach, recedes from our human grasp as he is portrayed as less and less like us. As with the Jesus of Cecil B. de Mille productions, we see him eerily still, eyes rolled heavenwards, distant and remote. In the Church, attitudes to the body which treat it as essentially separate and inferior to the soul or mind have not only marginalised or expunged dance from the Church, they have obscured the truth that Christ assumed a full human body. These attitudes have impeded a full 'person' knowledge of Christ, the Son who has become incarnate for us.

Gender and the dread of embodiment

Notwithstanding intermittent bursts of dance in worship in the medieval period, for many Christians, abhorrence of the physical body remained a way of progressing religiously. To deny the body of food or sleep was often normative in monastic tradition. Religiously devout females in the Middle Ages could go to extreme lengths to starve themselves in their search for sanctity.

Undoubtedly, the preparation and provision of food was one area where women did exercise some authority; food was an arena in which women could 'act'.[12] But even seen in this light, hagiographies which regale the way women tried to prevent their bodily functions (such as eating, drinking, excreting, menstruating) echo a cultural aversion towards embodiment, which was all the more damning for women. Women were commonly identified with lower nature, and seen as responsible for bringing sin into the world (this owing much to Augustine's interpretation of the Genesis story and a mis-identification of original sin as sexual in nature[13]). Holy women had to work all the harder to eradicate the taint of embodiment.

Such prejudice against the body was not an inevitable product of Christianity, but more an 'accidental' result of Christianity's early inculturation, especially into high Greek culture. The concept of the human person in the Old Testament is presented as a complex mixture of physical, mental, emotional and intentional attributes. There appears to be no assumed hierarchy.[14] In the New Testament, apostolic writers do not appear to regard the human as comprised of a distinct soul and a distinct body. 'Soul' stood for the whole person; and 'flesh' likewise.[15] The word *soma*, or body, signified the complete person, usually also emphasising his or her corporeal nature. For example: 'Present your bodies as a living sacrifice' (Rom. 12:1) is an instruction concerning not only the physical, but our entire selves.

The message of the incarnation could have been read more emphatically as an affirmation of humans as embodied. Instead, when the virginity of Mary was emphasised as foundational, the incarnation could be interpreted as a denial of embodiment and human sexuality. Not only was dance forbidden, in some parts of Europe women had to cover their hand with a piece of linen to receive the bread of the eucharist, so defiling was human, and particularly female, embodiment.

As we have seen, the cultural dread of embodiment is intensified by the feminine. Femaleness has traditionally been associated with the non-rational, emotional, dependence and nature. The overriding assumption during the Enlightenment

period was that only males possessed the capacity to think rationally, and thus achieve a certain transcendence over their body. Women, by contrast, were considered more bound to nature, and thus to sin.

In our culture today, it is women, children, the elderly, blacks and the disabled who are accorded with a body as an intrinsic part of their person. And all these classes of persons have a body in a problematic sense: they cannot escape their body's impact.[16] The subtext is that bodies are *objects to be controlled*. Feminists have been quick to point out the logical progression of this standpoint. Women, as embodied, become objects: hence they can be used to serve the purposes of men (as objects of desire or procreation). Embodied blacks are also objects: their enslaved (or low-paid) labour is thus justified. Elderly, dead, or disabled bodies are objects reminding us of our mortality: they are to be kept hidden from sight. Such culture-wide practices take on a seamlessly 'natural' look.

Yet a few cracks remain. That the objectification of bodies is a social construction rather than a 'natural state' is evidenced in the sporadic nature of this construction. One only has to be rejected by a lover to know how much a sexual rejection of one's physical body is experienced as a rejection of one's core person. The arena of sexual love is the place par excellence where we can still experience our bodies *as ourselves*. Our bodies are the domain where our 'radical vulnerability', as men and women, to each other is played out. And this vulnerability to each other, some would argue, belongs to the core of our beings.[17] Our embodiment is fraught with risk; hence our desire to control bodies at all costs. Life would be so much simpler if bodies *were* objects; our vulnerability could be 'controlled'.

Christianity, clothed in the cultural raiment of various forms of dualism, has reinforced the denial of our gendered embodiment and its vulnerability. Dualism affects both men and women, but in different ways: for women it has meant being an inferior being, for men it has meant being cut off from themselves and others. In this context, dance as an avenue of Christian expression is either unthinkable, or, as a 'woman's thing', it is simply embar-

rassing. Western Christianity especially has inadvertently screened out whole swathes of human reality and offered us a preferred flavour of being a Christian: cerebral, disembodied, male, emotionally controlled, hierarchically ordered. Very often, we have portrayed Jesus in similar terms, and at the same time attenuate our capacity to relate to him: typically, we know him only *with our minds* and allow him to know only *our minds*.

Individualism

Another early effect of dualism was to over-emphasise the individual's sanctity. The private battle against the so-called 'fleshly' sins became a major preoccupation in Christendom, in stark contrast to the Old Testament prophets' stress on care for the poor and the oppressed, and for loving one's neighbour as oneself. This shift to individualistic piety may have been partly necessitated by the persecutions of the first centuries AD which forbade a public expression of the faith. The persecutions meant that Christians had to meet in secret, to remain incognito, and to be prepared to risk torture and death. They had to be prepared to count the body as nothing.

However, the emphasis on an individual, body-denying piety needs to be contrasted with Jesus' rather relaxed attitude to the physical side of life: 'The Son of man came eating and drinking, and they say, "Here is a friend of tax collectors and 'sinners' " ' (Matt. 11:19). Jesus was apparently not fastidious about these things, as long as they did not stand in the way of a person's commitment to the Kingdom of God. In fact, he reversed the understanding of bodily defilement: it is not what goes into the body, but what comes from the heart that makes a person 'unclean' (Matt. 15:17–20). Jesus' description of the Christian life was one in which relationship with others was intrinsic: 'Love one another as I have loved you' (John 15:12).

As we grow in person knowledge, it becomes harder to determine where one person begins and another ends. We possess a unique identity, based on the sum of our experiences, choices and personal memories. We also possess a social identity resulting from our past and present interactions with other

people, our evaluations of those persons and groups to whom
we belong, and more importantly, our evaluations of *their* evalu-
ations of us. This part of our identity is closely, perhaps
uncomfortably, connected to other people. We live in a vulner-
able, dynamic tension between these two poles of individual and
social identity. We are not hermetically sealed, psychologically or
socially. The interwovenness of social and individual aspects of
our identity is increasingly demonstrated in studies of social
psychology. Formation of identity, and even the activity of
thinking, is not the activity of separate individuals, but results
from our participation within a community of knowing, with its
shared values and meanings. Human identity remains a paradox:
we are both individual and social beings. Yet, if we continue to
think of the human person in terms of a container model (an
'object' body inhabited by soul/spirit), are we not also con-
strained to think of ourselves as inherently separate from each
other? In western modernity we customarily elevate individual
identity over shared, social identity.[18] In keeping with this, a view
of Christ has been encouraged which portrays him as essentially
an isolated individual – without reference to Father and Spirit,
or, indeed, other people. This individual Christ – also distant,
immobile, dispassionate and neutered – would appear to be best
known by equally isolated individuals – who sit in detached,
ungendered, disembodied stillness. No wonder we, as Christians,
so often feel ourselves to be incapacitated in our attempts to
affect social life.

Dance and Dualism

In the face of this cultural heritage, what can dance possibly
contribute to the life of the Church and, specifically, to our under-
standing of the incarnation? I make no claim that dance is an
automatic good in the life of the Church. Dance can be badly
done, the theology that informs it trite, the expression inappro-
priate to the shared meanings and values of the audience.[19] Given
the cultural background to our dread of embodiment, dance can
bellyflop more hideously than other well-meaning, but mediocre,

artistic contributions. Christian dance can be guilty of the very 'psychological docetism' that it should be subverting: dancers waving chiffon scarves, arms wafting about, eyes rolled heavenwards.[20]

Nevertheless, dance does have the potential to subvert the effects of dualism, both with regard to the *way* we approach the person of Christ, and with regard to Christ as the one we know. Dance can bring back *more of ourselves* with which to know Christ, and, in a sense, can bring back to us *more of Christ*.

More of ourselves

Dance is a carrier of our paradoxical nature: body/mind, male/female, individual/social. As an embodied art form, dancers' bodies are the very presence of the person, the conveyor of personhood, rather than the 'tomb' that hides the inner nature. Our abhorrence of the body and the divide between male and female, which maps so neatly onto the mind/body split, are also transformed when both men and women celebrate their embodiment in the presence of the Creator who sanctifies and redeems both. Dance reminds us of Christianity's joyful celebration of physical creation, and of the liberty of being God's children. In dance, bodies are not objects; they are subjects, in dynamic motion and in relationship. Dance can engage us as Christians into dynamic relationship with others and the persons of the Trinity.[21] In sum, dance can be a way of releasing us from some of the cultural assumptions incorporated into Christianity which limit how much of ourselves we are allowed to be.

More of Christ

Although it is easier to divorce ourselves from the messiness of embodied human life, its emotional anguish and physical pains, and to prefer a 'spiritualised' Christianity, in doing so, we lose sight of much of the human reality of Christ's earthly life. Through the nourishment of the physical and emotional aspects of our experience, we come to a deeper person knowledge of ourselves, and, amidst a degree of unknowing, of Christ, who shares our humanity even though he is not still physically present to us in

bodily form. Dance, although more concerned with emotional rather than propositional knowledge, enriches our propositional knowledge of Christ and makes manifest what is implicit within it.

Dance is about physical bodies in historical time and space. This is an emphasis which is especially distinctive of the Judaeo-Christian tradition. Why did the Gospel writers include the rather mundane details about what Jesus had for breakfast during his post-resurrection appearances, if not to underline that the risen Jesus was no ghost, but a flesh-and-bone embodied human being (albeit somehow unencumbered by the normal limitations of time and space)? Earlier in the Gospels we see Jesus using movement symbolically to convey truths too deep for words: touching the leper, receiving the 'wasteful' outpouring of costly perfume, breaking the bread and sharing the wine, laying himself down upon the cross. Indeed, without bodily movement, would his personhood have been grasped by the disciples? It took an even greater physical event to bring the message home: Jesus' death and resurrection. The shock of Jesus' shameful death, followed by his astonishing bodily resurrection, recapitulated that surprising theme that the disciples had begun to hear throughout their three years of walking with this itinerant Jewish rabbi: that the man Jesus is God in human, bodily form. Jesus used bodily movement in this world as a way of revealing his true person-hood, both before and after his crucifixion. Dance can bring all this back to us, reminding us that he himself lived an authentic human existence. This is the ground which we have in common; it is the place we meet him. More than this, we are reminded that this dynamic, physical humanity he assumed was taken permanently into the life of God as the pledge of our own future.

Dance of the Trinity

The incarnation is God's pre-eminent movement towards us, it is his best, most wildly extravagant gesture. Through this daring, reckless invitation we are called to take part in the life of the Trinity.

Dance can open up to us this participative aspect of the incarnation. The dance of God is a metaphor used in many world religions, including Christianity. Hippolytus' Easter hymn exclaims: 'O thou leader of the mystic round-dance! O thou leader of the spiritual marriage feast!' Here the Logos is described as 'the leader of the dance which moves the world. The eternal perichoresis of the Trinity might also be described as an eternal round danced by the Triune God, a dance out of which the rhythms of created beings who interpenetrate one another correspondingly rise like an echo'.[22] Echoing this, the famous Rublev icon of the Trinity (Plate 1) depicts the three messengers who came to Abraham to assure him of the promised seed. Even though the messengers are portrayed sitting down and supping together, the graceful rhythms of the three, their inclined heads and gesturing hands suggest a dance of relationship that passes from one to the other, on and on, first in one direction, then in another. As the eye follows the lines of the messengers' drapery, in their gaze, even in the way their feet are crossed, the ease of oneness is suggested; yet within this unity each figure is unique in identity.

Why would this blissful Trinity interrupt such a sublime dance to adopt the embodied human condition, a condition which we ourselves so often despise? What was it like for the Godhead to have the Son take on the fragile flesh of a foetus? What was it like for the Godhead to 'lose' the Son to the human condition, to suffering, humiliation and death? This abandonment to total degradation was not left behind when Jesus rose from death. Into the dance of the Trinity is subsumed the experience, the scars, the memory, the burden of Jesus' human experience. All of this was enfolded into the Trinity when Jesus returned to the Father. What profound adjustments, what steep 'learning curve' might we imagine taking place through this scandalous turnabout in the dance of the Trinity?

The dance of the Trinity is now opened to us; we are invited to participate. We are part of this dance. We can no longer treat ourselves, or others, as body-objects to be abused. Our very bodies are included in the Godhead through Jesus. And because

the human being is indivisible, our body, feelings, mind and spirit, are all incorporated into this dance of unity. The suffering we both bear and inflict has been adopted into the dance of the Trinity; now we can see even more clearly what our actions can cost. Like the Trinity, not an iota of our particularity or freedom is annihilated. We become more fully ourselves, we become free.

Dance as a Window to the Incarnation

Dance as window to the incarnation is possible, unless we under-estimate the humility of God. These sweating, groaning, hormone-driven bodies make an unlikely tabernacle for the divine. Yet God embraces the things we reject: our bodies, emotions, woundedness, mortality. We can glimpse Christ there, unless we are offended that God should choose to be limited by what we despise.

Yet, we have often been offended. Throughout Christian history, there is a recurring trend to lose hold of the dynamic tension the incarnation thrusts upon us, and to envision God in the easy terms of some form of dualism: God as separate, impassable, beyond our human sphere. The philosophic solution of dividing the universe into two discrete realms of the material and the ideal is a heuristic device to which we often resort, especially in the face of grave suffering and unanswered prayer. Such a solution can help us temporarily to 'survive'. The carnage of the wars of this century have fomented a watershed in our thinking about God. 'God is not here' proclaims the last century's history. Those who hang on to God have sometimes done so at the cost of losing sight of God's embodiment in Christ, because the paradox of the incarnation feels impossible to hold on to in the face of cruel facts. We need to believe that perfection exists *somewhere else*. We cannot bear that God may himself have been, and continue (in a different way) to be present in, and subject to, this senseless suffering. Both emotionally and intellectually, the dualist solution can at times seem attractive. Yet behind either extreme pole concerning the incarnation (Christ is all divine/ Christ is all human) can reside a powerful emotional preference

to distance ourselves from human suffering. We imagine that God prefers this as well.

The devout Roman Catholic composer Oliver Messiaen wrote his *Quatour pour la fin du Temps* ('Quartet for the End of Time') in 1940 when he was a prisoner of war in the Nazi camp of Görlitz in Silesia.[23] In direct contrast to these conditions of death, Messiaen's penultimate piece in the Quartet, 'Louange à l'Immortalité de Jésus' ('Praise to the Immortality of Jesus'), describes the immortality of Jesus in terms of musical stasis, suspension, an ever-ascending violin melody, which is impervious to the ravages of time. For Messiaen, the melody's progress to the highest register mirrors the ascent of Jesus' humanity towards God. Perfection does exist – it is 'other', it is beyond, it is untouched by this present world. It is ecstatic music, provoking the listener to move far away from the present into a timeless eternity.

As a choreographer, I have taken licence with this exquisite piece of music, and have constructed a dance to it which moves in the *opposite* direction, emotionally and philosophically. The dance is entitled 'The Deposition' (which refers to the taking of the body of Jesus down from the cross). It is danced by four dancers (male and female), three able-bodied and one disabled, a wheelchair user. These 'disciples' have the horrific task of taking down the mangled, unrecognisable Body of Christ from the instrument of execution (portrayed by an enormous torn, shredded cloth sculpture hung on a triptych[24]). Against the ever-ascending violin melody, the dancers' movements are earthbound in grief and revulsion.

The dance begins in semi-darkness. Side lighting creates strong shadows, evoking black and white photos of 1940s' concentration camps. The only moments of colour occur when the side triptych panels are moved forward or back creating a slight vertical opening on either side, through which painfully bright red light appears momentarily. Each of the dancers has a different movement dynamic: sustained slow motion, sharp abdominal contractions, or swift motion with sudden turns of the wheelchair. The dancers have the repellent task of taking down this mangled Body. Drawn like a magnet to the terrible cruciform,

its messy physicality, they are also repelled. There is a mutual alienation in this private horror. The wheelchair movements add choreographic possibilities, but the movements are all trapped by gravity, in contrast to the resolute ascent of the melody.

The second phase of the dance involves solving the problem of getting the Body down from the cross. After several attempts and failures, the task appears to be humanly impossible for the dancers. Only by working together and using the wheelchair and each other's human bodies as 'ladders' is it possible to get up high enough for the task. Footholes in the triptych enable the dancers to scale upwards, using hands or feet. The pinnacle of the musical ascent is matched by all four dancers, able-bodied and disabled, hanging upon the triptych. The dancers' own twisted, tortured shapes evoke the weirdly rhythmic photos of gassed corpses. There is stillness, and quiet.

As the music repeats, the dancers take the body down, the sagging lines and diagonals of the cloth sculpture evoking images of 'deposition' paintings. The dancers move together with rhythmic sighing, slowly moving down the triptych to reach the stage floor. Here there is an embracing of this tortured body. Living with this death is made bearable because of the compassion that emanates from the mangled body (evoked by draping parts of the cloth sculpture over the dancers). Near the end of the dance, as the music climaxes a second, final time, the fabric sculpture is unfurled, forming great enfolding wings which are flung upwards and then float downwards to embrace and cover the dancers completely. Colours of resurrection life flash momentarily as the body is unfurled, but the dancers do not yet 'see' this: the colours of the resurrection reside on the other side of the torn body. The dancers carefully wrap the body, and carry it out. One dancer returns to face the empty triptych. The lights fade out as the music, in the highest register, has the last word: 'Praise to the Immortality of Jesus'.

Why have I taken licence with this music, and created a movement narrative which appears only to subvert the music's intended message? I have done so because as Christians we live within the crossfire of cultural dualism and a Christian revelation

which tells us that God has become broken with us, and that we can be taken up into God's eternity because he has come to us where we are. At the end of the dance, with its hint of resurrection, we can celebrate with Messiaen – Jesus is immortal, his life could not be destroyed. But this was hammered out, not in a timeless sphere, but in the here and now which includes nothing less than the inertia of death.

FURTHER READING

Martin Blogg, *Healing in the Dance* (Eastbourne: Kingsway, 1988).

Sarah Coakley (ed.), *Religion and the Body* (Cambridge: Cambridge University Press, 1997).

Paula Cooey, *Religious Imagination and the Body* (New York: Oxford University Press, 1994).

John Gordon Davies, *Liturgical Dance* (London: SCM, 1984).

Elochukwu Uzukwu, *Worship as Body Language* (Collegeville, MN: The Liturgical Press, 1997).

Rowan Williams, 'The Body's Grace', in *Our Selves, Our Souls and Bodies*, ed. C. Hefling (Cambridge, Boston, MA: Cowley Press, 1996) pp. 58–68.

NOTES

1. This has obvious links with Michael Polanyi's account of 'personal knowledge' – although he is concerned with our knowledge not just of persons but of the non-human world as well. See Jeremy S. Begbie, *Voicing Creation's Praise* (Edinburgh: T & T Clark, 1991), pp. 201–2, for a concise discussion of Polanyi.

2. It is possible, and richer, to operate with both kinds of knowing: our minds have the capacity for the parallel processing of information in more than one mode.

3. How, and even if, these sensations are processed by the developing foetus is a matter of debate. There is some evidence, however, that, especially in the later months of pregnancy, sounds and movement provoke a response in the baby.

4. See Jean Piaget, *The Origin of Intelligence in Children* (New York: International University Press, 1932).

5. See Lev Semenovitch Vygotsky, *Thought and Language* (Cambridge, MA: MIT Press, 1962).

6. In this essay I am limiting myself to a subset of dance, 'dance as performance', that is, dance as a highly rehearsed, polished art form. (This is not to say that other forms of dance – communal dance, for example – cannot also be theologically powerful.) I further limit this chapter to a specifically Christian practice of dance, a subset I term 'dance-as-icon'. What distinguishes 'dance-as-icon' from 'dance as performance' is not merely religious content (many excellent 'secular' dance works are of a biblical or religious theme), but the intentions of the choreographer, the performers and the audience. Each comes

to the dance in the same prayerful manner in which one approaches an icon in the Orthodox tradition: with the hope of catching a 'glimpse of the divine'.

7. Elochukwu Uzukwu, *Worship as Body Language* (Collegeville, MN: The Liturgical Press, 1997), pp. 6–7.

8. ibid., p. 8.

9. See John Gordon Davies, *Liturgical Dance* (London: SCM Press, 1984) for an excellent discussion of the history of dance in worship.

10. As quoted in Paul Davies, *God and the New Physics* (London: Simon & Schuster, 1983), p. 79. My italics.

11. It is clear that the concept of 'substance' – which has a long history – is serving as a particular kind of metaphor. The prime function of metaphor is to provide a partial understanding of one kind of experience in terms of another. Trouble arises when we believe overmuch in our own metaphors, and credit them as providing one-to-one correspondence. See Janet Martin Soskice, *Metaphor and Religious Language* (Oxford: Clarendon Press, 1985).

12. See Caroline Bynum, *Holy Feast, Holy Fast* (Berkeley, CA: University of California Press, 1987), for an enlightening discussion of this phenomenon.

13. To the present day, there is widespread misunderstanding that fallen nature equates with physical sensuality. This contrasts with the biblical record which depicts fallen nature as something much more pervasive: humankind's desire to live out our human potential separately from God; to be *as* God, to be our *own* gods.

14. In the Old Testament, the word 'soul' appears frequently as *nephesh*, which is translated as *psyche* in Greek. There is no word for body, most likely because the writers did not consider the body as something distinctly separate from the soul. Soul could be used of a corpse (Lev. 21:11), while the Hebrew word for 'flesh' could be used as a synonym for the soul (Ps. 63:1). Indeed in Ps. 84:2 the flesh longs for the living God. There is no concept of the soul inhabiting a body like a vessel.

15. The word for 'flesh' – *sarx* – is used in at least three ways: to signify (a) the whole person (Gal. 2:16), (b) a physical connotation to human materiality (2 Cor. 4:11), and (c) a moral connotation to indicate lower nature (Gal. 5:13). 1 Thess. 5:23 seems to imply a trichotomos view (spirit/soul/body), but the language there is rhetorical to emphasise the totality of the human person.

16. Elaine Graham, *Transforming Practice: Pastoral Theology in an Age of Uncertainty* (London: Mowbray, 1996).

17. See Rowan Williams, 'The Body's Grace', in *Our Selves, Our Souls and Bodies*, ed. C. Hefling (Cambridge, Boston, MA: Cowley Press, 1996), pp. 58–68.

18. Perhaps, as with a quantum understanding of mind, individual identity is better understood as the *achievement* of the supporting structure of social identity *upon which it relies.*

19. One common anxiety about dance in a Christian context is that it might replace preaching, but this does not need to be so. Dance does not stand alone. Dance with a theological thrust is often strongest as part of a service where word and movement serve the same intent. Dance is not the final 'word', but serves the Word by going beyond words.

20. Psychological docetism denotes an emphasis on Christ's deity at the expense of his humanity. In the early days of the most recent wave of Christian dance (1960s–70s), it is likely that dancers adopted this emphasis and style of movement in order to 'fit in' and be accepted by a Church which, since its inception, had rejected dance. It is unfortunate that this style has often been 'cloned', at the cost of the authenticity that comes from original creativity. Despite these

pitfalls, many Christians today in various wings of the Church greatly value the contribution dance can make to worship.

21. Dance is most often performed collectively. A well-choreographed dance is an organic, collective unity; it is the sum of the dancers that creates something more than its parts. Dance portrays the person as an individual embedded within a network of relationship and can evoke the sheer joy and power of our human community.

22. Jürgen Moltmann, *God in Creation* (London: SCM, 1985), p. 307.

23. 'The first performance took place on January 15, 1941 in one of the stalags of the camp. Messiaen himself played the piano part on an instrument whose keys did not always repeat, while the cello used in the performance reportedly had only three strings. Thousands of French, Belgian and Polish prisoners sat listening to the work in the freezing cold.' Stephen Pruslin, Olivier Messiaen: *Quatour pour la fin du Temps*, CD cover (London: Lambourne Productions, 1994).

24. Set design is by Jane Hildreth, an artist residing in Richmond.

5

THROUGH ICONS:
Word and Image Together

JIM FOREST

The icon tradition, although very ancient, has attracted wide-spread interest in recent times, far beyond the Churches in which it emerged. Writing from within the Orthodox tradition, Jim Forest shows not only that Christ is the subject of numerous icons, but that the justification and importance of icon-painting are closely bound up with the incarnation: icons are an essential testimony to the truth that, in Jesus Christ, God became a human being, visible and accessible. Hence the importance, as the author's historical section shows, of tracing icon-painting back to Christ himself, and of the 'iconoclastic controversy' of the eighth and ninth centuries, which led to the affirmation that icons safeguard a proper doctrine of the incarnation.

Jim Forest goes on to demonstrate that icons can testify power-fully to the consequences of the incarnation, which extend far beyond the earthly life of Christ. The famous Rublev icon of the Trinity speaks of that which the incarnation makes possible – our transformation through sharing in the life of the Trinity, what the Orthodox call theosis *('divinisation'). Nativity icons also bear testimony to the transformation of the entire creation, another outworking of the incarnation. Moreover, icons not only witness to the transformation made possible by the incarnation, they themselves become means through which that transformation is experienced by the worshipper.*

There is no better way to understand iconography than to connect these two passages from the New Testament:

And the Word [*logos*] became flesh and lived among us . . . we have seen his glory. (John 1:14)

He is the image [*eikon*] of the invisible God, the firstborn of all creation. (Col. 1:15)

Christ the Word is also Christ the Image: Logos and Ikon. He who became incarnate became the visible image of the invisible. And today we meet him not only with our ears but also with our eyes.

Historical Roots

In recent decades, icons have come back to life in the western Church after a long exile, though one must add that in most parts of the eastern Church they survived only in a decayed form from the late sixteenth until well into the twentieth centuries. Yet icons are as old in Christianity as the Gospels. 'I have seen a great many portraits of the Saviour, and of Peter and Paul, which have been preserved up to our time,' Eusebius recorded in his *History of the Church*[1] early in the fourth century. Not only did he see 'portraits', but during a visit to Caesarea Philippi in Galilee he saw a centuries-old bronze statue of the Saviour outside the house of the woman whom Christ had cured of incessant bleeding. His witness is all the more compelling as Eusebius was one of those who regarded religious images as belonging more to the pagan world than to the Church.

According to legend, the first icon was made when King Abgar of Osroene, dying of leprosy, sent a message begging Jesus to visit him in Edessa and cure him. Hurrying toward Jerusalem and his crucifixion, Christ instead sent a healing gift. He pressed his face against a cloth, making the linen square bear his image. The miraculous icon remained in Edessa until the tenth century, when it was brought to Constantinople. After the city was sacked by the Crusaders in 1204, it disappeared altogether. Known as 'Not

Made by Human Hands' or the 'Holy Face', the icon has often been reproduced down to our own day. The original survives in countless copies with all their variations. In the western Church a similar story is linked with the name of Veronica, one of the women who comforted Jesus as he was bearing the cross. She offered him a cloth to wipe the blood and sweat from his face and afterward found the fabric bore a miraculous image. A building along the Via Dolorosa associated with Veronica is today home to a community of the Little Sisters of Jesus who, appropriately, support themselves by selling icon prints mounted on olive wood. The tradition reveals the theological principle that Christ himself, God incarnate and visible, is the basis of all icon-making.

The evangelist Luke, author of the third Gospel, is credited with painting three icons, one of them on the wood of the table where Christ's mother and St John had eaten their meals. One of the three is 'The Mother of God of Tenderness' in which the face of the child Jesus is pressing his face against his mother's. Another, the 'Hodigitria' ('She Who Shows the Way'), has a more formal arrangement, showing Mary presenting her Son to us. Finally, there is 'The Mother of God Orans' – Mary standing with outstretched arms and raised hands in prayer, a gesture that seems to say, 'Let it be with me according to your word'.[2] In time the Orans icon evolved into the icon of the Mother of God of the Sign. Within Mary, usually contained in a circle, her unborn child is revealed as Christ Immanuel, 'God With Us', vested in golden robes and looking outward while his right hand offers a blessing. It is an image often seen in Orthodox churches above the altar, a reminder that Mary, like the altar, is a bridge linking heaven and earth. The icon echoes the words of St Paul: 'it is no longer I who live, but it is Christ who lives in me.'[3] As one sees when standing before the famous Vladimir Mother of God in Moscow, a gift from the Patriarch of Constantinople to the newly baptised Russian church nearly a thousand years ago, ancient icons often bear layer upon layer of paint as later iconographers restored work that had become too dark or damaged with the passage of time. But perhaps at the foundation level of the Vladimir icon or

another ancient icon is pigment laid down by the hand of St Luke.

Nearly all ancient icons were destroyed either during times of persecution in the first three centuries of the Christian era or during the iconoclastic periods in the eighth and ninth centuries. Fortunately there are many Christian images from the age of martyrs which have survived, most notably in the Roman catacombs and similar places, from Asia Minor to Spain. These frescoes are simple and sober images, made with few brush strokes and a narrow range of colours, with such subjects as Christ carrying a lamb, the three young men praising God from within a furnace, the raising of Lazarus and the eucharistic meal. The catacombs bear witness that wherever Christians prayed, they sought to create a visual environment that reminded them of the Kingdom of God and helped them to pray. Early icons of a more developed style also survive in Rome, though they are chiefly mosaics and thus have a monumental aspect, a type of public Christian art that only became possible after the age of persecution ended. In one of Rome's earliest great churches, Santa Maria Maggiore, there are two long rows of mosaics dating from the fourth century, but, as they are high up on the walls, the visitor needs binoculars to see them in detail. The large and vivid fifth-century mosaic icons above and behind the altar, however, are easy to see and deeply moving.

The remarkable freshness of this very early Christian imagery has hit many modern viewers like a bolt of lightning – not least when they bear witness to the One who became incarnate. Among these was the writer and monk Thomas Merton who came to Rome in 1933, aged eighteen, and found himself yawning until he came upon the mosaics that predate the east-west division of the Church. 'I was fascinated by these Byzantine mosaics,' he records in his autobiography. 'I began to haunt the churches where they were to be found, and . . . all the other churches that were more or less of the same period . . . Without knowing anything about it, I became a pilgrim.'[4] The principal icons were windows through which he felt Christ's gaze. 'For the first time in my whole life I began to find out something of who this Person

was that men call Christ . . . It is the Christ of the Apocalypse, the Christ of the Martyrs, the Christ of the Fathers. It is the Christ of Saint John, and of Saint Paul . . . It is Christ God, Christ King.'[5]

Because of the storms of iconoclasm, it may be that no original icon from the apostolic age has survived. Even so, in generation after generation iconographers have sought to make faithful, though not slavish, copies of earlier icons, a process that continues to the present day. Thus images of Christ and the apostles are recognisable from century to century despite shifts in culture, style and aesthetic sensibility. We know, for example, that Peter had thick curly hair while Paul was bald. But most important, the memory of Christ's face is preserved, the face of God incarnate – the Word and the Image of God, Logos and Ikon.

Controversy

Just as there is still controversy about images in our own time, so were there disputes in the early Church, and to a large extent they were bound up with the theology of the incarnation. Early critics of icons included Tertullian, Clement of Alexandria, Minucius Felix and Lactancius. Eusebius was not alone in fearing that the art of the pagan world carried with it the spirit of that world, while others objected on the basis of Old Testament restrictions of imagery. Christianity was, after all, born in a world in which many artists were employed doing religious, political and secular work. Idolatry was a normal part of pagan religious life. Thus we find that in the early centuries, in the many areas of controversy among Christians, there was division on questions of religious art and its place in spiritual life.

It is especially instructive to notice that those who were reluctant to accept that Christ was God incarnate were often also opponents of icons. The most burning question at the heart of the early Church's many theological disputes was: Who is Jesus Christ? Some argued that Jesus was simply a man of such exemplary goodness that he was adopted by God as Son. Taking this idea further, others believed God so overwhelmed Jesus the Galilean that his manhood was gradually absorbed into divinity.

There were those who argued that Jesus merely appeared to be a person of human flesh but was in reality pure spirit; flesh being subject to passions, illness and decay, they argued that God could never inhabit flesh. The orthodox answer – that in the womb of Mary the second Person of the Holy Trinity became a human being, and that therefore Jesus was both true God and true man – was both too simple and too radical for many people. How could the all-powerful God clothe divinity in that which can sweat, suffer and die? Discussion of this issue and its implications constituted the centre point for the Church's Ecumenical Councils. Though we find the orthodox teaching already expressed in the creed of the first Council, in Nicea in 325, it took centuries for the Church to shake off the influence of heresies which, in a variety of ways, denied the incarnation. In fact, the ancient debate burns hot to this day.

Particularly significant is that each Church assembly which affirmed the icon was doing so primarily to assert that God had become fully human, accessible and visible to us. For example, the Quinisext Council in Trullo, in 692, while condemning 'deceitful paintings that corrupt the intelligence by exciting shameful pleasures,' recognised the icon as a mirror of grace and truth. 'In order to expose to the sight of all what is perfect,' the Council declared, 'even with the help of painting, we decide that henceforth Christ our God must be presented in his human form'.[6]

The argument over icons reached its boiling point in the eighth and ninth centuries in what is known as 'The Iconoclastic Controversy'. In the background was the rapid expansion of Islam in areas that had formerly been Christian. In 725 the Emperor Leo III, ignoring the opposition of both Patriarch Germanus of Constantinople and Pope Gregory II in Rome, ordered the removal and destruction of icons from churches and private homes. Leo may have hoped his order would help stop the spread of Islam, which was firmly opposed to images. Many iconographers from the Byzantine world fled to Italy, finding protection from the Pope. Many who upheld orthodox belief suffered loss of property, imprisonment, beatings and mutilation. Some lost their lives.

'Iconoclasts' – those who rejected the use of icons and sought their destruction – argued that images of Christ, representing as they did his physical appearance, diminished his divinity by revealing only his humanity. One beneficial consequence of the iconoclastic movement was that makers of icons searched for better ways to represent in paint the hidden, spiritual reality rather than merely the physical aspects of the person represented.

The theologian who most powerfully defended the use of icons in Christian life was St John of Damascus (676–749), a monk and poet kept safe from the power and edicts of the iconoclastic emperor through ironic circumstances: his monastery, Mar Saba, perched on a deep ravine in the desert south-east of Jerusalem, was in an area under Islamic rule. Here he wrote his essay 'On the Divine Images' in which he appealed directly to the incarnation, reasoning that

> If we made an image of the invisible God, we would certainly be in error . . . but we do not do anything of the kind; we do not err, in fact, if we make the image of God incarnate who appeared on earth in the flesh, who in his ineffable goodness, lived with men and assumed the nature, the volume, the form, and the colour of the flesh.[7]

St John also responded to the arguments of those who regarded Old Testament prohibitions of religious imagery as applying to the Church:

> Since the invisible One became visible by taking on flesh, you can fashion the image of him whom you saw. Since he who has neither body nor form nor quantity nor quality, who goes beyond all grandeur by the excellence of his nature, he, being of divine nature, took on the condition of a slave and reduced himself to quantity and quality by clothing himself in human features. Therefore, paint on wood and present for contemplation him who desired to become visible.[8]

The first iconoclastic period lasted until 780. Seven years later, at the Seventh Ecumenical Council, the bishops rose in defence of the icon. The Council affirmed that it is not the icon itself

which is venerated but the prototype whose image is represented
in the icon. A careful distinction is made between the image
and the person to whom it refers, without denying the powerful
connection between the two – a distinction not always appreci-
ated by those outside the Orthodox tradition who too easily
suspect idolatry.

> Just as the holy and vivifying cross, similarly the holy and
> precious icons painted with colours, made with little stones
> or with any other matter serving this purpose, should be
> placed in the holy churches of God, on vases and sacred
> vestments, on walls and boards, in houses and on roads,
> whether these are icons of our Lord God and Saviour, Jesus
> Christ, or of our spotless Sovereign Lady, the holy Mother of
> God, or of the holy angels and of holy and venerable men.
> For each time that we see their representation in an image,
> each time, while gazing upon them, we are made to
> remember the prototypes, we grow to love them more, and
> we are even more induced to worship them by kissing them
> and by witnessing our veneration, not the true adoration
> which, according to our faith, is proper only to the one divine
> nature, but in the same way as we venerate the image of the
> precious and vivifying cross, the holy Gospel and other
> sacred objects which we honour with incense and candles
> according to the pious custom of our forefathers. *For the
> honour rendered to the image goes to its prototype, and
> the person who venerates an icon venerates the person repre-
> sented on it.* Indeed, such is the teaching of our holy Fathers
> and the Tradition of the holy catholic Church which propa-
> gated the Gospel from one end of the earth to the other.[9]

None the less, a second iconoclastic period, less severe than the
first, was initiated by Emperor Leo V in 813. Resistance included
an impressive act of civil disobedience – an icon-bearing pro-
cession in Constantinople by a thousand monks. With the death
of the Emperor Theophilus in 842, imperial objections to icons
ended. In 843, Theodora, widow of the former Emperor, who
herself possessed icons, convened a Council which reaffirmed

the teaching of the Seven Ecumenical Councils and confirmed the place of the icon in Christian life. The first Sunday of Great Lent was set aside henceforth to celebrate what came to be known as the 'Triumph of Orthodoxy', a custom maintained to the present day in the Orthodox world when the faithful bring their home icons to the Church. One of the texts sung on the Sunday of Orthodoxy declares:

> The indefinable Word of the Father made himself definable, having taken flesh of thee, O Mother of God, and having refashioned the soiled image of man to its former estate, has suffused it with divine beauty. Confessing salvation, we show it forth in deed and word.

Rublev – Trinity and Incarnation

If in Byzantium the encounter with Islam initially had a devastating effect on icons, further north, in the thirteenth and fourteenth centuries, the Tartar invasion and occupation was to have a disruptive impact on every aspect of religious life among the Russian people, themselves latecomers to Christianity, their conversion having begun in Kiev at the end of the tenth century. Little iconography of the first few centuries of Christian culture in Russia survives. But from the late fourteenth to the mid-sixteenth centuries, iconography was to reach heights in Russia that many regard as unparalleled before or since.

Russia's most renowned iconographer is St Andrei Rublev, first noted in 1405 while working in a cathedral of the Moscow Kremlin as a student of the master iconographer Theophan the Greek. (In 1988, when the Russian Orthodox Church was celebrating its millennium, he was added to the calendar of the saints.) In 1425 St Andrei painted the Holy Trinity icon, widely regarded as the highest achievement in iconographic art (Plate 1). The icon expresses in silence aspects of the nature of God beyond the reach of words. The biblical foundation of the image is the story of Abraham and Sarah's hospitality to strangers by the oaks of Mamre near Hebron. Three nameless visitors who

appeared in front of their tent were provided with food and drink, then promised the aged couple that barren Sarah would soon bear a son.[10] Finally Abraham and Sarah understood their guests were messengers of God: angels. The three acted in perfect unity and spoke with one voice. In this the early Christian community recognised a revelation of the Holy Trinity: a communion of three Persons as One God. Painted for the iconostasis of the principal church of the Holy Trinity Monastery north of Moscow, the icon mirrors the teaching of the monastery's founder, St Sergius of Radonezh: 'Contemplation of the Holy Trinity destroys all discord'.

The icon's principal colours are gold and hues of gold. Azure blue is used in the garments of the three figures with many touches in their robes of a wash of lapis lazuli. The hardly visible staff each figure holds is a thin line of vermilion. There is a small area of deep green in the tree and a wash of delicate mossy green in the figure to the right. Apart from the colour of clothing, the three figures – all shown in the typical form of archangels – are identical. Each head is submissively inclined toward one of the others; none of the three assumes an imperial attitude. There is an atmosphere of love, freedom, rest and the most intimate communion. The sense of oneness is achieved primarily through the gentle, attentive engagement of the three with each other, the joining of eyes.

The structure of the icon contributes as well. Most important is the circle, symbol of perfection and eternity, created by the three figures; within the circle there is a sense of a slow counter-clockwise movement. There is also a triangle, the peak of which is the head of the central figure. Due to inverted perspective, the icon has no vanishing point. The three figures are not part of a disappearing plane but rather seem to move ever closer to the person viewing the icon. The effect of inverse perspective attracts us, drawing us toward the table and thus toward eucharistic life.

This icon has enjoyed enormous popularity far beyond Ortho-doxy as a symbolic representation of the Trinity and as an invitation to share in the divine life. At the same time, it serves to deepen our understanding of the incarnation by portraying

what the incarnation of the Son makes possible. It includes many reminders that we can participate in the life of God only because God has first engaged with us, supremely by becoming incarnate. There are the three symbols at the top of the icon. At the centre is a tree. What was the oak of Mamre becomes the Tree of Life planted by God in Paradise; beneath its branches Adam and Eve fell, but from it the life-giving cross was made. As a tree is linked with our downfall in the Garden of Eden, it is also linked with our salvation through Christ. The building without a door – the Church – is open to all who seek sacramental life, in which we hear Christ through his word and receive him in the eucharist. Over the Holy Spirit (the right-hand figure) there is a mountain – at once Mount Sinai and Mount Tabor – places where people have witnessed the glory of God, Mount Tabor often being associated with the transfiguration of Christ. Between the three figures is an altar on which stands a gold chalice containing, in miniature, a blood-red lamb's body symbolising the sacrificial death of the Lamb of God. And the colours of the clothing of the Son (the central figure) is most substantial – deep red, dark blue, and a band of gold – an indication of the incarnation.

There is a sense of silent conversation among the three figures. The biblical text most often linked with their exchange comes from the Gospel of John, expounding the purposes of the incarnation: 'God so loved the world that he gave his only Son, so that everyone who believes in him may not perish but may have eternal life. Indeed, God did not send the Son into the world to condemn the world, but in order that the world might be saved through him' (John 3:16–17).

The Word Made Flesh

The incarnation has consequences not only for humanity, but also for the whole creation, consequences vividly revealed in icons of the nativity. In the Feast of the Nativity of Christ, the Orthodox Church celebrates both the incarnation of the eternal Word, the Son of God, and the fact that the ultimate purpose of the incarnation was nothing less than the transfiguration of the

whole created order. A prayer of the Christmas Vespers Service speaks of the whole creation joining in an act of gratitude and welcome to God incarnate:

> What shall we offer you, O Christ, who for our sake has appeared on earth as man? Every creature made by you offers you thanks. The angels offer you a hymn; the heavens a star; the Magi, gifts; the shepherds, their wonder; the earth, its cave; the wilderness, the manger; and we offer you a virgin mother.[11]

This rich liturgical material is reflected in a fifteenth-century icon of the nativity from the Novgorod school (Plate 2). Around the newly-born divine child in the centre, representatives of the whole created world give thanks in their own way. Even animal creation joins in recognising the incarnation of the Son of God: the ox and the ass gaze down on the incarnate Lord, fulfilling Isaiah's prophecy: 'The ox knows its owner, and the donkey its master's crib' (Isa. 1:3).

There is no charming Bethlehem bathed in the light of the nativity star but only a rugged mountain with a few plants: a hard, unwelcoming world in which survival is a real battle, the world since our expulsion from Paradise, the world in need of transformation. In contrast to the homely nativity stable that would become familiar in nativity images in the West after the era of St Francis, eastern icons depict Christ's birth in a dark, rocky cave, though what happened in the cave is placed before the cave's entrance. The rigorous black of the cave of Christ's birth in the icon's centre represents all human disbelief, all fear, all hopelessness. In the midst of a starless night in the cave of our despair, Christ, 'the Sun of Truth', enters history having been clothed in flesh in Mary's body: 'The light shines in the darkness' (John 1:5) dispersing the darkness of the shadow of death over the world. We see that the Christ-child's body is wrapped 'in swaddling clothes'. In icons of Christ's burial, we will see he is wearing similar bands of cloth, as does Lazarus in icons of his raising by Christ. In the nativity icon, the manger resembles a coffin. In this way the icon links his birth and death.

The most prominent figure in the icon is Mary. Orthodox Christians call her the *Theotokos*: 'God-bearer' or 'Mother of God'. As Eve is the 'mother of all who live' (Gen. 3:20), so Mary is the mother of the new humanity restored and transformed through the incarnation of the Son. Placed against a red mattress – the colour of life, the colour of blood – Mary is the supreme thanksgiving to God, humanity's finest offering to its Creator. 'By this offering in the person of the Mother of God,' Leonid Ouspensky writes, 'fallen [humankind] gives assent to its salvation through the incarnation of God.'[12] The Virgin's posture is significant. In some nativity icons, she is half-sitting, signifying her virginity and the divine origin of Jesus, refuting the idea that the humanity of Christ was not entirely God's initiative. More commonly, she is lying down, exhausted after childbirth, which is intended to remind the worshipper of her full humanity. In the icon, hers is not a joyful face. She lives with the mystery of a child with no human father and also the mystery of his future: a ruler, yes, but it is clear from the circumstances of his birth that his way of ruling is in absolute contrast to the way kings rule. The ruler of all rules in meekness from a manger in a cave. His death on the cross is implied in his birth.

Angels are an essential part of the nativity icon, bringing good news to the shepherds while praising and glorifying God. In our Novgorod version, two of them look upward while one looks downward. A shepherd plays a pipe, adding the human art of music to the angels' choir. The wise men on the other side make their way toward Bethlehem with gifts, following the star which shows them the way. The star is not simply an astronomical object but a heavenly sign communicating news of the heavenly One born on earth. A ray extends downward from a sphere at the centre of the upper edge of the icon, an indication of the heavenly world penetrating the ordinary. The shepherds represent the Jews, the Magi the Gentiles. Not the wise men but the shepherds were permitted to hear the choir of angels singing God's praise. The wise men are portrayed as of different ages – revelation is granted independently of people's experience.

Below the Virgin, midwives wash the child, a detail based on

apocryphal texts concerning Joseph's arrangements for the birth. They also are a reminder of the midwives who saved the life of the newborn Moses, who under the law of Pharaoh should have been murdered at birth. The midwives' presence also underscores the humanity of the incarnate Son, refuting the heresy that Christ only *appeared* to be human.

We find Joseph crouching in the lower left-hand corner. The old and bent figure standing before him represents Satan come to fill Joseph's mind with doubt. This links with liturgical texts which speak of Joseph's troubled state of mind. He cannot quite believe what he has experienced. Joseph has witnessed that birth, has had his dreams, has heard angelic voices, has been reassured that the child born of Mary is none other than the Awaited One, the Anointed, God's Son. Still, belief comes hard. He cannot comprehend this event which transcends the expected order of the world. 'In the person of Joseph the icon discloses not only his personal drama, but the drama of all [humankind] – the difficulty of accepting that which is "beyond words or reason" – the incarnation of God.'[13] But our eyes travel back to the Virgin, turned towards Joseph, a symbol of compassion for those beset by doubts and struggles of belief.

The angels, the heavens with a star, the mountain and cave, the Magi, shepherds, ox and ass, Mary, Joseph – the icon gathers them all into a stupendous vision of the meaning and implications of the incarnation.

Silent Icons in a Noisy Time

For Orthodox Christians and many others, icons not only witness to the process of transformation made possible by the incarnation, but provide a means through which this process is effected in and experienced by the worshipper. It is one of the more encouraging signs of the times that they have been making such a comeback in Christian life, and even become objects of fascination for many people resistant to Christianity or any form of 'organised religion'. Perhaps in this age of words and noises,

icons in their silence can help us find our way to the Holy Trinity through the incarnate Son.

FURTHER READING

Jim Forest, *Praying With Icons* (Bath: Alban Books; Maryknoll, NY: Orbis, 1997).

Simon Jenkins, *Windows into Heaven* (Oxford: Lion, 1998).

Henri Nouwen, *Behold the Beauty of the Lord* (Notre Dame, IN: Ave Maria Press, 1987).

Conrad Onasch and Anne Marie Schnieper, *Icons: The Fascination and the Reality* (New York: Riverside, 1997).

Leonid Ouspensky, *Theology of the Icon* (Crestwood, NY: Saint Vladimir's Seminary Press, 1992).

Leonid Ouspensky and Vladimir Lossky, *The Meaning of Icons* (Crestwood, NY: Saint Vladimir's Seminary Press, 1982).

Michel Quenot, *The Icon: Window on the Kingdom* (Crestwood, NY: Saint Vladimir's Seminary Press, 1991).

St John of Damascus, *On the Divine Images* (Crestwood, NY: Saint Vladimir's Seminary Press, 1980).

NOTES

1. Eusebius, *The History of the Church*, chapter 7, section 18.
2. Luke 1:38.
3. Gal. 2:20.
4. Thomas Merton, *The Seven Storey Mountain* (New York: Harcourt, Brace, 1948), p. 108.
5. ibid., p. 109.
6. Leonid Ouspensky, *Theology of the Icon*, vol. 1 (Crestwood, NY: St Vladimir's Seminary Press, 1978), pp. 91–9.
7. St John of Damascus, *On the Divine Images* (Crestwood, NY: Saint Vladimir's Seminary Press, 1980).
8. ibid.
9. Ouspensky, *Theology of the Icon*, vol. 1, pp. 134f. My italics.
10. Gen. 18.
11. *The Festal Menaion*, tr. Mother Mary and Archimandrite Kallistos Ware (London: Faber & Faber, 1969), p. 252.
12. Leonid Ouspensky and Vladimir Lossky, *The Meaning of Icons* (Crestwood, NY: Saint Vladimir's Seminary Press, 1994), p. 159.
13. ibid., p. 160.

CHAPTER

6

THROUGH SCULPTURE:
What's the Matter with Matter?

LYNN ALDRICH

Lynn Aldrich is a sculptor living and working in Los Angeles. In this chapter she invites the reader to 'think the incarnation' through this very specific engagement with the materials of stone, metal, or whatever. Making sculpture involves a costly but respectful struggle with physical matter, in which one is made acutely aware of its materiality and our own, while at the same time, in and through this materiality, being granted an awareness of what is 'more than' material. To cite words from Trevor Hart's introduction, 'in the epiphanies which art grants us through its transfigurations of the commonplace, we know more than is presented to us at the level of the physical or historical'. Without assuming that this 'more than' can simply be equated with God, the author takes us on a journey through some pieces of contemporary sculpture (including her own), and allows them, 'in a culture entranced with immateriality', to make their own kind of allusions to the incarnation. We are granted fresh knowledge of that supreme engagement of God with matter, in which temporal, physical material was taken up, renewed and transformed.

I cannot go for more than a month without getting out of the studio, away from my own art, to look at the work of the best of my peers. So on a sunny afternoon

when most Southern Californians are headed for the beach, I am walking into a Los Angeles gallery, thinking about the usual subjects – love (some call it sex), death, rock and roll, and (my personal bias) God.

When what to my wondering eyes should appear but the latest in an entire genre of religious pictures named 'Ecce Homo' in western art history? These works were developed around the depiction of Christ, wearing a crown of thorns, presented to his accusers by Pontius Pilate. This is hardly a fashionable theme, and yet: 'Behold the Man!' – this ancient exclamation flashes across my interior 'screen' when I enter the last room of the contemporary exhibition and am brought up short by a couch crowded with Jesus ragdolls (Plate 3). It is actually a soft blue, moiré-covered love seat centred on an elegant, floral-patterned area rug. Five large ragdolls are sitting or sprawling on the sofa; one headless doll (is it incomplete or mutilated?) lies on the rug. They wear traditional robes that look homespun and tiny, brown leather sandals on their delicate, wax-modelled feet. Each Jesus has a waxy face with a distinct expression, ranging from peaceful and saintly to a Charles Manson-like madness. One doll is black with a curly Afro hair-do; another is a blue-eyed, baby-faced blond. All are strangely compelling, but evidence of a struggle is everywhere, from ripped open rag bodies with stuffing spilling out to open cans of Kiwi brown leather shoe polish with smeary rags on the floor. The title of Kim Dingle's work is 'My Struggles with Jesus'.

And that is exactly what I must welcome into contemporary culture – the tension of the struggle to ask the ultimate questions again – such as 'who is God?' and 'who, for God's sake (as this sculpture so specifically asks) is Jesus?' Here we inadvertently arrive at the doctrine of the incarnation, a label I consider trustworthy – 'the historical Jesus was and is fully God and fully man', or something like that – yet primly tidy and almost clinical in its attempt to describe divine mystery indwelling matter. Dingle's sculpture, not unlike a television talk-show host, asks of Jesus: 'were you white, black, or brown?' (Incarnation is specific, concrete and very human.) 'Were you holy, cool, or crazed?'

(Incarnation is monumentally extraordinary and unreasonable.) 'Were you rich or poor? Powerful or broken? Or both?' (Incarnation is extravagant and paradoxical.) Since I believe that Christians ought to be more at home with complexity instead of less, my goal here is not to give answers so much as to circle around and hint at revelations that *enhance* rather than define the incarnation. Also, to contemplate incarnation while making or looking at contemporary sculpture might give us insights into other aspects of our understanding of God or of the conditions of our reality. We will certainly be made more aware of ourselves and our environments as material, with the attendant astonishment that God would take on this physicality. By so doing, he affirms the physical realm (including our bodies) to be of intrinsic worth and value to him, and therefore, to be so valued by us. He declares himself to be at home in the universe. And, ultimately, so are we. Let us roll the stone away from the entrance (a sculptural endeavour) to a deeper, more complex knowing of the incarnation.

In general, western intellectuals of the modern era have described our human condition as being a sophisticated alienation from the cosmos, from each other, and from ourselves. We think of this as a current experience, our much-discussed fragmentation into a worldview mosaic of lightly-held, momentary 'truths'. How odd to recall Pilate's two-thousand-year-old question to Jesus, who has just laid claim to his extravagant authenticity – 'I came into the world to testify to the truth' (John 18:37). 'What is truth?' replies the jaded, practical-minded Roman governor, and then immediately changes the subject. Refreshingly, this dialectic or dialogue has again opened up for me on a chance meeting with Dingle's tableau of Jesus ragdolls. The struggle to know the truth of Jesus is personal and gutsy; it is also universal and daunting. It is a struggle with reality and with appearances, with illusions and with delusions. It might make you mad (as in angry or crazy). As I gaze at the multiple faces of Jesus, I finally end up contemplating the sweetness of grace. Whatever else the incarnation is, it must be considered a great

gift, a Person extended to individual, peculiar persons in a form they recognise as almost familiar.

In a Body like Ours

So it seems that sculpture is capable of delivering to the viewer a way of knowing that is unique to itself. It is worth sketching some of the more important features of this way of knowing. Sculpture is a thoroughly physical business. It involves the physical matter of our bodies interacting with the matter of our cosmos. Yet, as Christians, we seem to have a more complicated relationship to the body than do many of our contemporaries. Perhaps that is because, in the very beginning of our history, governmental agencies and ordinary citizens alike were combing Jerusalem, looking for a body that was never found. Perhaps it is because Christians inherited the ancient Hebrews' view that God considers his creation 'good' and validates the human form as bearing his image. Some of the confusion must be caused by a call to sexual purity in a culture obsessed with sexual expression as a means to define individual 'freedom'. And then, while most religions and self-constructed opinions offer a safely vague and mystical idea of what happens to a person after death (with most longing to escape finally what they see as the encumbrance of physicality), Christians make the bizarre claim that one enters eternity in a body – altered, to be sure, yet fully present. The reason this claim is possible is first because of the incarnation, which demonstrated that ordinary flesh (redeemed in the fullness of all that Christ accomplished) could take on such other-world-liness.

Certainly a more intellectually tasteful and politically correct solution would be finally to rid ourselves of these diverse clumps of organic matter in a nirvana of cosmic fluffiness. Especially in our new era of virtual reality, we sense the embarrassing slowness of the body, its clumsiness and tendency toward inefficiency, quirkiness and decay. It is in the context of experiencing our lives within these less than perfect bodies that the most outrageous of Christian affirmations is flaunted. Incarnation declares God,

in the person of Jesus Christ, to be, simultaneously, the most
mysteriously other and the most down-to-earth of human beings.
And, it is that 'down-to-earthness' that bestows dignity to and
declares delight not just in the body but in all the matter of the
cosmos, continuing God's affirmation of the goodness of what he
has made. Our physical realm has an eternal worthiness
(somehow, it too will be redeemed) beyond its already spectacular
cellular, atomic and subatomic construction. This is the antithesis
of our culture's predominant view that stuff is just stuff: 'It's a
material world,' sings a currently popular Madonna.

Of course, whether she knows it or not, Madonna's pop lyrics
are a contemporary hymn to the joys of nihilism – if that's all
there is to life (material existence), then let's just shop, use up,
and consume. The philosopher's heady discourse filters down to
street level and soon we're not just giddily acquiring more objects,
but we are objects and treat each other as such. This is where
the biblical worldview introduces a stunning dialectic – if one
slows down long enough to contemplate the nature and beauty
of the material world, its structures and eccentricity are revel-
atory of an underlying 'text'. We 'read' the testimony of matter
which offers up a natural revelation – nature itself pointing to
the existence of an intelligent, personal God with plans for what
he has designed. The cosmos bears traces of the creator's attri-
butes – as a good sculpture will give clues to the personality,
mind and spirit of the artist who made it and will disclose an
interpretive meaning that is more than the sum of its parts.

Thus, the actual presence of real stuff in real space in real time
is laden with a given significance, derived from outside itself. It
testifies to an extravagant 'purposefulness' beyond its particular
limitations. Also, we experience an entropic universe in mortal
bodies, but most of us sense that there is more to know than
what we see. This is a feature of human knowing often addressed
in the arts, where the object or performance one observes points
to or hints at a reality bigger than or beyond itself. Trevor Hart
has already spoken about this in his chapter.[1] What is traditionally
called sculpture frequently seems to do just this. And among all
the arts, it seems especially capable of giving viewers a pro-

foundly visceral awareness of their own physical presence while making meaning inside their heads, feeling one's invisible spirit moved by the experience of the concrete art form. Sculpture is composed of volumetric material; its very presence speaks of the subjection of matter to the laws of the physical universe. To view a sculpture, one walks back and forth and around and sometimes through or upon a three-dimensional object in three-dimensional space. The body of the viewer senses its own three-dimensionality and the fourth dimension of movement through time. All the while, one is involved in a complex, hidden activity of thinking and feeling, of describing and interpreting what is being seen. Knowledge happens. And the activity that produced this knowledge gives the viewer a more acute awareness of his reality – *simultaneously* being a spirit (or soul) and a body. By inference, the viewer can begin to acquire a better knowing of the mystery of incarnation – God assuming and redeeming physical matter, Christ in a body like ours.

In what follows, I will present a quirky 'history' of sculpture (touching on some cultural milieus 'through the ages') and describe some of the attributes of sculpture as a medium. Along the way, we will be musing over the implications of the incarnation, with a growing awareness of the philosophical difficulties our present culture has with 'imagining' this engagement with our world. This will set the stage for thinking about some of the sculpture that is being made today, mirroring back to us the confusion and inconsistencies of our zeitgeist whose influences we cannot escape.

In the Beginning There Was Sculpture

Sculpture, of all objects and things that human beings deem necessary to make their lives more livable, belongs for several reasons in a rare and extraordinary class of its own. Rare, because even just looked at quantitatively, very few kilograms of sculpture are made on an average day, while many billions of tons of materials are made into other more useful things. Extraordinary, because although sculpture remains

for the greater part useless, unlike designed objects, it is an attempt to make dumb material express human thoughts and emotions. It is the attempt not just to project intelligence into material but also to use material to think with. Sculptures are often and at their best not just the result of an artist taking a material, for example a piece of stone or a lump of clay, out of its normal environment and forcing it into a form which expresses a preformulated notion, but rather a result of the dialogue between the material and the artist. The material finds itself in a new form and the sculptor finds himself with new content and new meaning.

Joachim Peter Kastner, 'The Articulated Column'[2]

. . . then the LORD God formed the man from the dust of the ground, and breathed into his nostrils the breath of life.

(Gen. 2:7)

That God would even bother to create the universe in the first place is a hint of the coming incarnation. He makes 'good' stuff, and he likes what he has made. The ancient text uses earthy, anthropomorphic terminology to describe God in his making process – though his creation is uniquely 'out of nothing'. We earthlings catch a glimpse of the magnitude of what is happening because of this simple, direct 'human talk'. And human beings are an art-making species – any artist in the studio, rigorously engaged with her craft, can understand a bit of the exaltation God expresses in Genesis over the work of his hands, even though the sculptor's creating is never 'out of nothing'. Especially a sculptor, who forms, shapes or builds a thing where there wasn't a thing before, a volume of matter, taking up space, constructed for a place and time in the world.

In addition to all the thinking going on, it is often hard, physical labour to make a sculpture. The artist bends, lifts, carries, drags and pushes material around, digs at it with tools or instruments, walks around it again and again to see it from different perspectives, trying to break its resistance to change. The very inertia of matter is just another embarrassing reminder to the sculptor

of his own physical limits. Material can seem to have a 'will' of its own, stubbornly refusing transformation to the envisioned form. This brings to mind Jeremiah's image of the potter and the clay (Jer. 18), a wonderfully sculptural scenario. Through a process of changing plans, testing, struggle and dialogue between potter and lumpy, earthy material (his chosen, yet recalcitrant people), the 'spoiled' vessel is remade in God's hands. A kind of wrestling with physicality also occurs within the 'dialogue' of the incarnation event, the Son on earth speaking with the heavenly Father. Recall the struggle at Gethsemane where immense effort is applied, before the man who is Jesus and the eternal Son who is Jesus submit lovingly and willingly to the next step – crucifixion. The potter's wheel turns and turns, through wrenching, painful, costly circles, before the completed form rises – Christ, in a body, but somehow awesomely transformed for eternity. The re-creation of our distorted humanity into its God-imagined perfection is thus made possible.

The sculptor must also admit that sometimes a sculpture 'fails'. Perhaps it fails grandly as a result of the artist's miscalculated risk or perhaps it dies a thousand small deaths, not meeting expectations. Sculpture will often be extremely burdensome or expensive or just impossible to alter once the artist recognises a change he wishes to make, so it may finally be shoved to a corner of the studio. This is most often the result of 'going against the grain' of a material, attempting to force a concept that destroys its physical 'integrity'. Or the artist loses sight of what material is appropriate for a particular idea so that the finished work somehow loses its authenticity. Sculptors learn to respect the inherent attributes and conditions of what they have to work with, seeing these not so much as limitations but as the perimeters of a space wherein the best work can be made. It is revelatory to note here that 'the incarnation did not do violence to the structures and goodness of physical matter. Matter is respected; Jesus is still utterly human. The Son of God assumes our humanity but does not violate it or obliterate it.'[3]

If the sculptor 'gives up' on completing a particular piece, there

is still reason to hope that something was learned in the process. Some qualities of the discarded sculpture may be preserved in the next attempt, or perhaps the artist knows it is time to move past earlier ideas that no longer seem pertinent and enter a new phase of his labour. Surely, artists and designers will have no difficulty imagining, in an anthropomorphic dream, God creating the dinosaurs, enjoying them for a few hundred, million years, and then setting them aside to flesh out other compelling visions. And, since art is also about a kind of unexpected pleasure, imagine God planning that one day, we humans would enjoy discovering dinosaurs, digging them up, and displaying their skeletons in our museums. We walk in wonder among these sublime sculptures.

The concept of 'the sublime' in aesthetic philosophy might be described as the overwhelming presence of beauty, tinged with terror, in nature's sweeping vistas or in large-scale works of art. The viewer is reminded of her human frailty, the insignificance of her life-span in the vastness of space and the antiquity of time. Yet there is exaltation. We can sense a similar experience in biblical descriptions of the Israelites as they followed Yahweh across the empty desert, erecting piles of stones to mark where he spoke or to commemorate great events of his deliverance. This impulse to make sculpture when in awe of the transcendent was shared by most ancient peoples, though usually the carved or stacked stone was formed into idols, altars, or grave markers. Rather than making God into a thing, the Jews uniquely insisted that sculpture could refer to him or remind us of our need of him while still remaining a mound of material. Understanding God to be wholly spirit yet capable of and desiring relationship with human beings in bodies of flesh, in a world of matter, is one of their foundational contributions to western culture with far-reaching ramifications. This can perhaps also be understood as a foreshadowing of the coming of the Messiah, the incarnation.[4]

Through the centuries, sculpture has continued to serve the role of marker, memorial and monument. As an art form, it has had a tendency toward monumentality – in content

(commemorating the reign of a king), in material (heavy blocks of stone, carved marble, metal), and in scale (bigger is better). This lends sculpture an air of awesome immobility or permanence, which is appropriate if the particular art-piece requires and deserves to make such an impression. But around the middle of the nineteenth century, western art shifts into the period some call modernism, attempting to reflect the ideas and conditions of a rapidly changing culture. Scientific innovation, industrialisation and urbanisation generate sweeping alterations in social life and political expectations.[5] An immovable, obdurate art form like sculpture, much of it in public spaces, appears to commemorate people and events that no longer seem pertinent, much less heroic. Now, a distaste for 'false' illusions in both thought and practice generates the quest for more down-to-earth realities in art and literature. This secularisation will eventually lead to the modern claims of autonomy in art and in life, a lack of need or reference to anything outside of oneself. What you see is what you get. The sub-text of this shift exhorts our culture to forget sentimental, romantic notions that God is alive and at work in the cosmos.

Relativity, Pluralism, Distopia and You

Remember Tomorrow

Starting point for search:
It no longer avails to start with creatures and prove God.
Yet it is impossible to rule God out.

The only possible starting point: the strange
fact of one's own invincible apathy – that if
the proofs were proved and God presented
himself, nothing would be changed. Here is
the strangest fact of all.

Abraham saw signs of God and believed. Now
the only sign is that all the signs in the world

make no difference. Is this God's ironic revenge?
But I am on to him.

> Walker Percy, 'The Moviegoer'[6]

Nothing is new; neither is anything old.

> Robert Smithson, 'Ultramoderne'[7]

We might have to learn to balance the network idealist's
enthusiasm for computerised life with the need to ground
ourselves more deeply in the felt earth that the realist affirms
to be our primary reality.

> Michael Heim, 'The Cyberspace Dialectic'[8]

For a while, modernity, implying an idealistic progress in society,
and modernism, purporting an ideal inherent in the self-referen-
tial, material presence of the art work, reigned supreme. However,
the ground quakes again, and the utopian vision is challenged.
Robert Smithson, a conceptual, earth-art sculptor working in the
late 1960s, reviving allegory and messy, multi-faceted references
in his work, is one harbinger of the changes in thinking and
making that we are now experiencing. For want of a better term,
we often describe our contemporary time as being postmodern.
Reality fragments into multiple appearances; language free-floats
in a sea of relativity. The age-old dialectic between order and
chance swings from clarity and rationality to the pleasurable
play of multiple subjectivities. 'Signs', once designated as truth-
bearing indicators, are disengaged from their referents, and the
accumulation of knowledge over time is challenged by ephemeral
webs of computer hypertext. The cyborg-futurist optimistically
promotes digital culture, 'software cities' and 'virtual communi-
ties'. Though the technology is faster and ever more refined,
present-day 'network idealism' seems a lot like modernist opti-
mism in response to nineteenth-century industrialisation. The
slower, deeper knowledge acquired in embodied minds knowing
they live in real time is subsumed by a glut of insubstantial
information, momentarily floating across the shallow space of
the computer screen.

How has sculpture fared in this milieu? One of the greatest

pleasures of viewing postmodern or contemporary art is made possible by one of its most cherished values – it seeks to acknowledge the viewer's contribution to the experience and interpretation of an art work. Meaning is constructed in a process that varies according to what the viewer brings to the table. While some regret the loss of 'standards' and complain that art and culture have no idea where they are headed, let us acknowledge that a pluralistic 'feast' of ideas and objects is laid out before us – some of it is too sweet, too sour, too overcooked or just plain poisonous, but some of it is subtly flavourful, surprisingly tasty, and good for our hardened arteries. The part sculpture plays in the visual feast is an expansion into all sorts of media and materials, ranging from earthworks, site-constructions and installations to marked sites, named objects, conceptual performances and video projections. 'Sculpture is what you bump into when you back up to see a painting,' Barnett Newman said in the 1950s. The late modernist painter's urbane wit perhaps reveals an underlying disdain for the clumsy embarrassment of physicality and the preference for a sort of 'purer' revelation inherent to abstract painting. In contrast, postmodernism, if one can avoid the cynicism of relativity, introduces the possibility of a healthy scepticism – the bullet train to utopia has derailed so let us wade around in the messiness and see what we can find that is of interest or of value, expressive of our true conditions. At any rate, 'sculpture', no longer a distinct medium, is now a kind of catch-all genre for multiple sorts of 'impure' works that evade neat categorisation.[9]

What can we expect from sculpture at the dawn of a different (though perhaps not new) epoch where speed and disappearance are desired over weight and solidity?[10] (Recall that, in *The Great Divorce*, C.S. Lewis describes heaven as a place where things are actually more solid, painfully so, than what we are used to on earth.) And how might viewing contemporary sculpture increase an incarnational understanding of reality in an age of newly gnostic pseudo-spirituality?[11] (Recall the apostle Paul's observation that Christian faith is a foolish invention and a waste of time if Christ didn't enter real time in a real body that truly died

and was fully raised (1 Cor. 15)). With these questions in mind, let us return to our art pilgrimage – carefully observing and describing some of contemporary culture's image production and, especially, its sculptural icons.

A Journey Through the Wilderness

> Will the veiled sister between the slender
> Yew trees pray for those who offend her
> And are terrified and cannot surrender
> And affirm before the world and deny between the rocks
> In the last desert between the last blue rocks
> The desert in the garden and the garden in the desert
> Of drouth, spitting from the mouth the withered
> apple-seed.
>
> O my people.
>
> T.S. Eliot, 'Ash Wednesday'[12]

We have the Jews to thank for first calling us, out of a circle of repetition that continually winds back upon itself, onto a path leading to a garden in the desert.[13] An epic journey, through dryness and difficulty, toward a promised place of spiritual fulfilment and the pleasures of abundance and prosperity is a continually renewed trope in western thought. The latest desert journey of note is to pack the kids into a camper and head out across the hot sands of the Great Mojave for a break from the banalities of everyday life in the lush excess of Las Vegas. Approaching from Los Angeles (another mythic garden city of the Far West), I am caught in the wonder of a cool, dark, purple desert night and a stretch of highway splitting the ground into equal blank halves. Not unlike the children of Israel, scanning the horizon for a column of fire, I finally spot the light beaming from the apex of the Luxor, a pyramid-shaped luxury hotel and casino. Soon I will be refreshed in a fertile oasis by the waters of the Nile (a miniature version of which runs through the hotel lobby).

While I am not immune to the seduction of casinos designed as simulated versions of Manhattan, Rome, Paris and Venice, and so on, or of the newly acquired 'wholesome' glamour of 'gaming' for all ages, it does not take long for a disengaged ennui to settle over my view of the Vegas scene. I am reminded of Eliot's prophecy of the wasteland, where the great promises of the newly-born twentieth century, freedom and passion, morph into bondage and indifference. Later, in 'Ash Wednesday', the poem of his conversion, Eliot describes a garden I can live with. It does not hide the desert under a layer of green plastic, but invites me into the reality of my time to be alive. A strange fecundity of commodities and choices, accompanied by spiritual drought, is my particular desert. But by welcoming God back into the land-scape, I experience a redeemed desolation that is simultaneously a garden of delights. God, once incarnate in Christ, descends and inhabits our horizontal plane of existence.[14]

Returning to the City of Angels (as opposed to Sin City?), I am soon out looking at art again when I am confronted and oddly refreshed by the startling sculpture of a Las Vegas-based artist, the Reverend Ethan Acres. Like the city of extravagance he calls home, Acres is a current phenomenon of excess in the contemporary art world. He earned a Master of Fine Arts Degree at the University of Nevada and also has a degree from a Bible college as a minister of the gospel. He gives Sunday services in a camper turned tacky chapel parked beside the gallery where his works are being exhibited. 'The Highway Chapel' has neon lights attached to its undercarriage, louver windows in stained glass, and coloured water, circulating through clear tubing, that bubbles up near the doorway. So far, I am intrigued and entertained. Having lived in the rural South originally, I am perhaps already 'wired' to respond to the dramatic grotesquerie, raw urgency and unfettered expressions of faith in much naive art from the Bible Belt. But I also know I have long since left that region, at least in my head. This condition of being over-educated makes it difficult to express sincere faith, especially for an art audience which is rightly suspicious of sentimentality or didacticism. I am geared up to expect the worst – he will probably just 'rip' on Christianity

in heavily ironic clichés which periodically resurface in western art.

Entering the gallery, I am immediately engaged with a large camel, knitted out of woolly yarn, standing in a desert landscape made from glued together matchsticks, and looking like the image on a pack of cigarettes. He (I know this because it has a pink yarn penis) is unravelling to a single long thread which stretches across the wall and passes through the eye of a protruding, oversized needle. I visually follow the thread down to the floor where it ends in an abject pile of tangled brown and pink yarn. I am deeply moved. Here is physicality translated to another state yet retaining its full identity, a body pushed through a process of painful passage where everything is changed, but nothing is lost.

It is sometimes commented that when an art critic writes about a piece of art, she is simply offering the reader her particular fantasy of the work. But artists often grumble that the critics 'don't get' something or other about their art. To no avail, since the artist gives up control of the work's meaning once it is presented to the viewer, now privileged to bring his own thoughts and experience to the viewing process. Therefore, when I read the title of the work, 'Camel Passing Through the Eye Of a Needle', I feel the tears behind my eyes. Staring at the silly, lumpy pile of yarn that looks like stringy guts, I think I am witnessing a miracle. Jesus said: 'it is easier for a camel to go through the eye of a needle than for someone who is rich to enter the kingdom of God' (Luke 18:25). I had always dwelt on the hopelessness of this situation, overlooking his simple next statement, 'What is impossible for mortals is possible for God' (v. 26). (Including the incarnation!) Ethan Acres reveals, in his 'pathetic' materials, the unnerving possibility of real transformation – the entire camel does make it through the tiny eye, but is radically and humbly altered on the other side. Simple, common material seems laden with eternal significance.

At this point, I enter the next room of the gallery and am confronted by a most peculiar, rotating sculpture. It appears to be a kind of sheep, made by spraying insulation foam on a plastic

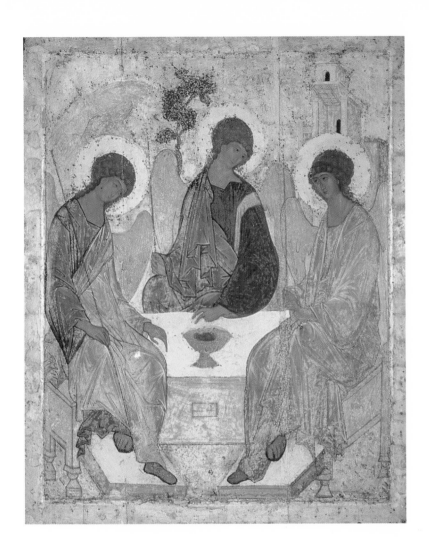

1. The Holy Trinity by Rublev. Tretiakov Gallery, Moscow.
Photo: Bridgeman Art Library, London.

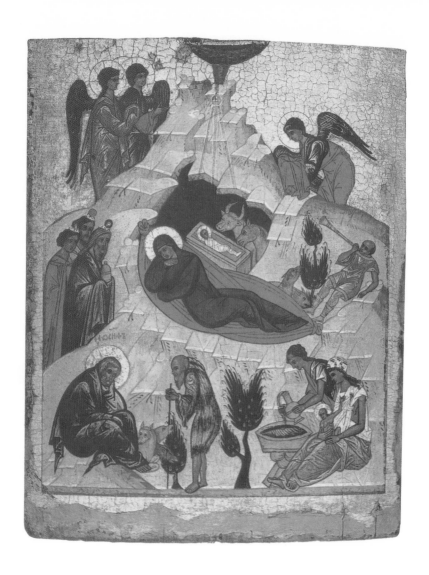

2. The Nativity of Christ, Novgorod School, attributed to the fifteenth century.

Photo: Christie's, New York.

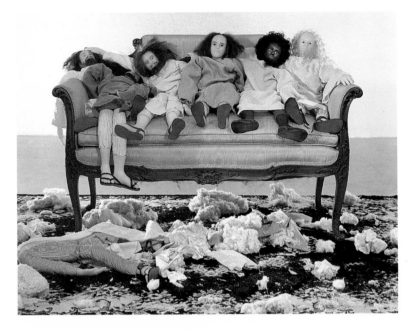

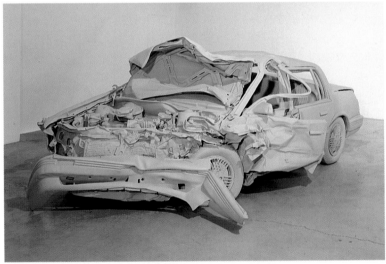

3. Kim Dingle, *My Struggles with Jesus*, 1995, beeswax, cotton, mohair, leather, oil paint, glass, plastic.

Courtesy of the artist and Blum & Poe Gallery, Los Angeles.

4. Charles Ray, *Unpainted Sculpture*, 1997, fiberglass, paint.

Courtesy Regen Projects Gallery, Los Angeles.

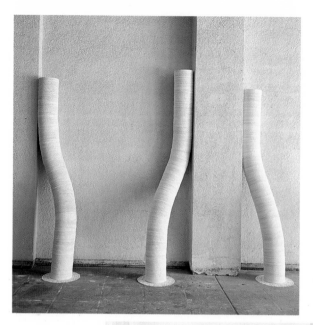

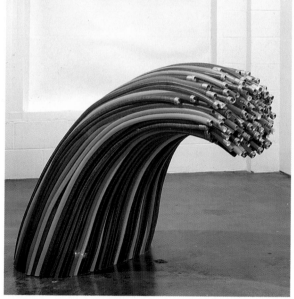

5. Lynn Aldrich, *Western Civ.*, 1995, stacked paper plates on paper doilies.
 Courtesy of the artist and Sandroni Rey Gallery, Venice, California.
6. Lynn Aldrich, *Breaker*, 1999, steel, fiberglass, garden hoses.
 Courtesy of the artist and Sandroni Rey Gallery, Venice, California.

rocking horse, which is suspended a few inches off the floor, hanging from a motorised, pivoting arm. Grey plastic horns curl from its head while a cluster of pupil-less eyeball lights flashes an orange glow. (Later, I count them – seven horns, seven eyes.) Faint strains of Gregorian chant emit from a speaker in the animal's head, bringing to mind the childhood memory of carnivals and carousels, a time when religious longing was ripe and innocent. Acres titles his sculpture 'Lamb of God', but of course, I have already recognised the fleshed-out vision from St John's Revelation. Embodied in the bizarre elaboration of this form, made from ridiculous 'low' materials, charged with electricity, is reference to the Lord of the Universe, stunning beyond imagination. And why shouldn't this One appear weak and silly, yet contain power and mystery surpassing our comprehension? That is the paradox of the incarnation, which will be fully grasped only at a future time when revelation is at last complete. It seems that the Apocalypse, the drawing back of the veil, is attempting through language to picture what is ultimately most real – the flawed material creation at last redeemed. Here in the gallery I am facing the noisy, tactile physicality of the text's stunning description of the triumphant Lamb – I am jolted out of my complacency with 'things as they seem' and for a brief interlude, I contemplate a strange glory.

Yet another experience awaits in a small mid-town gallery. I enter and find myself immediately in the presence of one large sculpture (Plate 4). It is an object at once completely recognised and familiar, yet with a ghostly distance. It is a wrecked car, of the kind so mangled that sometimes the police display one along the highway with a warning to 'slow down or this could happen to you'. I intuitively know that at least one person's life was lost here, that I am observing a relic, a sort of architectural ruin of a death scene. The entire surface of every piece of crumpled metal (also the tyres and interior upholstery) is a soft grey patina, the primer paint used before the auto body enamel. I feel that I am looking at a real automobile from a real accident, though the piece is strangely 'unreal' because of its over-all similar smoothness and cool, neutral colour. Then I read that the

artist, Charles Ray, had actually purchased a smashed Pontiac Grand Am, dismantled and cast its several hundred parts in fibreglass, and reconstructed them in their original positions as this sculpture. By this time, I have walked to the rear of the car and see, intact on the bumper, a metal (or actually, grey-painted fibreglass) sign: 'Jesus is Lord'.

The artist has embodied a deep irony by including this last detail – evidently, the car's driver died in a sudden, catastrophic accident and he believed Jesus was in control. This is the profound and ironic foolishness of faith; I think of that most ancient of arguments between Job and God – 'Why is there suffering?' Especially, 'why do I suffer?' Ray's sculpture, a deconstructed and laboriously reassembled picturesque ruin, helps me ask that question again, for my time to be on the planet. The work is carefully planned and meticulously crafted, yet its title – 'Unpainted Sculpture' – signifies the condition of being not quite finished, less than complete, partial. Like Dutch Protestant paintings of decaying flowers, broken bread and half-filled goblets, the twisted wreck is an allegorical still life, reminding me of my transience, but pointing toward eternal life, the hope of completeness. Ray himself says, 'Looking at the sculpture, you can't tell if I am an atheist or a Catholic.' He allows the viewer a site for 'dialogue' with the work in the construction of its meanings.

Another impression begins to grow while I continue circling the car. As I am aware of my own body in movement, I am haunted by the absence of the driver's body. No figure is present in the work, yet from my staring at the bent cavity of the front seat (the negative space of the sculpture), I know more about human flesh than I could learn from any image. Flesh is weak, fragile, breakable, painful, mortal. 'And the Word became flesh and lived among us.' Christ took on this way of being, our way of being. But there is more. The absence of a body in the cave of twisted metal speaks to me of Christ's risen and ascended body – 'He is not here.' Confrontation with the empty tomb is where I first begin to imagine the possibility of the resurrection.

Our art tour now continues to my own studio where I am working on a sculpture that has been frustrating me. By now, I

understand that my method as an artist begins by observing very simple things – the commodities, banal objects and materials readily available in ordinary life. Methods of 'sculpting' are low-tech or invented as I get to know each medium – 'stuff' like waxed paper, lampshades, fake fur, paper plates, plastic roofing material, aluminium crutches, patio furniture covers, fence pickets, etc. The ephemerality of some installations, using cactus, moss, pine needles or insect bodies, is an acknowledgement of our transience. A material will perform in a way that is appropriate to its reality; for example, a recent sculpture made from ten feet of stacked paper plates on a base of large paper doilies leans crazily into a corner, held in place (miraculously!) only by gravity. It is a beautiful and silly, white, Grecian column, titled 'Western Civ.' (Plate 5). In a way, this work is a critique of the very idea of stability or permanence; it has an inept monumentality which I associate with what it is to be human, paradoxically flawed yet 'in God's image'. To 'think the incarnation' through my artistic medium is to grapple with concrete matter in its varied forms, to 'bring forth' volume and texture in a culture entranced with immateriality. I construct each work while imagining that its final form will somehow hint or whisper at the visitation of God into his creation.

Currently, I am making a large 'wave', an ocean breaker, cantilevered and poised to crash (Plate 6). It is constructed of steel rod and fibreglass, and I am trying to attach lengths of purchased garden hoses to its skin. Finally, after much trial and error, I have obtained the right industrial adhesive and it is 'working'. I begin to enjoy the odd beauty of the multi-green, snakeskin patterned hoses as they spill into a head of sea-foam – the brass hose nozzles or couplets on their ends. I am thinking, allegorically, of the sea as the realm of chaos for the ancient Hebrews, the depiction of human frailty threatened by uncontrolled nature in Hokusai's famous print of the 'Great Wave' or in Albert Pinkham Ryder's 'marine' paintings.

A few months pass, and I am still riding the crest of these swelling aspirations. On another sunny afternoon, I am installing the finished sculpture for exhibition in a gallery in Venice Beach

(an early Southern California real estate development built on a network of canals with cute, arched bridges). I hear a loud tap on the window and look up. Two blond surfers with boards under their arms are pointing at my wave and giving me the high sign of their in-the-know approval. The universal of my longings meets the particular of my circumstances.

And that is how it is with the incarnation. There is a crashing through, a breaking into the stream of human history. God is not shocked or embarrassed by anything human, and he values the diversity of our labour, art and invention. He fully comprehends our reality and our multiple realities. We don't have to clean him up, prop him up, or protect him from harm, nor wonder if the world will change so much he will not recognise it. We are the ones who see things from a distance, 'through a glass, darkly'. He comes up close and walks around in the thick of it.

FURTHER READING

Gil Bailie, *Violence Unveiled: Humanity at the Crossroads* (New York: Crossroad, 1995).

Thomas Cahill, *The Gifts of the Jews: How a Tribe of Desert Nomads Changed the Way Everyone Thinks and Feels* (New York: Nan A. Talese, Doubleday, 1998).

Andrew Causey, *Sculpture Since 1945* (Oxford: OUP, 1998).

Richard Hertz and Norman M. Klein (eds.), *Twentieth Century Art Theory: Urbanism, Politics, and Mass Culture* (New Jersey: Prentice Hall, 1990).

Peter Lunenfeld (ed.), *The Digital Dialectic: New Essays on New Media* (Cambridge, MA: MIT Press, 1999).

Paul Virilio, *The Aesthetics of Disappearance* (New York: Semiotext(e), 1991).

NOTES

1. See above, pp. 22ff.
2. From an exhibition catalogue for Anthony Cragg (Viersen: Skulpturen-sammlung, 1996), p. 21.
3. From my correspondence with Jeremy Begbie, 1999.
4. Thomas Cahill, *The Gifts of the Jews* (New York: Nan A. Talese, Doubleday, 1998), p. 226.
5. Richard Hertz and Norman M. Klein (eds.), *Twentieth Century Art Theory* (New Jersey: Prentice Hall, 1990), p. 8.
6. Walker Percy, *The Moviegoer* (New York: Fawcett Columbine, 1960), p. 146.

7. Robert Smithson, 'Ultramoderne', in *Robert Smithson: The Collected Writings*, ed. Jack Flam (Berkeley, Los Angeles, London: University of California Press, 1996), pp. 62–5.

8. As quoted in Cahill, *The Gifts of the Jews*, p. 41.

9. Rosalind Krauss, 'Sculpture in the Expanded Field', in *Theories of Contemporary Art*, ed. Richard Hertz (New Jersey: Prentice Hall, 1985), pp. 215–25.

10. Paul Virilio, *The Aesthetics of Disappearance* (New York: Semiotext(e), 1991), p. 104.

11. Paul Virilio, *Pure War* (New York: Semiotext(e), 1983), pp. 131–4.

12. *Collected Poems 1909–1962* (London: Faber & Faber, 1963), p. 103.

13. Cahill, *The Gifts of the Jews*, pp. 250–2.

14. See Gil Bailie, 'T. S. Eliot's Poetic Parable of Conversion: From Prufrock to Ash Wednesday and The Four Quartets' (lecture series, The Florilegia Institute, Sonoma, California, 1993).

7

THROUGH POPULAR MUSIC:
'Wholy Holy'?

GRAHAM CRAY

To take the incarnation seriously is to take the temptations of Jesus seriously. But the Church has often struggled to find effective ways of holding both together – either his temptations were play-acting, or Christ was not fully God and was sinful. Either way, salvation is compromised. Graham Cray sets the whole issue in a trinitarian context: the humanity the Son assumed from us is 'turned back' in obedience to the Father through the Spirit, and this necessarily involves authentic struggle. But Cray throws this into relief not directly but through a study of the soul singer Marvin Gaye, setting the lyrics of his songs within its multiple contexts, including Gaye's various musical styles, his lifestyle and, not least, his own Christian background.

The suggestion that aspects of the incarnation can be better understood when approached through the perspective of popular culture causes problems for both modern and postmodern perspectives on the world. The Enlightenment outlook typically included a clear distinction between 'high' art and 'popular' art. High art was seen as a noble vehicle, well suited to noble themes. Popular art, by comparison, was a worthless diversion for the uneducated. This attitude lingers on and it is important to remember that it is of compara-

tively recent origin, being primarily a nineteenth-century innovation.[1] In the twentieth century the critique developed by the Frankfurt school continued a similar dichotomy as a response to mass-produced popular culture. It identified the 'culture industry' as a form of 'mass deception', another conquest of standardisation and mass production.[2] From this perspective either the 'trivial' nature of the medium or its commercialisation renders it incapable of being the door to significant themes.

Postmodern theory raises a different challenge. Rather than seeing popular culture as an inappropriate vehicle for transcendent themes, postmodern theory denies the accessibility (and even the existence?) of the transcendent. Popular culture is understood as simply one aspect of a system of signs which have nothing to point to beyond other signs; there is nothing beneath the surface, so the surface needs to be enjoyed for its own sake. Postmodern culture has been described as 'a labyrinth of inter-reflecting mirrors from which there is no escape'.[3] Related to this, a great deal of popular culture – whether pop song, movie or computer game – seems designed as an enjoyment of the present for its own sake. Indeed, some elements of postmodern theory regard life as little more than a series of 'permanent presents'.[4]

This chapter will resist both modern and postmodern extremes. I hope to show that popular culture has the capacity to bear and enlighten the most substantial questions of human existence. Furthermore, Christian theology insists that humans made in God's image cannot but create works which communicate beyond the immediate and 'internal' sensations they stimulate. Popular culture, that is to say, can have its moments of transcendence.

It is the relatively new discipline of cultural studies which has brought popular culture back on to the scholarly agenda. Raymond Williams wrote that 'culture is ordinary.'[5] The term is no longer exclusively nor chiefly linked to 'high art'. Rather, within this discipline, and within the human sciences as a whole, culture now refers to the whole of society with particular references to the ways in which human beings make or discover meaning. Cultural studies recognises that people make meaning through

the everyday resources of their lives. A Sony Walkman[6] has as much involvement in the making of meaning as the underlying economic and social forces involved in its creation and marketing. 'Culture, thought of more broadly as a way of life and as the actions through which people create meaningful worlds in which to live, needs to be understood as the constitutive context within and out of which the sounds, words and images of popular music are made and given meaning.'[7] In fact, this understanding of the relationship between culture and meaning applies to every aspect of culture, including any art form regarded as élite. Hans Bertens writes that 'Postmodernism has led to a spectacular upgrading of cultural studies . . . Culture, long seen by many as determined, either directly or indirectly, by a more fundamental mode of production, has now become a major constitutive power.'[8]

Christian theology must resist the tendency of some cultural studies to claim that reality is *entirely* constructed by culture or through language. Instead it adopts a view that combines God's initial and ongoing creativity with human stewardship and discovery in partnership with God. 'Because of God's presence and action, our involvement in culture has real theological significance. We are called to reflect God's own commitment to the world.'[9] But theology can nevertheless agree that culture, including popular culture, does involve the shaping, as well as the identification of meaning.

For the rest of this chapter I will focus on popular music. I regard this art as of prime importance because, together with film, it has been the primary popular art form in the media-saturated world which emerged in the twentieth century and continues into the twenty-first. In such a culture, popular music has to be interpreted less as a concise medium with its own internal rules and more in relation to the other dimensions of the culture in which it is shaped. Such music does not have a separate meaning by itself, in isolation from its context. Rather the context makes the music possible and is integral to the meaning. 'Music becomes an essentially open field of reference for the most varied cultural activities. And in this process to a

great extent it loses its textual quality and instead acquires a *media* character'.[10]

It is just because popular music is a mass medium that it has the capacity to introduce substantial themes into its audience's everyday life and experience, in such a way that people are enabled to engage with them significantly. As Peter Wicke has said, 'rock music produces new experiences in art, that, within the framework of a high-grade, technologically-dependent mass culture, a totally altered relationship between art producer and recipient has asserted itself; that everyday life and creativity, art and media have been brought together in a new context.'[11] Since rock and pop music have helped create a new relationship between art and everyday life, then – on first appearances at least – it should be of particular help in understanding the incarnation.

To this academic argument I will add a more personal one. As someone who grew up in the 1960s, pop music was central to my self-awareness. Through a Bible class I learned to believe, and entered into the Christian story and its worldview. Through rock music my faith became more 'wholistic': I learned how to identify my own emotions and to integrate the physical and the 'feeling' parts of my nature into my growing faith. The Black Panther leader Eldridge Cleaver once said that the rock and roll generation was 'a whole generation of whites getting back into their bodies'.[12] This was true for me. There was, of course, a conflict between some of the values expressed through the music and the Christian values I was learning on a Sunday, but there was never an inherent contradiction. Through the music I discovered more of myself as a whole person being redeemed.

Real Temptation?

At the same time, the music acted as one vehicle for temptations to ways of life which were not consistent with my Christian commitment. It is precisely this subject of temptation that I wish to address, for the temptations of Christ focus a crucial aspect of the incarnation. The incarnation of Christ only has power to save if the temptations of Christ were real. 'This was a real attack and

not play-acting.'[13] For the New Testament writers, it is clear that Christ shared authentic humanity, which meant encountering actual struggle and genuine temptation. 'For we do not have a high priest who is unable to sympathise with our weaknesses, but we have one who in every respect has been tested as we are, yet without sin' (Heb. 4:15). What is at issue theologically here is nothing less than the effectiveness of our salvation: if Christ did not share our full humanity, we cannot be saved as we are. The New Testament letters use the language of exchange. Paul states in a variety of ways that Christ became what we were in order that we might share in what he is (2 Cor. 5:21, 8:9; Gal. 3:13, 4:4–5; Rom. 8:3–4; Phil. 2:6–8). 'What Paul describes is the self-identification of Christ with men and women which, in turn, results in their sharing in what he is.'[14] In the doctrinal struggles of the Patristic period the negative implication of this was emphasised in statements like those of Athanasius: 'If all is not assumed all is not healed', and Gregory of Nazianzus: 'what has not been assumed (in Christ) has not been healed'. As Christopher Cocksworth has written,

> The humanity which God assumed at the conception of Christ had to be reformed and refashioned by the obedience of the eternal Son to the Father through the Spirit now being lived out in the full reality and conditions of human life. The temptation and Gethsemane narratives make it clear that Jesus was fully engaged with the human realities of temptation and fear.[15]

The concept of recapitulation lies at the heart of this understanding of the incarnation. In Luke's account of the temptations (ch. 4) Jesus is tempted in the wilderness as a recapitulation of Israel's calling. He is led by the Spirit around the wilderness for forty days, just as Israel was for forty years (4:1–2). Jesus also recapitulates the temptation of Adam and Eve at the Fall. Yet he does not yield.[16]

Nevertheless, we are continually inclined to shrink back from the reality of Christ's temptations, often out of an ill-informed desire to protect Christ's deity. This amounts to little more than

an attempt to saw off the (redemptive) theological branch we are sitting on!

In order to open up the depth and significance of the biblical testimony on this matter I will approach it through an interaction with the work of the soul singer Marvin Gaye, in particular the two albums which formed the peak of his career 'What's Going On' (May 1971) and 'Let's Get It On' (August 1973). Although released more than twenty-five years ago, they continue to appear in both critics' and readers' polls of the top albums of the rock era. They also continue to inspire today's artists. (The major albums of previous decades are now all available on mid-price CDs. This has created a music scene which is highly informed about its past.[17]) Gaye's life and death still fascinates many fans, and biographies continue to be written.[18]

Church Roots

Of all the various musical traditions loosely labelled 'rock' or 'pop', the Afro-American music known as 'Soul' or 'RnB' is the most helpful to our inquiry, because its roots are in the Church. During the First Great Awakening (reaching its peak in the 1740s) large numbers of slaves came to faith in Christ, and as a consequence a music was born which combined their West African heritage with the hymns and metrical psalms from the European tradition. This music we now call the 'Spirituals'. From it grew Blues, Gospel, Jazz and Ragtime.[19] Blues and Gospel, when combined with white country music, formed Rock n' Roll. The influence of Gospel music upon the rock form was such that one writer could claim that 'All rock's most resilient features, the beat, the drama, the group vibrations derive from gospel. From rock symphonies to detergent commercials, from Aretha Franklin's pyrotechnics to the Jacksons' harmonics, gospel has literally reformed all our listening expectations. The very tension between beats, the climax we anticipate almost subliminally, is straight out of the Church.'[20] Yet from the time of the Second Great Awakening (early nineteenth century) a strict dualism had been introduced into the interpretation of the emerging new music. A

sharp divide was eventually established between 'Gospel' as the music of the Church and 'Blues' as 'the Devil's music'. This was to create a tension which was carried into the history of rock and pop, exemplified in a series of artists who were raised in the Church and who became 'secular' singers. The reality of temptation and a profound inner struggle marks these musicians and characterises their music, from the 1950s to date.

The 1950s' rock n' roller Little Richard ricocheted between times of sexual abandon and times of remorse and Christian ministry. One of the founders of Soul music, Sam Cooke, came to fame on the Gospel circuit as lead singer of the Soul Stirrers before making his name in pop. At the peak of his 'secular' fame Cooke once tried to perform again with the Soul Stirrers and was booed off the stage by the Gospel audience. He died tragically, shot dead by a lover and had a posthumous hit with his poignant song 'A Change Is Gonna Come':

> It's been too hard living,
> But I'm afraid to die,
> Cause I don't know what's up there
> Beyond the sky.
> It's been a long, long time coming,
> And I know a change gonna come,
> Oh! Yes it will.[21]

Next came Marvin Gaye to whom we will soon return. He was closely followed by Al Green who became a pastor, after a near miss with death, when he was at the height of a hugely successful soul career. Green announced his final choice between two ways of leading his life, and between Christ and his lover, in the song 'Belle', singing 'It's you that I want, but it's Him that I need'. The story still continues with artists like Whitney Houston, Michael Jackson and above all Prince (aka 'The Artist') of whom it has been said, 'we see both sides of Little Richard reconciled in sacred sin'.[22]

Trouble Man

As we turn to Marvin Gaye, it is worth recalling what we said earlier, namely that popular music can only be interpreted within a context. In fact, the context is multiple and complex. It is not adequate to analyse lyrics alone, as though they were the only key to the music's meaning. Lyrics in much pop music are simply a resource to one instrument, called the human voice, as it is integrated into the overall sound-mix. Even this musical whole should be placed in the context of an artist's previous work, their carefully portrayed image, including liner notes and artwork. In addition, with a well-established artist, each new release will be understood as revealing the next instalment of an already well-publicised private life. Further, relevant also are the mythologies about the meaning of such music which are shared between artist and audience.

The two Marvin Gaye albums are regarded as classics, and the artist's history is well known.[23] Gaye was raised in a Pentecostal Holiness family. They belonged to the House of God, a group which combined the usual Pentecostal emphasis on the activity of the Holy Spirit with the observation of Passover, some Old Testament food laws, and the keeping of Saturday as the Sabbath. (An extraordinary combination of liberation and legalism!) Marvin's father was a 'bishop' in this small denomination. Musically Marvin was very talented and sang in church and for his father's meetings from the earliest possible age. His relationship with his father was appalling and was to dominate his whole life. It was a manipulative one, including physical beatings, which left the young Marvin trapped between his longing to please his father and his determination to resist him. Eventually he was to die at his father's hand.

Gaye was one of the artists who made the Tamla Motown label famous in the 1960s, with classic singles like 'I Heard It Through The Grapevine'. His life and music was marked by two inseparable conflicts. The first was between his confusingly legalistic Christian upbringing, and the licence offered by the classic pop star indulgence in sex and drugs. The second was between his

resentment of his father and his deep need for his father's love. If we are to engage with the depth of struggle involved in Christ's temptations, with the powerful attraction of the alternative future which was offered to him in them, and with the huge significance of a trusting relationship with a loving heavenly Father – might it be that, despite the obvious contrasts, we could approach these themes through the music of Marvin Gaye?

Marvin's career took on a whole new dimension with the release of the 'What's Going On' album, which represented a major break from the traditional Motown sound. Motown had been built on a highly successful formula which took the essence of Afro-American church music and used it as the vehicle of short memorable, melodic love songs. Marvin broke with this mould. Producing himself for the first time, he recorded a thirty-five minute suite of nine songs. The theme was the pain and need of society as he knew it: in violence and war, drugs, racism, inner-city conflict, the plight of children and ecological disaster. Instead of the Motown Gospel formula he wove together a 'symphonic pop suite in which Latin beats, soft soul and white pop, and occasionally scat and Hollywood schmaltz'[24] formed a unified lush whole. The songs were also longer than the Motown norm, but the vocal style was pure Gospel. Marvin was one of the first to multitrack his own voice and sang as a pleading gospel preacher. In the light of the state of the world Marvin not only asked 'What's Going On', but set the question within a vision of what should be, a vision that was deeply informed by his Christian upbringing.

The temptation narratives in Luke are also framed within a vision, the vision of the Kingdom of God. The Father's voice at Jesus' baptism (3:22) alludes to Isaiah 42:1 and the servant 'who will bring forth justice to the nations'. On his return from the wilderness (Luke 4:16ff.) Jesus announces his calling by quoting Isaiah 61: 'The Spirit of the Lord is upon me, because he has anointed me to bring good news to the poor. He has sent me to proclaim release to the captives and recovery of sight to the blind, to let the oppressed go free, to proclaim the year of the Lord's favour.' Marvin sang out a vision for his culture in the early 1970s

(and for today) that had strong echoes of Christ's vision and calling.

He drew on his own church background and also strongly identified with the experience of his brother Frankie, who had just returned from Vietnam. Christ was central to what Marvin portrayed: that the mercy the world needs comes from Jesus and that Jesus was more than willing to give it. One of the few positive statements Marvin ever made about his own father was that he introduced him to Jesus. 'He made Jesus come alive for me, and that's reason enough to be grateful to him for the rest of my life.'[25] The songs 'God Is Love' and 'Wholy Holy' establish the basis of the hope which the album evokes and the basis of the action for which it calls: a holistic vision of life in the world sustained by God. The voice which was formed in the Church pleaded to and for the world, and Marvin was singer as preacher. Scripture was also central to this vision. 'Jesus left us a book to believe in. In it we've got an awful lot to learn.'[26] Marvin broke with another Motown practice by publishing the lyrics with the album, and in his liner notes calling his audience to 'find God' and 'check out the Ten Commandments. You can't go far wrong if you live them.' (The ten commandments were read out at the start of every House of God service.) Serious artists set the same vision before themselves which they set before their audience. Further, Marvin believed he was being inspired by God as he put this album together and as he fought Motown for the right to release it. 'It was a very divine project and God guided me all the way.'[27]

Even at this stage, Marvin's personal life was far from the commandments he commended, but the other side of his life, and a shift further away from his church roots, is best portrayed through his next major album 'Let's Get It On'. Here the theme is unashamedly sexual. During the period between the albums, Marvin's marriage to Anna, fifteen years his senior, had become increasingly strained. (His drug consumption had also increased.) During the recording of the title song Marvin met Jan, a high school student fifteen years his junior. Much of the album was recorded with her in the studio and is an unabashed plea for her

to enter his life, and his bed. By the time the album was released she had dropped out of school and was living with him. Later she became his wife.

As the title track begins to fade out, Marvin is improvising beyond the original lyric. The style is directly drawn from a gospel singer's repertoire. He calls on the presence of the Holy Spirit as evidence that the relationship with Jan must be right.

> Gonna get it on, right with you, baby,
> I'm gonna get it on.
> You don't have to worry that it's wrong.
> If the Spirit moves ya, come let me groove ya,
> Let your love come down, oh get it on, come on baby.
> Girl you give me a good feelin, gonna sanctify ya.
> If you want to love let yourself go.

Despite the gospel vocabulary his lyric was a seducer's plea, recorded live in the studio. Musically, the style was much nearer to Motown's Gospel roots than the earlier album. For those who know the background there is a tension between the musical style and the lyrical content. Church music was pleading for sin. Here, long before Prince's recording career, sin was being portrayed as sacred.

David Ritz comments that the song was 'Marvin's attempt to . . . integrate his two strongest sources of emotional enthusiasm – God and sex' and that 'Marvin was arguing with his Pentecostal background, even arguing with his own liner notes.'[28] On the surface the music appears to be an untroubled plea for sexual pleasure, in narrative context a troubled man was losing a battle with temptation. Jan said:

> . . . after we met the emphasis of his work shifted away from the social awareness of 'What's Going On' and focused on sex . . . I think that was his way of confronting the feelings he held inside about sex and sin because *he knew what was right and wrong.* I think there was something at the back of his mind where he thought he could change and that he

would change people, but in another way he revelled in what
he knew to be wrong.[29]

Ritz's point about the liner notes was well made. After pointing
approvingly to the ten commandments on one album, Marvin
used the next to argue that 'sex is sex and love is love' and that
they do not need to go together. 'I don't believe in over moralistic
philosophies. Have your sex. It can be very exciting if you're
lucky.' The album continues with a series of sex-related songs
and concludes with 'Just To Keep You Satisfied', Marvin's goodbye
song to his first marriage.

> It's time for us to say farewell, farewell my darlin'
> Maybe we'll meet down the line
> It's too late for you and me, it's too late for you and I,
> Much too late for you to cry . . .
> Well, all we can do is, we can both try to be happy.

One album, then, called for love and justice in the name of Jesus,
respected the ten commandments, and set out the vision of being
'wholy holy'. The other justified adultery in the name of the Spirit,
walked out on a marriage, rejected 'moralistic philosophies' and
renamed sin as sanctification.

Contrasts

Any theological insights gained from this music must obviously
point to strong elements of contrast. The biblical account is of a
battle won. From a Christian perspective the singer's account is
a battle lost and a surrender justified. Marvin Gaye was a 'Divided
Soul' – Jesus Christ, as represented in the Gospels, was not, even
though the purpose of the tempter was to turn him into one.

The temptations of the last Adam recapitulate the temptations
of the first Adam. The depth and reality of the temptation is the
same. It is the outcome that is different. The temptations of
Christ were in one sense unique. 'Their context was not merely
moral, but the eschatological clash of the power of the enemy
against the purpose of God, so that the newly called and empow-

ered Jesus can be diverted from his Father's will and the world's salvation.'[30] These temptations were unique because of their key place in the history of salvation, but that same history requires that Christ be tempted 'in every respect' as we are, 'yet without sin'.

Put Marvin's music into the context of Marvin's story and we have a gateway into the intensity of Christ's temptation. If those temptations were real they involved *at least* the depth of personal struggle revealed through Marvin's music. Of course, their content was not the same as Marvin's – there is no hint of a sexual element, for example – but the underlying direction was the same. Christ was tempted to satisfy himself apart from trusting the provision of God the Father. 'The devil said to him, "If you are the Son of God, command this stone to become a loaf of bread" ' (Luke 4:3). He is tempted to order his own affairs and provide his own needs rather than trust the Father. He responds by quoting Deuteronomy 8:6: 'It is written, "One does not live by bread alone" ' (4:4). Marvin asserted the importance of Scripture initially, but departed from it finally, when it forbade something he wanted to do.

Jesus was offered power and glory for the price of a compromise. 'Then the devil led him up and showed him in an instant all the kingdoms of the world. And the devil said to him, "To you I will give their glory and all this authority; for it has been given over to me, and I give it to anyone I please' (4:5–6). He is tempted to gain glory in the world by compromise with the forces which control it. In Luke's account the implicit contrast is with the cross as the price of resisting the world and the powers of evil. Satan is seen as working through every form of self-aggrandisement. 'This temptation is experienced by Jesus in a uniquely messianic context, but the temptation itself is a universal temptation.'[31] Marvin maintained his fame and commercial success ('Let's Get It On' was the biggest hit of his career) for the price of changing his beliefs. Having justified his lifestyle morally his theology was modified to fit his chosen way of life. Moving away from the theology of his childhood he embraced increasingly New-Age-style beliefs. He maintained the view from 'What's Going On' that

the world was in deep trouble, but abandoned it to its fate. He imagined himself as 'part of an élite who were evolving towards a higher consciousness and who would escape the eventual destruction'.[32]

At the heart of temptation is choice. Choice made against conscience results in self-justification. In his third assault the tempter went on to offer Jesus an interpretation of Scripture that would provide a way forward without personal cost. 'Then the devil took him to Jerusalem, and placed him on the pinnacle of the temple, saying to him, "If you are the Son of God, throw yourself down from here" ' (4:9). Jesus is then offered apparent scriptural grounds for presuming upon God's protection of his life. (The scene has moved to Jerusalem; the temple was regarded as the central place of God's presence and protection.) Again, evasion of the cross is central to the temptation. Marvin yielded to a different sort of presumption, that of sin and self-justification without penalty or spiritual consequence. Inside he was still arguing with his own liner notes. The fourth track, 'Keep Gettin' It On', is taken from a studio improvisation on the title track of 'Let's Get It On'. In it Marvin becomes the preacher again, no longer pleading with Jan but asserting the rightness of his actions to his audience, urging 'making love' which makes you 'feel so good'. The exhortation comes complete with a cry of 'Yes Lord' (meaning 'No Lord'?).

Temptation and Incarnation

This interaction between Marvin Gaye's music and the biblical account throws light on four elements of the temptation narrative.

Firstly we must look at *the dynamic of temptation and the nature of evil*. In Luke's account Jesus' temptations involved a direct encounter with the Devil, who is portrayed as the tempter. Christians today vary in their beliefs about a personal Devil and about the nature of the demonic, but the great majority agree that evil is to be understood as something more substantial than a force within individuals, and that it is a power which impacts

the lives of individuals from the outside. Marvin's music shows no evidence of an awareness of the Devil even in this sense. He experiences his conflict as one within his own desires and between two parts of his personal history. He seems quite unaware of the power to which he was yielding himself by turning from the commandments. 'Then the devil led him up and showed him in an instant all the kingdoms of the world. And the devil said to him, "To you I will give their glory and all this authority; for it has been given over to me, and I give it to anyone I please" ' (Luke 4:5–6). For all his awareness of the social evil in the world Marvin showed no awareness of a personal source of his temptations, or even that he was being tempted. Jesus overcame temptation in part because he knew who or what he was dealing with and what the stakes involved in the conflict were. This does nothing to undermine the depth and reality of his conflict. A temptation which has no attraction is not a temptation. If Marvin's temptation was rooted in his sexual desires, Jesus' temptation was rooted in an even deeper dimension of human identity, the desire to survive. The way of the cross was being challenged long before Gethsemane, although the story of Gethsemane reveals the emotional intensity of this challenge at an even greater depth. If the incarnation was to lead to our salvation it had to involve a doing of battle with the forces of evil which assail humankind, and to which humans are tempted to yield.

Second, there is the role of the *Spirit.* In striking irony, Martin invoked the Spirit to justify his abandonment of the ten commandments. Thus he set one part of his Pentecostal upbringing over against another. The lesson is clear; to separate the anointing of the Spirit from the will of the Father is to domesticate the Spirit, in Marvin's case to reduce the Spirit to a pleasurable emotion used to justify a bad conscience. If it feels good, do it. Let's get it on! No wonder Marvin dropped the word 'Holy' from the Spirit's title. Marvin's fall paradoxically can serve to illuminate the Spirit's role in Luke's narrative; where the temptations precede the Father's gift of the Spirit, occur under the leading of the Spirit, and result in a deepened experience of the power

of the Spirit together with an announcement of the purpose of the gift of the Spirit. Jesus depended upon the Spirit as the one to empower him to do the Father's will; Marvin used the Spirit as an excuse to avoid it. This is more than surface use of Christian language: Marvin was not trying to leave his whole Christian upbringing behind. He wanted to engage with the Spirit *and* to sleep with Jan. At the key point of temptation he was more vulnerable than Christ because in his life so far he had already yielded to temptations and gone against his spiritual heritage many times, while Christ had not. Christopher Cocksworth writes, 'The difference between him [i.e. Christ] and us was that although tempted in *every way* as we are, he remained so consistently open to the transforming work of the Spirit (who drove him into the desert and directed him towards the cross) that he remained faithful to his Father and did not sin.'[33]

From this we can also make an important connection between the Spirit and Gethsemane. The cry of *Abba*, the distinctive word of intimate privileged relationship with God, is the gift of the Spirit. But *Abba* is a Gethsemane word, only recorded in the original Aramaic in Mark's account of Gethsemane (14:36), in Romans (8:15) and Galatians (4:6). The gift of the Spirit is a gift to enable costly obedience, not a diversion to avoid it. The letter to the Hebrews takes this activity beyond Gethsemane's battle for the will to Calvary's moment of self-offering to the Father on our account. 'Christ . . . through the eternal Spirit offered himself without blemish to God' (Heb. 9:14). Marvin tried to separate that which God had joined together; under the same temptation and to the last moment of his life, Christ remained faithful.

The third point is about *the nature of renewed humanity in Christ and its growth to maturity*. Luke records the temptations as events through which Jesus grows in wisdom, and in understanding of the nature of his call. Simply put, he comes out stronger than when he went in. Hebrews dares to speak of him as *becoming* perfect (i.e. mature):

In the days of his flesh, Jesus offered up prayers and suppli-

cations, with loud cries and tears, to the one who was able to save him from death, and he was heard because of his reverent submission. Although he was a Son, he learned obedience through what he suffered; and having been made perfect, he became the source of eternal salvation for all who obey him. (5:7–9) (See also 2:10.)

The route to maturity went from baptism to temptation to Gethsemane to dereliction and then to resurrection. Only then was there a fully renewed humanity in which we could share. (The quotation from Psalm 22 as the cry of dereliction was not merely a useful quote, or a timely fulfilment of prophecy, it was the only way the depth of this suffering could be expressed – theology through the arts indeed!) If the incarnation involved a recapitulation of human life, lived in obedience to the Father, then it required a growth to maturity through an increasing pattern of temptation and real conflict; 'although (because) he was a Son'. From this point on Marvin shrank rather than grew as a human being. His life was increasingly characterised by paranoia, addiction, laziness and fear of public performance.[34] Our growth into mature renewed humanity in Christ cannot be expected to take any other route than the one taken by the pioneer of our faith. We grow or shrink according to the outcome of temptation. But we never face temptation alone or unaided: 'Because he himself was tested by what he suffered, he is able to help those who are being tested.'[35]

The fourth and final point is that of the centrality of trust *in the Father* in the whole matter. This approach to the incarnation through Marvin's music has turned out to be a study in the character of two different F/fathers. In Luke's Gospel, Jesus is tempted as second Adam and new Israel, but above all he is tempted as a Son (3:22) who was privileged to share the family honour and resources.[36] Everything depended on his trusting obedience to his Father. Marvin hated and distrusted his father (with some reasonable cause) and yet also craved his love. His ambivalent view of his father was brought out in the song 'God Is Love' on the 'What's Going On' album.

Don't go and talk about my father,
Cause God is my friend, Jesus is my friend . . .
Love your mother, she bore you
Love your father, he works for you,
For when we call on Him for mercy, mercy Father,
He'll be merciful, my friend.

When resistance to temptation becomes costly, the critical issue is the trustworthiness of the Father. The cost is bearable if the Father can be trusted. At the heart of the incarnation is the revelation of the trustworthiness of the Father.

Marvin was shot dead by his father. He was the victim of his father's rejection. Jesus gave up his life for us according to the will of his Father who was at work through his death ('in Christ God was reconciling the world to himself', 2 Cor. 5:19). Father and Son were united in their love for us and in their action for our redemption. The Spirit was the gift from the Father who enabled the Son's loving act of recapitulation. It was this which the tempter tried to abort.

FURTHER READING

Christopher Cocksworth, *Holy, Holy, Holy: Worshipping the Trinitarian God* (London: DLT, 1997), especially chapter 6.

Paul Du Gay (ed.), *Production of Culture/Cultures of Production* (London: Sage/Open University, 1997).

C. FitzSimons Alison, *The Cruelty of Heresy* (London: SPCK, 1994).

Steve Turner, *Hungry for Heaven* (London: Hodder & Stoughton, 1995).
Trouble Man: The Life and Death of Marvin Gaye (London: Michael Joseph, 1998).

Peter Wicke, *Rock Music – Culture, Aesthetics and Sociology* (Cambridge: CUP, 1990).

NOTES

1. 'In the seventeenth and eighteenth centuries, before the deep dissolving effects of the Enlightenment became apparent, there was a unity in the whole culture. As far as music was concerned there were different streams, and certainly different kinds . . . But there was no break in society. Ordinary church goers in Leipzig would listen to Bach's cantatas in church. Even if they did not understand the supreme quality and depth to the music, they could enjoy it. The

music was not written for an élite. Nor were the simpler and folksier kinds of music strange to the ears of the cultivated. There was a sense of normality and genuineness about all this music that made it everybody's music.' Hans Rookmaaker, *Modern Art and the Death of a Culture* (London: IVP, 1970), p. 186.

2. See e.g. Theodor Adorno and Max Horkheimer, *Dialectic of Enlightenment* (London: Verso, 1977).

3. Richard Kearney, *The Wake of Imagination* (London: Routledge, 1994), p. 31.

4. Fredric Jameson, 'Postmodernism and Consumer Society', in Hal Foster (ed.), *Postmodern Culture* (London: Pluto Press, 1983), pp. 119, 125.

5. Raymond Williams, 'Culture is Ordinary', in *Resources of Hope* (London: Verso, 1988).

6. See Paul Du Gay, et al., *Doing Cultural Studies: The Story of the Sony Walkman* (London: Sage/Open University, 1997).

7. Keith Negus in *Production of Culture/Cultures of Production*, ed. Paul Du Gay (London: Sage/Open University, 1997), p. 101.

8. Hans Bertens, *The Idea of the Postmodern* (London: Routledge, 1995), p. 11.

9. William Dyrness, *The Earth is God's: A Theology of American Culture* (Maryknoll, New York: Orbis, 1997), p. 69.

10. Peter Wicke, *Rock Music: Culture, Aesthetics and Sociology* (Cambridge: CUP, 1990), p. 181.

11. ibid., p. 174.

12. Quoted by Mick Farren in *Melody Maker* [exact reference unknown].

13. Thomas Smail, *Reflected Glory* (London: Hodder & Stoughton, 1997), p. 90.

14. Morna Hooker, 'A Partner In The Gospel', in *Theology and Ethics in Paul and His Interpreters*, ed. Eugene Lovering and Jerry Sumney (Nashville: Abingdon 1996), p. 90.

15. Christopher Cocksworth, *Holy, Holy, Holy: Worshipping the Trinitarian God* (London: DLT, 1997), p. 154.

16. Luke's genealogy goes back further than that in Matthew, who traces Jesus' descent back to Abraham. Luke follows it back to 'son of Adam, son of God' (3:23–38). The passage implies a Christology of Jesus as the 'last Adam'.

17. Witness, for example, the influence of the music of 'The Beatles' on the band 'Oasis'.

18. Most recently, Steve Turner, *Trouble Man: The Life and Death of Marvin Gaye* (London: Michael Joseph, 1998).

19. See William Edgar, 'On the Off Beat', *Third Way*, 9 (1986), pp. 18–20. There is a considerable literature on these connections. See in particular Viv Broughton, *Black Gospel* (Poole: Blandford, 1985); James Cone, *The Spirituals and the Blues* (New York: Seabury, 1971); Dena Epstein, *Sinful Tunes and Spirituals* (Chicago: University of Illinois, 1977); Eugene Genovese, *The World the Slaves Made* (New York: Vintage, 1976); Michael Harris, *The Rise of Gospel Blues* (New York: OUP, 1992); Anthony Heilbut, *The Gospel Sound* (New York: Limelight Editions, 1985); Gerri Hirshey, *Nowhere to Run – The Story of Soul Music* (London: Pan, 1984); Paul Oliver, *Songsters and Saints* (Cambridge: CUP, 1984); Samuel A. Floyd, *The Power of Black Music: Interpreting Its History from Africa to the United States* (Oxford: OUP, 1995).

20. Heilbut, *The Gospel Sound*, p. x.

21. See Daniell Wolff, *You Send Me: The Life and Times of Sam Cooke* (London: Virgin, 1996).

22. Dave Hill, *Prince: A Pop Life* (London: Faber & Faber, 1989), p. 129.

23. See David Ritz, *Divided Soul* (London: Grafton, 1986), and Steve Turner, *Trouble Man*.

24. Review in *Time* magazine quoted in Ritz, *Divided Soul,* p. 195.

25. Quoted in Ritz, *Divided Soul,* p. 199.

26. Lyric from 'Wholy Holy' on the 'What's Going On' album.

27. Turner, *Trouble Man,* p. 133.

28. Ritz, *Divided Soul,* pp. 234, 233.

29. Turner, *Trouble Man,* p. 158.

30. Smail, *Reflected Glory,* p. 91.

31. John Nolland, *Luke 1–9:20 Word Biblical Commentary 35a* (Dallas: Word, 1989), pp. 178–183. (My chapter draws substantially on the insights of Nolland's commentary.)

32. Turner, *Trouble Man,* p. 156.

33. Cocksworth, *Holy, Holy, Holy,* p. 154.

34. See Turner, *Trouble Man,* pp. 236–42, where the author contrasts Marvin's life with Paul's account of the fruit of the Spirit in Galatians 5.

35. Heb. 2:18; see also 1 Cor. 10:13.

36. Nolland, *Luke 1–9:20,* pp. 178–83.

THROUGH MUSIC:
Sound Mix

JEREMY BEGBIE

Graham Cray has focused on a particular form of music. This essay stands back a little and examines a basic characteristic of virtually all the music we hear – namely, that it includes simultaneously sounding notes. Unremarkable as this may seem, I attempt to show that the experience of hearing notes sounding together, and reflection on that experience, has the power to liberate theology from some of its most potentially damaging ways of working, and open up fresh and unexplored avenues for the future. This is especially so when it comes to exploring the incarnation, and its companion doctrine, the Trinity.

'A *picture* held us captive. And we could not get outside it, for it lay in our language and language seemed to repeat it to us inexorably.'[1] So wrote the philosopher Ludwig Wittgenstein, looking back at his own early philosophy. He was pondering a particular way of thinking about the link between language and reality, one he had since abandoned. But his words could easily apply to much theology, the way we explore the Christian faith. Whether we are academic theologians or not, we can all be 'captive' to pictures which do more to obscure truth than reveal it, pictures latent in the very words we use. And 'picture' need not mean visual images, but

anything we use to help us think – models, metaphors, concepts, symbols, or whatever.

When we try to probe the depths and wonder of the incarnation, we automatically fall back on certain habits of thinking, the way a computer reverts to a 'default' page set-up when you open a new document. Everything gets 'framed' from the start in a certain way. Sometimes this can be quite harmless. But troubles start if our pre-programmed mental settings cannot cope with whatever it is we are trying to understand or articulate. And, as I hope to show, this has certainly been true when it comes to the incarnation.

How can we free ourselves from harmful 'pictures'? Just as a dog only drops a bone when a slab of meat appears, so we will only drop some ways of theologising when something better is offered. In this chapter, I want to suggest that music can often offer 'something better', helping us to 're-imagine a too-familiar theology' (Malcolm Guite). To pick up Lynn Aldrich's words, by being 'a way of knowing that is unique to itself', music can liberate our theology of some of its worst bad habits, and refresh it for the future. And I want to show that it can do this for 'This most tremendous tale of all' (Betjeman), the coming of God as one of us in Jesus Christ.[2]

Of course, music has conveyed the words of the Christmas message since the earliest days of the Church. From improvised chants in stone basilicas, through Bach's hushed 'Et Incarnatus' in the *Mass in B Minor*, to the rave-style alternative worship of the 1990s, music has borne the news of Bethlehem. And, as Graham Cray has shown in his chapter, songs without any intention of deepening our view of the incarnation can serve just this end. But here I want to focus on music without words, and take as our starting point a basic feature of most of the music we hear, whether classical or rock, Beethoven, Britten, bebop or hip hop: *it mixes sounds*, to be more accurate, *it combines two or more notes*. Certainly, much music in the western tradition has not mixed its notes – Gregorian plainsong is an example. Nevertheless, the majority of music we encounter in the West today involves at least two notes being played or sung at once.

Chalcedon's Trials

How can such a simple fact be relevant to the incarnation? To answer that, it will help to gain an historical perspective and find out the sort of things which happen when our theology becomes captive to bad habits. One of the classic and most famous statements of the early Church came from the Council of Chalcedon, convened in AD 451 in part to deal with numerous controversies in the Church as to how we should understand the relation between the divine and human in Christ. The statement came to be one of the landmarks of Christian orthodoxy and has set the stage for much of the Church's thinking since. It declared, among other things, that we should acknowledge 'One and the Same Christ, Son, Lord, only-begotten made known in two *natures*, without *confusion*, without *change*, without *division*, without *separation*.'

That is to say, the two natures of Christ – divine and human – are not to be thought of as confused or changed, nor divided or separated. As any student of the history of doctrine knows, Chalcedon has had a rough ride through the centuries, not least in the last two hundred years. Often this has been because the questions it was addressing and its leading concerns have not been fully appreciated. The Council's affirmation was never intended to *explain* a mystery but rather to *preserve* it: the mystery that in the one Jesus Christ we witness both the eternal Son of God, and a limited, finite human being, without either being compromised. Nevertheless, although it may have ruled out heresy clearly, its positive potential was, and has since been, much less clear. And, as many have pointed out, the overall impression given is somewhat static: two 'natures' – divine and human – sitting rather uneasily alongside each other, awkwardly juxtaposed in a single individual.

However misleading that impression may be about the intention of the Council, it is hard to avoid thinking that it represents a cast of mind by no means absent today, and one which seems to do little to advance our understanding of the union of human and divine in Christ. Typically, when we ask 'how can Jesus be

God and human?' we take one of three broad paths. The first is simply to throw up our hands and say: 'it's just a mystery. Christ is one person with two natures – we must affirm this with child-like trust, and stop asking awkward questions.' Unfortunately, this looks much too like whistling in the dark. The second path is to reject the statement as inherently nonsensical, and with it any orthodox account of the incarnation. How can an infinite, omnipresent, omniscient God cohabit with a limited human being? We might as well speak of a square circle. Talk of 'mystery' and 'paradox' simply masks nonsense. Third, we can try to fill out Chalcedon's assertion by insisting that without making it, salvation falls to bits: if Jesus is not a human being we cannot be saved as we are, if he is not divine it is not God who saves and we are left to ourselves. So far so good. But this path quickly forks in two smaller ones. There is the path which leads to the circus: we become 'tightropers', balancing humanity and deity in perfect equilibrium like a double-weighted bar, poised high above heresy. This is a precarious orthodoxy – we dare not say too much about either his humanity or deity in case we lose sight of one or the other, and so miss out on both. And it appears very much as if humanity and deity are working against each other: the more of one, the less of the other. Others leave the circus and become 'compromisers' – believing that Christ's deity was diminished in some way, that he was a sort of 'scaled down' version of God (Trevor Hart) or that Jesus' humanity, though real, was substantially adjusted to cope with God's overwhelming presence. But, of course, this reduces Christ's deity or humanity, depending on which one chooses, and hence undermines salvation. Again, we seem to be assuming that God and humanity are essentially incompatible with each other. Indeed, something like this assumption also seems to lurk behind the other two main paths.

I want to argue that none of these paths is adequate, but that what Chalcedon wants to affirm – insofar as it is in line with the New Testament – cannot be properly heard until we have been freed from certain 'default' ways of thinking and found 'something better'.

Space for Everyone

'A *picture* held us captive . . .' In this case, it seems that a visual picture is at least partly responsible for our dilemmas. Let us take a step back for a moment, and consider how we conceive God's relation to the world. Here, arguably, difficulties have arisen because we have been over-enamoured by visual ways of thinking about space. It is well known that the father of modern science, Sir Isaac Newton, saw space as a kind of container, an infinite receptacle, distinct from anything which goes on inside it. Things in this space-container are mutually exclusive. That is, you cannot have two things in the same place at the same time. By the same token, a thing cannot be in two places at the same time. This is at root a visual way of thinking; it applies to the things I see. A painter knows that you cannot have red and yellow on a canvas in the same space, and have them visible *as* red and yellow. What happens? One colour hides the other, or (if the paint is wet) they merge into some kind of orange. And, clearly, you cannot have the same patch of colour in two places at the same time.

Obvious as all this may seem, problems emerge when we allow these patterns of thinking to dominate the way we imagine God's presence to the world. To begin with, *it is hard to conceive of God as fully God*, upholding the universe of space and time, *while at the same time being active in the world*. It would seem that he has either to be 'in' the container or 'outside' it; he cannot be in two places at the same time. (Here a visual model of space is applied not just to the world's space, but to the God–world relation.) We will struggle to hold together God's 'transcendence' and 'immanence', for they are being set up as enemies from the start. Even a glance at the story of Christian thought shows the huge effort it has often taken the Church to maintain both.

But even if this problem is negotiated, the troubles are not over, as long as we lean exclusively on what our eyes tell us. If the world is conceived as a giant container (of the sort we can see), how can there be 'room' for an uncontainable God (or even a very large God!) within this limited space? It is hard to resist the conclusion that *the more active God is in the world, the more*

restricted the world is going to be, the less 'room' it will have to be itself. In line with this, one of the most persistent visions of the modern age is of the universe as a closed system, a machine, governed by the Newtonian laws of cause and effect, with God definitely on the 'outside'. One form of that is 'deism' – in its strong form, the view that God is an absentee landlord; he started up the world but is not now involved in it or with it. In response, some will insist God 'intervenes', but this language only perpetuates the picture of God essentially outside a self-sufficient world, like a burglar breaking in to a world which does not belong to him. The opposite swing of the pendulum to deism is some kind of merger between God and the world, where the world is seen as in some sense divine, or God is seen as in some sense needing the world to be himself. We are seeing something of a revival of such views in so-called 'new age' spiritualities and their many offspring.

What is said of the world at large can easily apply to humanity. If God is to be active in this world-space, anything already in the same space must either be pushed out or get swallowed up. If that 'anything' is you and me, it is a short step to believing that *the more God is active among us, the less room we will have to be ourselves.* 'The more of God, the less of us.' If God is 'here', he must either force me aside or swallow me up. This essentially competitive way of thinking about God and humanity[3] is focused in that pervasive certainty of the modern sceptic: belief in a God who is 'other' than us, freely involved in our lives in all his unlimited power, can only stifle our true freedom and humanity.[4] Much modern atheism, and much modern fear of Christianity, has traded on just this kind of conviction. The oppressive, tyrannical sovereign God of the Bible, who reduces us to passive objects of his will, must be firmly sent packing so that we can be 'free' and assume our displaced dignity.[5] The common conservative reaction to this – 'God is everything, we are nothing' – in effect plays the same game, presuming God and humanity are fundamentally opposed to each other. And, again, the only other major option would seem to be some kind of merger – for example, that humanity is seen as intrinsically part of God's

being, or that salvation is seen as a process in which humans are made divine.

What has all this to do with the incarnation? The more we remain wedded to this way of thinking and speaking, the harder it will be to make sense of the claim that in this very human Jesus, God is uniquely and decisively active. We are going to have colossal problems claiming that the Son of God is sustaining all things (Heb. 1:3) *and* that he is there in the baby Jesus. For how can he be 'out there' *and* 'in here'?[6] And even if we do believe that God can achieve this in some manner, even if we want to cling to orthodoxy and insist that in this human being the 'whole fullness of deity dwells bodily' (Col. 2:9), how are we to imagine that they both find 'room' in the one space? How can we effectively avoid the conclusion that the humanity of Jesus was set aside or swallowed up? It is hardly surprising that we are so easily left with those three broad paths we highlighted earlier: clinging to orthodoxy in blind trust; abandoning the incarnation as an absurdity dressed up in religious jargon; becoming 'tightropers' or 'compromisers'.

Is there a cogent way of refusing to be bound by the assumption which seems to control so much of what we have found – that God and the world, God and humanity are essentially at odds?

Notes and Space

Suppose for a moment that we allow ourselves to learn from the sound of a note. If I play a note on the piano – say, middle C – the note fills the whole of my heard 'space'. I cannot identify some zone where the note is and somewhere it is not. I do not say 'it is here, but not there'. Unlike the patch of red on a canvas, it is, in a sense, everywhere. Of course, I can identify the source of the note (the vibrating string), and its location ('it is over there'). But what I *hear* does not occupy a bounded space. It fills the entirety of my aural space.

If I play a second note – say, the E above middle C – along with middle C, that second note also fills the whole of my heard

space. Yet I hear it as distinct. The notes 'interpenetrate', occupy the same 'space', but I hear them as two notes.

Some will object that I am using the word 'space' very metaphorically, to speak of the experience of hearing, not the 'real' space we can see. This, of course, assumes that what we see, or what is visualisable, should wholly determine what 'real' space is – whereas even a casual glance at the development of modern physics shows much of the world stubbornly defies visualisation. But even leaving that aside, we have at least shown that a different way of thinking about space is possible. Here is a kind of space which is not the space of mutual exclusion, but space as relational, a space which allows for overlapping and interpenetration. From another angle, this is tellingly brought out by John Hull when he reflects on the experience of going blind. Even though he is not speaking of notes and music, he is worth quoting at length. Deprived of sight, he asks:

> What is the world of sound? I have been spending some time out of doors trying to respond to the special nature of the acoustic world . . . The tangible world sets up only as many points of reality as can be touched by the body, and this seems to be restricted to *one problem at a time*. I can explore the splinters on the park bench with the tip of my finger but I cannot, *at the same time*, concentrate upon exploring the pebbles with my big toe . . . *The world revealed by sound is so different* . . . On Holy Saturday I sat in Cannon Hill Park while the children were playing . . . The footsteps came from both sides. They met, mingled, separated again. From the next bench, there was the rustle of a newspaper and the murmur of conversation . . . I heard the steady, deep roar of the through traffic, the buses and the trucks . . . [The acoustic world] *stays the same whichever way I turn my head*. This is not true of the perceptible [i.e. visually perceptible] world. It changes as I turn my head. New things come into view. The view looking that way is quite different from the view looking this way. It is not like that with sound . . . This is a world which I cannot shut out, which goes on all around me,

and which gets on with its own life ... *Acoustic space is a world of revelation.*[7]

Let us go back to two notes sounding, and consider another feature of vibrating strings – though we rarely attend to this consciously. Suppose I play middle C, and open up the string an octave above by silently depressing the appropriate key. The upper string will start vibrating even though it has not been struck.[8] The lower string 'sets off' the upper. And the *more* the lower string sounds, the *more* the upper string sounds in its distinctiveness. It makes no sense to think of the strings as in competition, or as simply 'allowing' each other room to vibrate – the lower string enhances, brings to life the upper string, frees it to be itself, neither compromising its own integrity nor that of the upper string. Moreover, when certain other strings are opened up alongside both these strings, they too will vibrate in sympathy.

The Sound of the Incarnation

The value of all this for exploring the incarnation will not be hard to see (or hear!). It is not that all the perplexities suddenly dissipate, but we are freed from some types of thinking which have obscured the mystery, and given fresh ways of allowing the mystery to declare itself more fully. Let us retrace our steps. Our assumption that 'the more of God, the less the world can be itself' is sharply challenged if we work in the medium of notes sounding together. We are reminded that we are not dealing with two realities vying for the same space, but with God interacting with the world intimately, without violating it or merging with it, liberating it to be more fully itself. We will also be much less inclined to assume 'the more of God, the less of us'. Certainly, sin has introduced a dissonance which must not be forgotten nor downplayed; there is a sense in which we *are* indeed at odds with the Creator. But this is not our fundamental condition, nor must it set the stage for all our thinking about the God-human relation. God's involvement with our lives neither pushes us out, nor swallows us up, nor leads to some kind of fusion. God does

something much more creative – through intimate interaction with us, he frees us to 'sound' as we were created to sound, enabling us to be more fully ourselves. We are not de-humanised, but re-humanised. 'If the Son makes you free, you will be free indeed' (John 8:36). And this is hardly a trivial matter – in a world which suspects the Christian faith of being anti-life and anti-human, to find ways of imagining and conveying a perspective more true to the Bible's testimony is urgently needed.

And so to the incarnation. Why think of the humanity of Christ sitting awkwardly alongside the divine eternal Son (or competing?) within the one (visible) space? We can start to conceive of 'overlapping' spaces, the closest *interaction* in our limited space, without loss of either. We can rediscover the best of Chalcedon (true to the New Testament): here in Jesus Christ we witness the divine Son eternally in communion with the Father, engaging with our world so closely so as to assume humanity, flesh and blood; and far from being compromised, humanity here reaches its intended destiny in union with the Son – here *is* human existence as it was meant to be. In this person, we witness the closest interaction of divine space and human space ('without division, without separation') without either being compromised ('without confusion, without change').

And Three Notes?

It is likely that some readers will have jumped ahead to the Trinity. Why not add a third note to our two-note chord? What could be more apt than to speak of the Trinity as a three-note-resonance of life, mutually indwelling, without mutual exclusion and yet without merger, each occupying the same 'space', yet recognisably and irreducibly distinct, mutually enhancing and establishing each other? A musicologist writes about a three-note chord:

> Three tones sound . . . None of them is in a place; or better, they are all in the same place, namely everywhere . . . No

difference of places keeps them apart; yet they remain audible as different tones . . . the tones connected in the triad sound *through one another*.[9]

Perhaps a large part of our chronic tendency to treat the Trinity as essentially a problem to be solved rather than a reality to be enjoyed – a mathematical puzzle about threeness and oneness to be agonised over on Trinity Sunday – has been fuelled by giving pride of place to the eye in telling us what is possible and impossible. Then it is hard to escape imagining God as blandly one (unitarianism), or a celestial committee of individuals (tritheism), or three manifestations of the 'one' God who has no distinctions in himself ('modalism'). (The next time we hear a Trinity Sunday sermon, there is a good chance that the illustrations will all be visual.) Not only that, many depictions of the Trinity have been essentially static and still, whereas to speak of three strings mutually resonating instantly introduces a dynamism which is arguably far truer to the trinitarian, living God of the New Testament.

A number of writers have recently been pressing that if we started being more unashamedly trinitarian in our approach to the incarnation, we would have far fewer problems.[10] All too easily, 'divinity' becomes an abstraction – a 'nature' – which must be somehow fitted together with an equally abstract notion of 'humanity'. The New Testament writers do not seem to be very interested in 'divinity' – they do seem to be captivated by a living God, the God of Israel, now decisively identifying himself in and through the life, death and rising of Jesus, the authentic and ultimate human being. By the time John's Gospel is written (*c.* AD 90), this God is spoken of as including an eternal relationship. The relation between Jesus and the one he calls 'Father' is being traced to a relation within the heart of God – that between Father and Son. 'Divinity' is not the focus of attention, but the eternal love-relation of Son and the Father, into which we are adopted by the Holy Spirit. Likewise, in the New Testament, 'humanity' in some abstract sense does not seem to be the centre of interest, but (especially in Luke and Paul's writings) the particular Spirit-

filled representative humanity of Jesus in which we can now share.

Conceiving 'God' as the eternally resonating chord of Father, Son and Spirit encourages us to be far more faithful to these biblical currents. Instead of thinking of Christ possessing a 'divine nature', we can imagine an eternal lively resonance between Father and Son, mediated by the Spirit, into which we can be caught up. Instead of thinking of Christ possessing a 'human nature', we can conceive him as the one in whom humanity has been restored to its created destiny, 'tuned' to the Father through the Spirit, and of you and me being 'tuned in' to his humanity by the same Spirit.

Of course, if we were to expand on this, we would need to make many qualifications. The relations within the Trinity are not identical to those between Son and the humanity of Christ, nor, indeed, between us and Christ. Also, we would need to insist that we are not attacking visual modes of thinking in themselves – a chronic and much-discussed Protestant tendency – or ignoring the fact that there have been some magnificent visual renderings of the Trinity, and, of course, of the incarnation. The main point here, however, is to suggest that serious difficulties arise if we rely too heavily or exclusively on one sense at the expense of others, and that the world of simultaneously sounding notes offers underdeveloped resources, not least when we want to explore the incarnation.

Musical Drama

Music depends on these 'interpenetrating' and 'resonating' features of sound far more than any other sonic art form. When I go to a concert, and hear more than one note being played at once, I do not walk out complaining that what I hear is contradictory or unintelligible. We normally *enjoy* hearing a number of different sounds at once: we are caught up, drawn in. Compare our reaction to hearing four people talk simultaneously.[11]

Of course, music in the modern western tradition normally consists of more than two or three notes sounding together.

It consists of strings of notes – melodies – and melodies with accompaniments (monody), and melodies with melodies (polyphony), extended over many minutes, even hours. And even the simplest song is not a static block of sound we can 'view' from a distance, as it were, but a dynamic of simultaneous sounds into which we are caught up. Take for example a two-part invention of Bach – it is hard not to sway, or tap our feet, or at the very least be mentally caught up in all the criss-crossing and rhythmic interweaving. The piece is more than a succession of harmonic 'moments', it is a dynamic organic unity which attracts us, pulls us in. To use Andrew Rumsey's words about poetry, 'it draws you into the action'.[12]

Returning to the Trinity, instead of a chord, might it not be more appropriate to speak of God's life as three-part polyphony, even, as Robert Jenson intriguingly suggests, a fugue?[13] This more readily suggests response, giving and receiving, particularity of the persons, even the joy of God. Jenson can write: 'our enjoyment of God is that we are taken into the triune singing'[14] and this by virtue of the incarnation. Certainly, applied directly to the incarnation, polyphony highlights another and often forgotten feature of it, which (as I have already hinted) can be all too easily eclipsed by Chalcedon. The incarnation is not a theory, or a picture, or a concept – but essentially a drama of interpenetration between the triune God and humanity, extending from Bethlehem to Jerusalem, a story with shape, struggle and direction, and a glorious climax: Christ, as fully human, established in the life of God, humankind and God at last *together* as they were meant to be. Music can remind us that all the extraordinary patterns of interpenetration and resonance we have been tracing – within God, between the Son and the humanity of Jesus, and between us and God – all participate in a magnificent multi-voiced symphony of salvation, with the incarnate Son at its heart. It is a symphony which has embraced dissonance at its most destructive, including the arresting dissonance and silence of Good Friday and Holy Saturday. Like all music, it is played out *for us* objectively in time, in the incarnate life of Christ, and now by virtue of the Spirit, it is played *in* and *through* us, catching us

up in its manifold resonances – 'you are the music/While the music lasts' (Eliot).

Sounding Together

There is another dimension of the incarnation to mention which music, through its dynamic mixtures of sounds, can disclose with special potency. If it is typical of western modernity to see people as self-determining, isolated agents, sovereign over their carefully bounded 'space', the same is true of much thinking about the goal of the incarnation, which all too often is seen as the rescue of solitary individuals for heaven. But the true human goal of the incarnation is the creation of a new people, a community sustained by the Spirit, bound with that love which binds the incarnate Son to the Father (John 17:22). Models of people occupying mutually exclusive spaces (of the sort we saw earlier) will not help here. For we will likely begin to say: 'the more I can preserve my distance from you and others, the more likely I am to flourish and be free.' 'The more of me, the less of you' could well stand as a motto over a large amount of contemporary writing on human freedom.

During a recent visit to South Africa, a number of times I sang the national anthem, 'Nkosi Sikelel' iAfrika'. Wherever I sang it, it evoked in me an extraordinary sense of togetherness, even though I hardly knew the hymn and often hardly knew the people with whom I was singing. Part of the reason for that, no doubt, was that I knew this song had bound thousands together during the fierce decades of *apartheid*. Part of it was the overwhelming welcome I received at most of the assemblies where I sang it. But a large part of it also was its four-part harmony, in which no vocal line predominates over the others (unlike the British national anthem, for example). Sing this in South Africa and, in keeping with a vast range of African music, it will be in harmony. (Unlike the Western European tradition, singing in harmony does not need to be taught.) Your voice and all the others fill the same heard 'space'. It is a space not of a hundred voices each with their mutually exclusive and bounded 'place', but a space of

overlapping sounds, an uncrowded, expansive space without 'edges' where distinct voices mutually establish each other. Why was solidarity in South Africa so often expressed in harmonious song during the years of oppression? Among the many reasons, I suggest, is that when crowds met to sing – in camps, townships, churches, marches – the *music* provided a taste of authentic freedom, when in virtually every other sense they were *not* free. Why is it that freedom and reconciliation have so often been celebrated in this kind of singing? Because, I suggest, people are experiencing a kind of concord which embodies the kind of freedom in relation to others – even our enemies – which the trinitarian gospel makes possible.

It was from black sources that the vast river of jazz emerged. Micheal O'Siadhail writes of jazz improvisation:

> Moody solos. Unique. The stamp of one voice;
> Then pure concert as an ensemble improvises,
>
> Hearing in each other harmonies of cross-purpose,
> As though being ourselves we're more capacious.[15]

Anyone who has experienced 'singing in tongues' will probably search for similar words. Likewise anyone who has either sung or experienced Thomas Tallis' extravagant forty-part motet *Spem in Alium* (c. 1570). Here forty different voices weave their way in and through each other. Tallis' imagination transports the hearer into a fantastical sound-world, with freely-interweaving counterpoint, antiphonal exchanges in block harmony, and carefully-positioned massed outbursts of all forty voices singing together. Despite the sonic profusion, it never sounds 'jammed' or crowded. There is multiplicity without dissipation, togetherness without mutual overwhelming, each voice being enabled to become more fully itself: 'As though being ourselves we're more capacious.'

To explore the incarnation through music might well mean that even our most ingrained individualism is challenged. A rich theology of the Church spills out with comparative ease. The resonances we enjoy through the Spirit with the Son and Father,

made possible by the cross, catch others up and bind us to them, even those who are 'out of tune'. The miracle of the incarnation eventually makes possible a kind of ensemble, a 'pure concert' in which we find that in 'being ourselves we're more capacious'. We expand and we are able to accommodate others we have previously shunned. This is the harmony of 'cross-purpose' – the harmony purposed in the crucifixion of the incarnate Lord. When it is turned into music, it can, at best, be a foretaste of heaven – not the sterile bliss of so many portrayals, but an abundant, dynamic multiplicity:

> I heard the voice of many angels surrounding the throne and the living creatures and the elders; they numbered myriads of myriads and thousands of thousands, singing with full voice,
>
> > 'Worthy is the Lamb that was slaughtered
> > to receive power and wealth and wisdom and might
> > and honour and glory and blessing.'
>
> (Rev. 5:12)

FURTHER READING

Jeremy Begbie, *Music in God's Purposes* (Edinburgh: Handsel Press, 1989).

David Cunningham, *These Three Are One: The Practice of Trinitarian Theology* (Oxford: Blackwell, 1998), ch. 4.

Colin Gunton, *Yesterday and Today: A Study of Continuities in Christology* (London: SPCK, 1997), ch. 6.

Patricia Kruth and Henry Stobart (eds.), *Sound* (Cambridge: Cambridge University Press, 1999).

Alistair McFadyen, 'Sins of Praise: The Assault on God's Freedom', in *God and Freedom*, ed. Colin E. Gunton (Edinburgh: T & T Clark, 1995), pp. 32–56.

T. F. Torrance, *Space, Time and Incarnation* (London: OUP, 1969).

Victor Zuckerkandl, *Sound and Symbol: Music and the External World* (London: Routledge and Kegan Paul, 1956).

NOTES

1. Ludwig Wittgenstein, *Philosophical Investigations* (Oxford: Blackwell, 1974), sect. 115, p. 48.

2. Other areas of theology are taken up in my book *Theology, Music and Time* (Cambridge: Cambridge University Press, 2000).
3. Nicholas Lash writes: 'It is . . . only too easy for the metaphysically incurious imagination . . . to conceive of the relationships between God and the creature in competitive terms.' Nicholas Lash, 'Up and Down in Christology', in *New Studies in Theology* I, ed. Stephen Sykes and Derek Holmes (London: Duckworth, 1980), p. 38.
4. The theologian Karl Rahner speaks of the tendency in some quarters to presume that God can only 'become greater and more real by the devaluation and cancellation of the creature'. Karl Rahner, 'Current Problems in Christology', *Theological Investigations* I (London: DLT, 1961), p. 188.
5. Much of the writing of Don Cupitt, for example, relies on just this presumption; our 'spiritual autonomy' can only be realised if we 'take leave' of the God who inhibits human flourishing. For a lucid entry to Cupitt's writings, see Anthony C. Thiselton, *Interpreting God and the Postmodern Self: On Meaning, Manipulation and Promise* (Edinburgh: T & T Clark, 1995), pp. 81ff.
6. Anyone familiar with the rise of 'kenotic' Christology in the nineteenth century will know these problems well. Arguably, that debate was hampered by an over-reliance on visual models. For a trenchant treatment of the issues, see T. F. Torrance, *Space, Time and Incarnation* (London: OUP, 1969).
7. John Hull, *Touching the Rock: An Experience of Blindness* (London: SPCK, 1990), pp. 62ff. My italics.
8. This is because of what is called the 'harmonic series' – the upper C is the first 'harmonic' of the 'fundamental' lower C.
9. Victor Zuckerkandl, *Sound and Symbol: Music and the External World* (London: Routledge and Kegan Paul, 1956), pp. 297, 298, 299.
10. See e.g. Christoph Schwöbel, 'Christology and Trinitarian Thought', in Christoph Schwöbel (ed.), *Trinitarian Theology Today* (Edinburgh: T & T Clark, 1995), pp. 113–46. Schwöbel speaks of our need for a 'paradigm shift from natures to persons' (139).
11. This particular capacity of music in comparison to words alone is highlighted in some opera. In Act II of Verdi's *Otello*, there is a famous quartet when what happens in the Shakespeare play at different times – a scene between Desdemona and Othello, a conversation between Emilia and Iago – is brought together. The four voices sing *simultaneously*, in one texture. If spoken, each speech would make good sense on its own, but heard together they would sound nonsensical. When the simultaneous words are taken into the order of musical notes, however, nonsense turns to sense – the effect is intelligible and captivating. Zuckerkandl, *Sound and Symbol*, pp. 331ff.
12. ibid.
13. Robert W. Jenson, *Systematic Theology Vol. 1: The Triune God* (Oxford: OUP, 1997), pp. 234ff.
14. ibid., p. 235.
15. From Micheal O'Siadhail, 'That in the End', in *Our Double Time* (Newcastle: Bloodaxe, 1998), p. 96.

General Index

Index of Scriptures